OIL PAINTING ESSENTIALS

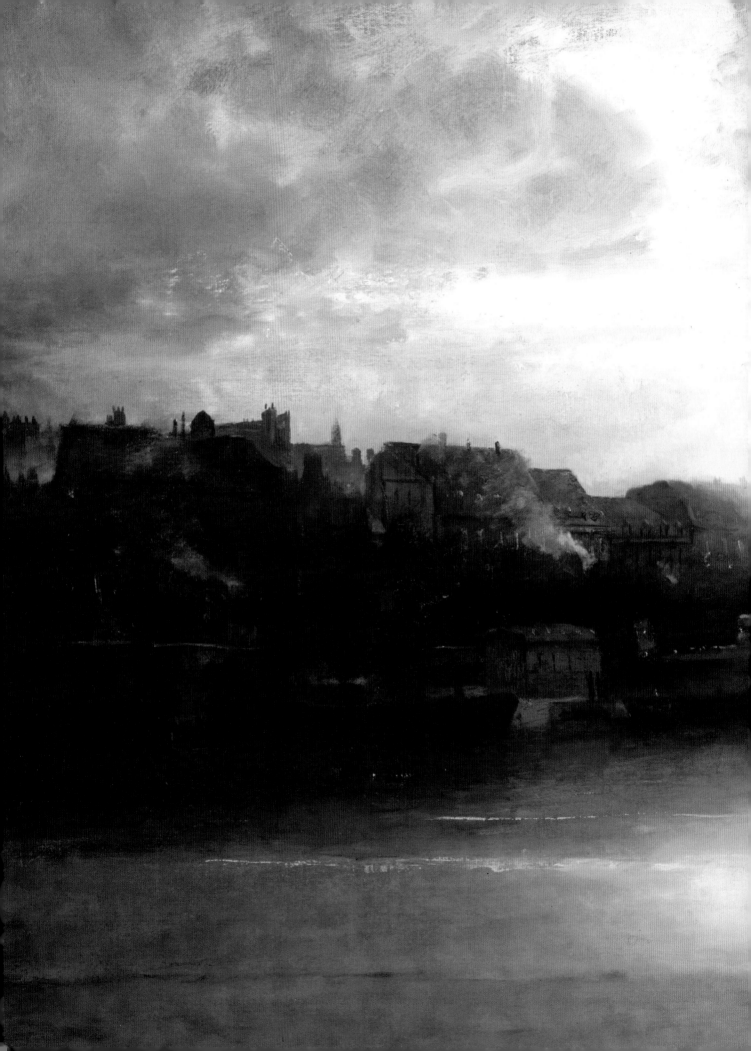

OIL PAINTING ESSENTIALS

Mastering Portraits, Figures, Still Lifes, Landscapes, and Interiors

GREGG KREUTZ

WATSON-GUPTILL PUBLICATIONS
Berkeley

Copyright © 2016 by Gregg Kreutz

Published in the United States by Watson-Guptill Publications,
an imprint of the Crown Publishing Group, a division of
Penguin Random House LLC, New York.
www.crownpublishing.com
www.watsonguptill.com

WATSON-GUPTILL and the WG and Horse designs are registered
trademarks of Penguin Random House LLC

Library of Congress Cataloging-in-Publication Data
Names: Kreutz, Gregg, 1947- artist, author.
Title: Oil painting essentials : mastering portraits, figures, still life,
landscapes, and interiors / Gregg Kreutz.
Description: First edition. | Berkeley : Watson-Guptill, [2016] |
Includes bibliographical references and index.
Identifiers: LCCN 2015037511 | ISBN Subjects: LCSH: Painting—
Technique. | BISAC: ART / Techniques / Oil Painting. | ART /
Techniques / General. | ART / Study & Teaching.
Classification: LCC ND1500 .K739 2016 | DDC 750.28—dc23 LC
record available at http://lccn.loc.gov/2015037511

Trade Paperback ISBN: 978-0-8041-8543-1
eBook ISBN: 978-0-8041-8544-8

Printed in China

Design by Chloe Rawlins

10 9 8 7 6 5 4 3 2 1

First Edition

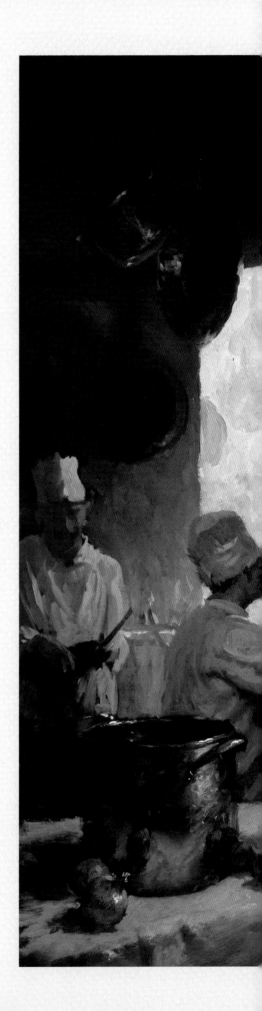

THIS PAGE: GREGG KREUTZ, *CHEFS*, 2009,
OIL ON CANVAS, 20 X 25 INCHES (50.8 X 63.5 CM).

pp. ii-iii: GREGG KREUTZ, *LIGHT ON THE WATER*,
2005, OIL ON LINEN, 30 X 40 INCHES
(76.2 X 101.6 CM).

pp. vi-vii: GREGG KREUTZ, *TAOS HORSES*,
1990, OIL ON CANVAS, 30 X 38 INCHES
(76.2 X 101.6 CM).

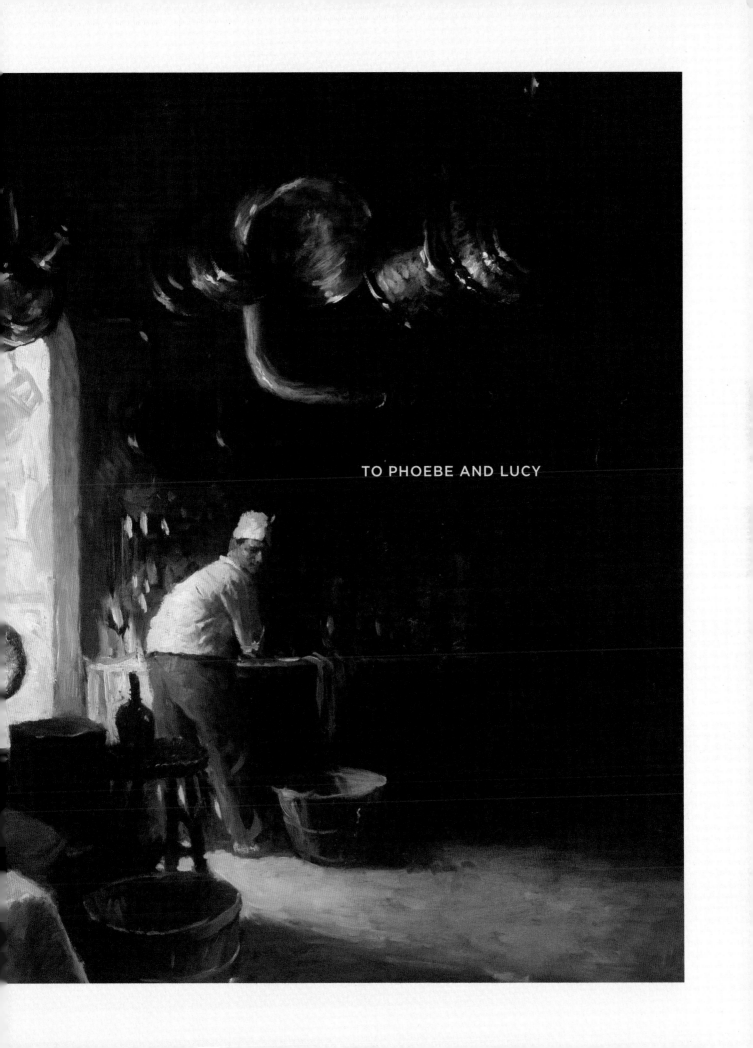

TO PHOEBE AND LUCY

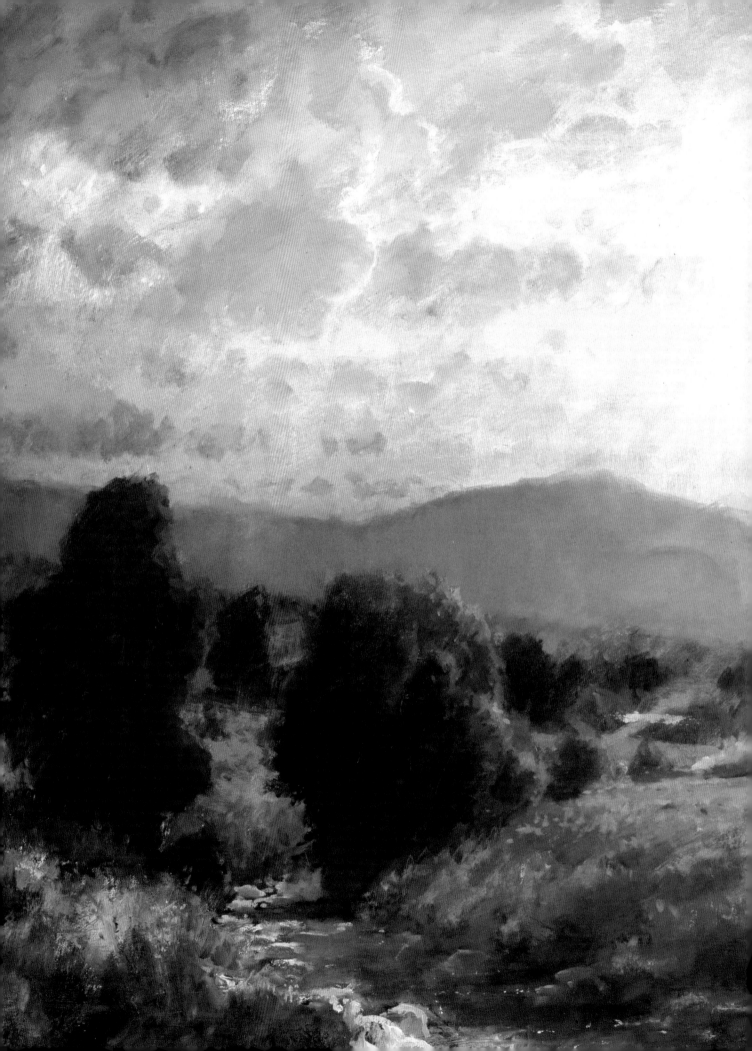

CONTENTS

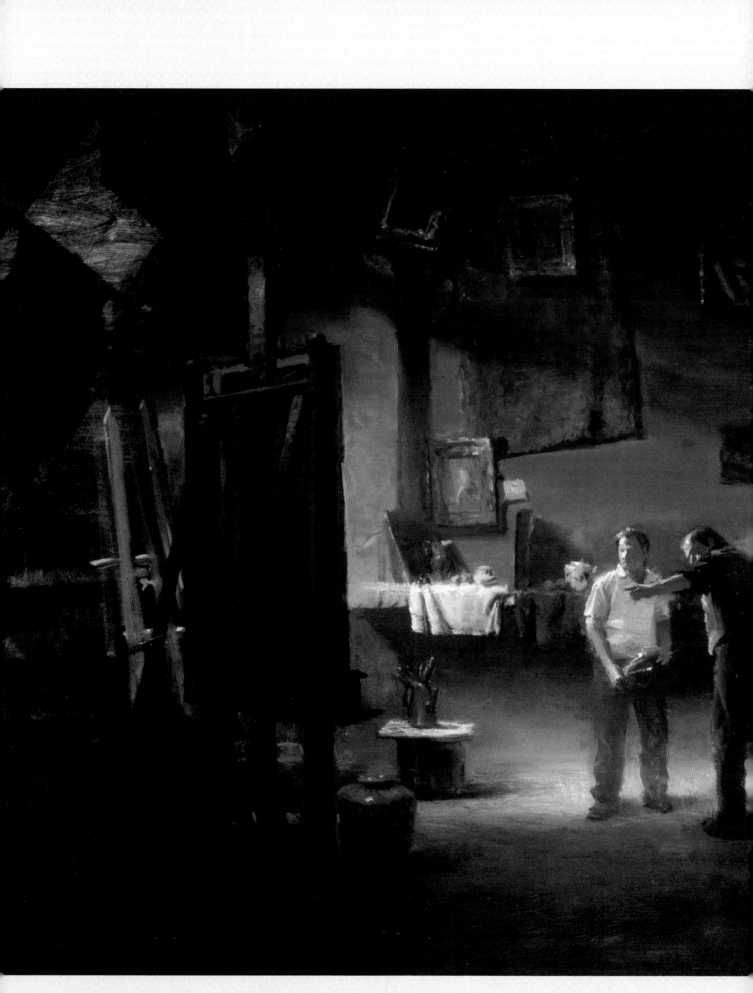

GREGG KREUTZ, *THE CRITIC*, 2002, OIL ON CANVAS, 22 X 24 INCHES (55.8 X 60.9 CM).

INTRODUCTION

Every oil painter knows the feeling: You're standing in front of the easel studying your painting, and while nothing seems particularly wrong with it, there's nothing particularly right about it either. The picture sits there, staring back at you, obviously in need of help, but sending no clear signal as to what kind of help.

In my experience, when that happens, when unknown forces have dragged the picture down to the murky depths and are blocking all attempts at resuscitation, it's time to hit the big issues, time to strip away superficiality and go after the essentials.

But which essentials? As you will see in the following pages, there are many oil painting essentials that are important, but they can't all be summoned up and thrown at the suffering painting. When you run up against a serious artistic impasse like the one described above what you need are—*prime essentials*!

And luckily, after forty years of intensive research, I've figured out exactly what these prime essentials are:

- *Accuracy*: Make sure you accurately depict the subject.
- *Design*: Arrange the material in a dynamic pattern.
- *Depth*: Make sure the near/far feeling of space is convincing.
- *Drama*: Intensify the visual energy.

Each of these prime essentials is important, and each needs to be given full attention by the oil painter.

What often happens, though, is that one or more of them is neglected, and the picture doesn't reach its full potential. For example, if you put all your energy into accuracy but neglect design, depth, and drama, the painting becomes just an inventory of what's seen. Or if you emphasize design at the expense of depth, accuracy, and drama, you get a picture with a flat, decorative, cutout look. If the picture is to succeed, each prime essential needs to be fully manifested on the canvas.

The painting, in other words, has to run on all four cylinders. Neglect any of them and you'll end up with a lopsided, incomplete picture.

Not that getting each prime essential right is easy—some artists may have no problem with drama, say, but may flounder on accuracy. Others might do brilliantly with accuracy, but fail to design the picture. So how do you master all four?

HOW TO MASTER ESSENTIALS

Researchers who study individual achievement say that skill mastering is the result of constant practice. They've even calculated exactly how much practice is needed. To achieve expert status in a discipline, they say, twelve thousand is the magic number. Put in twelve thousand hours and you'll nail it.

While that might be true of certain disciplines, it doesn't apply to oil painting. Spending four years churning out a painting a day won't guarantee that you'll end up a good painter. More likely you'll end up wanting to do something else—possibly *anything else*. Why? Because the skill of oil painting is not time dependent. It's insight dependent. Developing as a painter means figuring out the answers to questions like: *Why does the world look the way it does? What makes a picture effective? What is harmony? What is discord?*

Those questions aren't answered by repetitive action; they're answered by empathetic investigation, by hands-on (or perhaps brushes-on) exploration.

GREGG KREUTZ, *POOL HALL*, 2010, OIL ON CANVAS, 18 X 20 INCHES (45.7 X 50.8 CM).

Here's some focused attention on skill mastering.

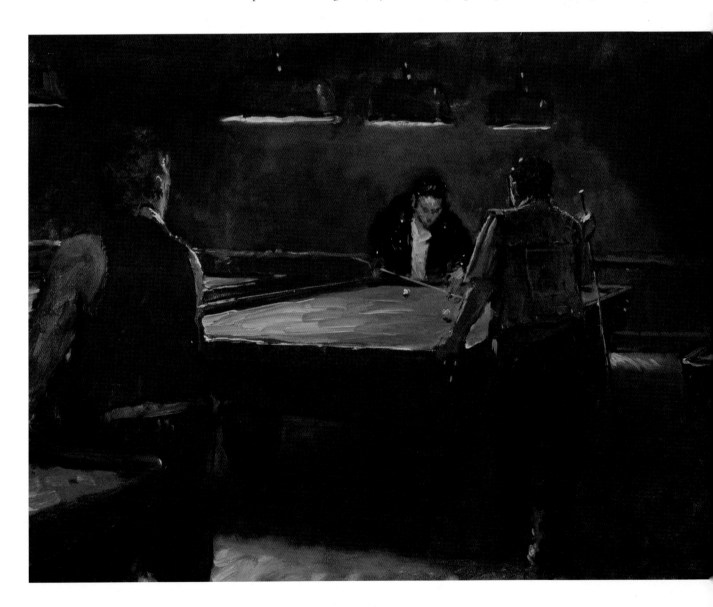

Just as a scientist won't make headway by doing the same experiment day after day, an artist can't expect improvement by painting the same picture day after day. How then does one master oil painting essentials?

Sensitivity

Sensitivity is the core component for mastering oil painting essentials. *Sensitivity*, in this sense, means being alert to the color of light, the gesture of a model, the delicacy of a leaf, and the sturdiness of a pot, as well as being keenly attuned to the touch of a brushstroke. In my view, that kind of holistic sensitivity—where equal attention is paid to both subject and process—is the real key to developing as an oil painter.

Sensitivity lays the groundwork for insight. In this book, I will share painting insights I've had over the past forty years, but ultimately for you to really benefit, you'll have to reach your own conclusions. What I've figured out will hopefully provide some guidance, but each insight I convey is only helpful if you experiment with it and turn it into your own. I believe—and hope you will discover—that there's an intelligence below the surface of consciousness that informs our insights. Part of our task as artists is both tapping into that intelligence and *trusting* it. Once accessed, that intelligence can increase your understanding, deepen your sensitivity to your surroundings, and enrich your oil painting.

Exploration of Multiple Genres

I believe that sensitivity-derived insights can best occur when the artist explores different kinds of subject matter. Portraits, figures, still lifes, landscapes, and interiors—each of these genres teaches important lessons about accuracy, design, depth, and drama. When practiced collectively, they help expand the artist's range of expression. And I say this knowing there are many artists who purposefully confine themselves to one particular genre. They become exclusively portrait painters or still life painters or landscape painters, and lock in on that one identity.

Why? For some, if they've mastered a certain discipline, they enjoy doing only what they do best. Others might feel that limiting themselves to one kind of subject makes them an easier commodity to package.

But in my experience as a painter, moving from subject to subject is the better approach because it widens the learning opportunity window. I like to work on a still life, for example, and then shift to a figure painting. Often the figure painting will benefit from some of the insights gained in painting the still life. Then when I move on to a landscape painting, there might be things I observed while painting the figure—maybe the way the light raked over a model's back—that I can use to enrich the landscape. Often these pictorial ideas can become strong design elements around which whole paintings can be built.

SPANNING GENRES

Here are three examples of how a visual idea can be used in multiple genres. These pictures below and opposite may depict different subject matter, but each is structured around the same visual scheme: the *S curve*. As its name implies, this particular design idea is a way to pull the viewer through the canvas in one direction and then (like the letter S) reverse that direction. It's a vital tool if the artist wants to control how the eye travels through the imagery.

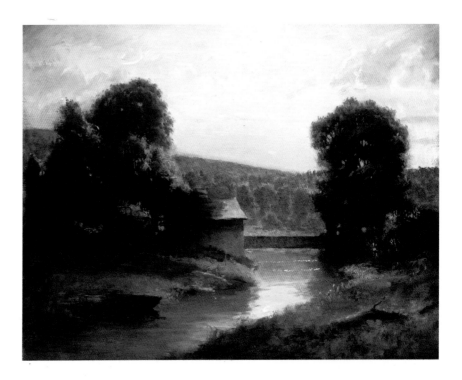

GREGG KREUTZ, *BEND IN THE RIVER*, 2007, OIL ON LINEN, 20 X 24 INCHES (50.8 X 60.9 CM).

I emphasized the S curve of the river to lead the eye through the canvas.

GREGG KREUTZ, *NUDE*, 1998, OIL ON PANEL, 18 X 24 INCHES (45.7 X 60.9 CM).

Here's a lot of *un*finished content contrasted with the highly finished figure, all united by the S curve.

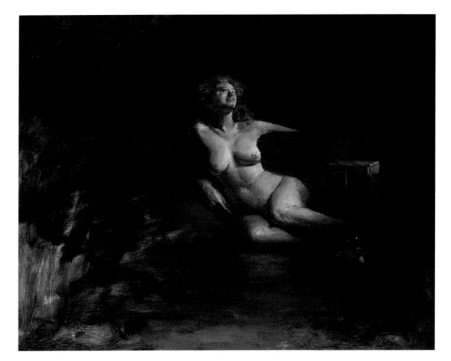

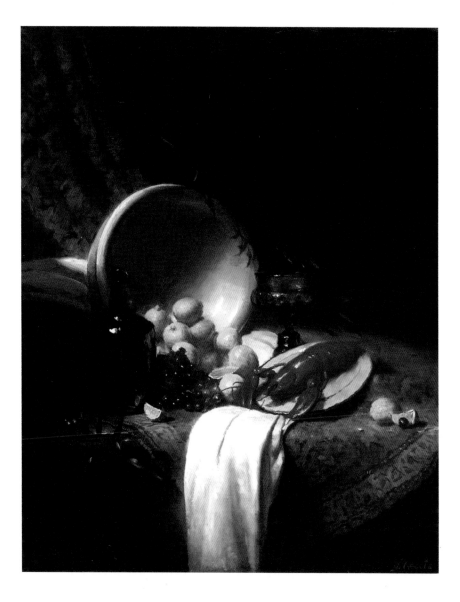

GREGG KREUTZ, *STILL LIFE WITH LOBSTER*, 2002, OIL ON LINEN, 34 X 25 INCHES (86.3 X 63.5 CM).

I used an S-curve format (arranging the props around the letter S) to hold all the disparate elements together.

On pages 6 and 7, there are two examples of another visual concept that spans genres. In this case, the concept is looking through a dark framing boundary into the lit center of interest.

Learning how to identify and employ shared design concepts within various genres helps pull the painter away from a sequestered approach. As artists, we may isolate ourselves in a specific genre or in an individual painting.

Even within single paintings, one of the big problems for the artist is *isolation*, that is, the tendency to focus too much on single visual issues. If you're painting a landscape, say, you might get stuck on a tree branch without ever relating it to the larger issues of the painting. Somehow our minds tend to zero in on a single phenomenon and lose sight of how that phenomenon connects to whatever surrounds it. This isolating tendency—whether it occurs within a single painting or an exclusive genre—ultimately limits the artist's development.

To counteract that, to help the oil painter break free of narrowing constraints, the first chapter of the book is devoted to oil painting essentials that need to be understood no matter what you're painting. The chapter is divided into two parts. Part 1—"Concept Essentials"—is about insights and ideas that apply to all painting. Part 2—"Process Essentials"—explores techniques and procedures that will help the artist regardless of subject matter. Then, in the subsequent chapters, I'll explore specific genres to show both what's unique to them and how they connect to the bigger essentials or ideas.

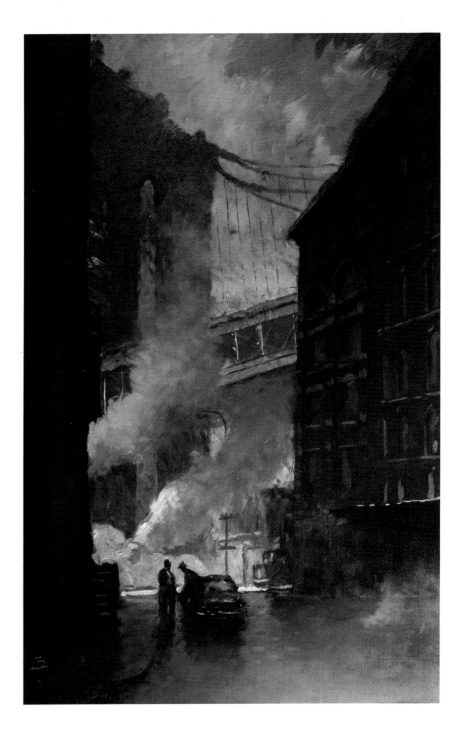

GREGG KREUTZ, *BELOW THE MANHATTAN BRIDGE*, 1982, OIL ON LINEN, 42 X 34 INCHES (106.6 X 86.3 CM).

Here I'm exploring the idea of dark surrounding light. In this picture, within the building-framed pocket of light, I used billowing smoke to silhouette and showcase the two characters at the bottom of the canvas.

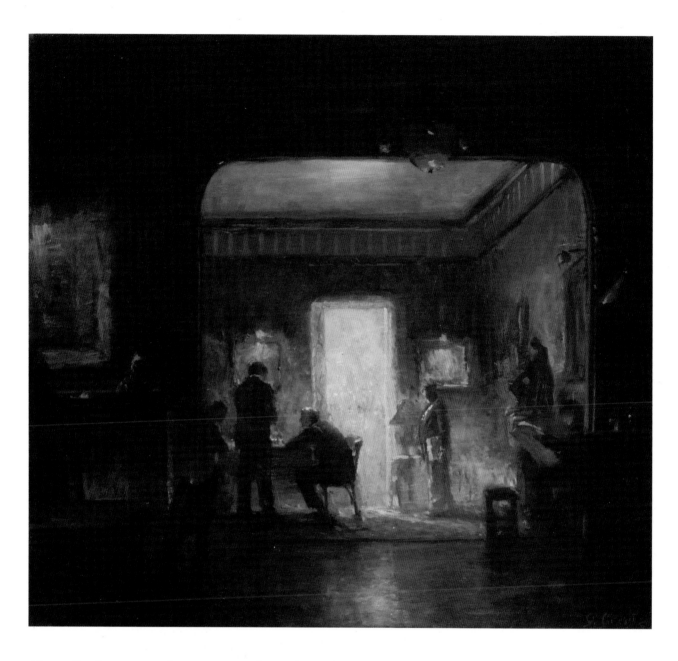

Above all, whatever you choose to paint ultimately needs to function as a *picture*—a visual event with a beginning, middle, and end. Or to put it another way: what's on the canvas has to have some kind of purpose, some pictorial meaning.

GREGG KREUTZ, *NATIONAL ARTS CLUB*, 1993, OIL ON LINEN, 16 X 18 INCHES (40.6 X 45.7 CM).

Another dark-surrounding-light concept. So as not to get paint on the club's carpet, I painted this in my studio from pencil sketches.

WHAT IS THE MEANING OF OIL PAINTING?

This leads us to the bigger question: *What is the* meaning *of oil painting?* Why should you indulge in this difficult, messy activity? After all, taking pictures with a camera is easier, faster, more accurate, and much less likely to ruin your clothes.

Why should you spend your valuable time pushing around oil paint?

Well, first of all, cameras may be convenient, but they don't really duplicate how we see. They duplicate how machines see. We've gotten so used to the look of photographs that we don't notice anymore how flat they look. A fully realized oil painting can have much more resonance and depth.

More significantly, in my opinion, the reason to become a representational oil painter is because it is a deeply fulfilling activity that connects you directly to life. But don't take my word for it—ask Leonardo da Vinci. In his notebooks, he says, "Of all the sciences, oil painting is the most important."

Of all the *sciences*!

In today's world, of course, we have trouble seeing the connection between oil painting and science, but da Vinci held that science and painting were deeply connected. How so?

Effective representational oil painting requires a scientific-like investigation into how visual life operates. Each painter has to analyze and decode the true nature of perceived reality. The artist must ask and answer questions like *Why do things look the way they do? How do we correctly read depth? How do we perceive color? What makes something bright? How do we recognize shadow?*

These questions are absolutely scientific. But there are philosophical questions as well that the representational oil painter needs to explore. Questions like *What is beauty? What is good? What is human? What is meaningful?*

All these and more are within the purview of the representational oil painter. In this sense, oil painting is neither a trivial endeavor nor just a recreational activity. If you're a representational oil painter, you're part of a proud tradition of truth-seeking men and women. And if you follow their lead and make oil painting a primary part of your life, you may not find riches or glory, you may not create a transcendent masterpiece, but I can assure you of one thing—you will *definitely* get paint on your clothes.

OPPOSITE: GREGG KREUTZ, *SELF-PORTRAIT*, 2008, OIL ON CANVAS, 18 X 14 INCHES (45.7 X 35.5 CM).

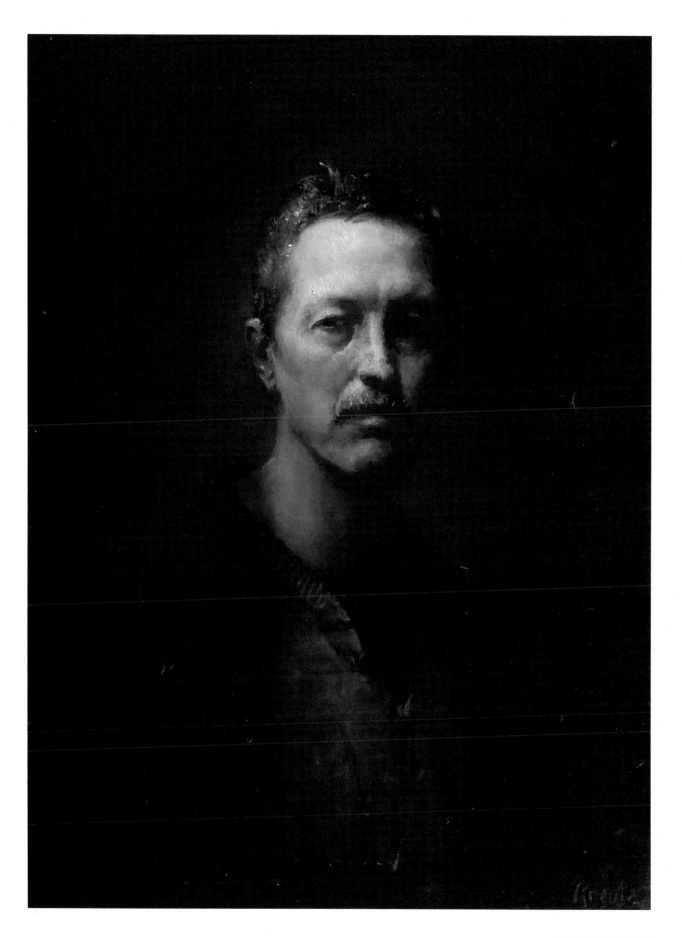

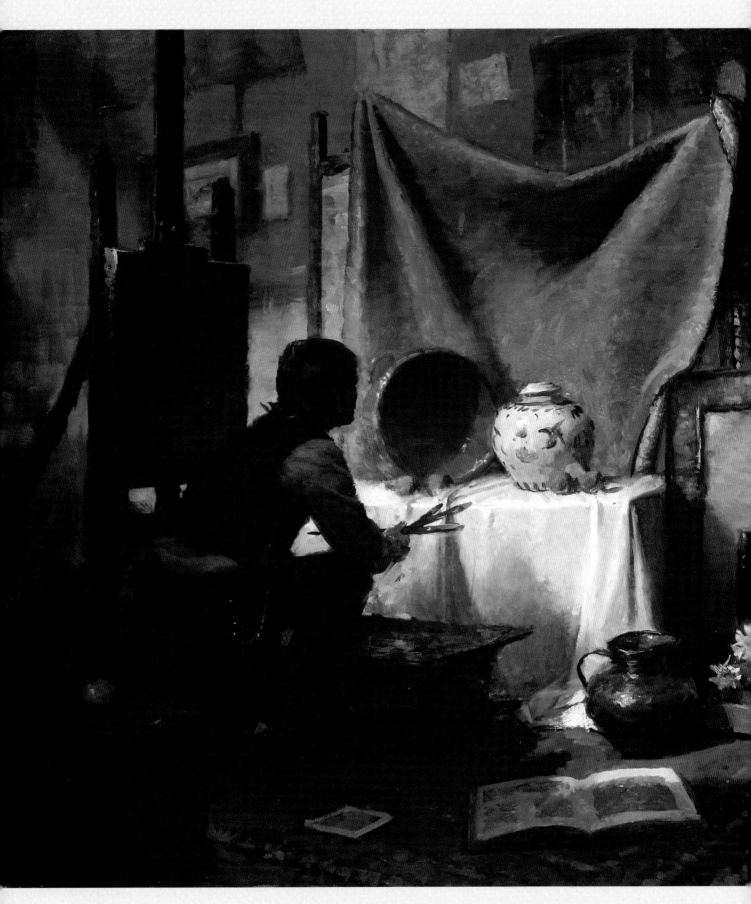

GREGG KREUTZ, *THE SETUP*, OIL ON LINEN, 2009, 22 X 30 INCHES (55.8 X 76.2 CM) .

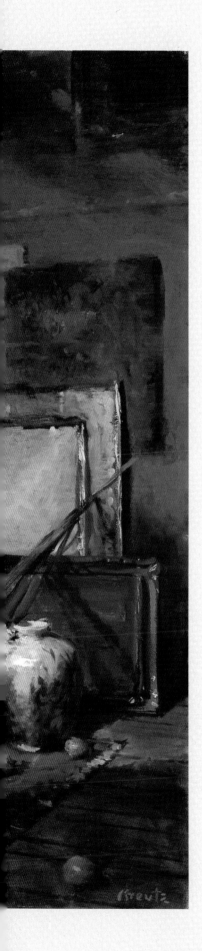

CHAPTER 1

ENGAGING THE ESSENTIALS: CONCEPT AND PROCESS IN OIL PAINTING

Whether you're painting a portrait, a figure, a still life, a landscape, or an interior, there are oil painting essentials common to all that transcend genre. In the introduction, I named the four prime oil painting essentials: accuracy, design, depth, and drama. These four both underlie and interact dynamically with the other oil painting essentials that I will map out in this chapter. Then, later in this book, I will show how they apply to particular genres.

As I also mentioned in the introduction, because oil painting involves both concept and process, I've divided this chapter into two parts. The first, "Concept Essentials," delves into *core ideas* like the nature of shadow, the nature of light, the perception of depth, the function of selectivity, and the specifics of what makes an image compelling. The second, "Process Essentials," explores the *procedure* of oil painting, including such things as the use of abstraction to start a painting, the four steps of completing a painting, the importance of stroke variety, and how to create the feeling of movement in pictures. Throughout the book, to make clear which type of essential I'm referring to, I'll use **CE** for concept essentials and **PE** for process essentials. I'll begin by covering the concept essentials.

Ceramic pots have cool highlights.

Copper pots have warm highlights.

CONCEPT ESSENTIALS: LEARNING TO SEE WITH CLARITY AND INSIGHT

Luckily for the oil painter (and especially lucky for someone with a memory like mine), grasping concept essentials doesn't mean retaining lots of rules and regulations. Learning to paint is not data accumulation. If anything, learning to paint means shedding data, getting rid of your preconceptions.

We're all, each of us, burdened with images, programming, and agendas; and it's these mental constructs that block seeing clearly. Seeing is the key—seeing what's in front of you with clarity and insight. If, say, you look at a ceramic pot and a copper pot, how do you know what each is made of? What communicates that one surface is ceramic and the other shiny metal? Of course, both painters and nonpainters alike can instantly tell the difference; there's no mental strain involved in figuring out which is metal and which is clay. But how do you *know*? What's behind the instantaneous deduction?

The relative heat of the highlights is what cues our perception. If the copper pot had a cool highlight, instead of a warm one, you would translate that information to mean you were looking at a *brown clay* pot. It's the orangeness of the pot's highlight that tells you it's a copper one. Our perceptions, are based on a sophisticated decoding of reality. This happens not because we've all rigorously studied highlight temperature variations, but because there's an intelligence below the surface that informs our insights.

Selectivity: Reduce Visual Complexity

Learning painting essentials, then, isn't about learning lots of rules— "copper has warm highlights, ceramic has cool ones." That would be endless. Learning essentials means gaining access to the visual intelligence already in place—the wisdom that's lurking down below. In this sense, learning to paint is reductive. It's a purging act, an attempt to reduce the clutter between you and reality. It is an act of selectivity.

CE REDUCE THE AMOUNT OF COLORS AND VALUES IN THE PICTURE

Values refer to the lightness or darkness of what's being seen. Having fewer values means that from white to black, instead of infinite gradation, you use only a few gray steps in between. *Fewer colors* means . . . um . . . fewer colors. One of the reasons making a color and value reduction is difficult is that visual life is infinite. The most rudimentary setup—a pot, say, next to some oranges—while ostensibly simple, on close inspection turns out to have incredible visual complexity (and, of course, the harder one looks, the more complex things get).

For the painting above the process was to reduce visual complexity down to its core elements. I did that by reducing values and selecting the most meaningful aspects of the setup: light shape, shadow shape, and local color (by *local color* I mean the essential color of what's being painted—for example, an orange's local color is orange).

The danger for the artist is in trying to put all of the complexity on the canvas. That's a problem because (1) it can't be done, and (2) even if it could, it wouldn't be "artful." *Artful* here means economic, lean, nonsuperfluous, uncluttered. How, then, can the artist translate such dense complexity into artful choices? How can infinite reality be converted into paint? The answer is *selectivity*.

GREGG KREUTZ, *THE WHITE POT*, 2011, OIL ON PANEL, 12 X 18 INCHES (30.4 X 45.7 CM).

CE DON'T JUST COPY, *SELECT* WHAT'S IMPORTANT

Selectivity is related to how we see. We pick out what we think is important and home in on it. Selectivity is the key to effective realistic oil painting. Instead of copying reality—trying to duplicate the infinite patterns and colors—the oil painter selects aspects of what's seen that he or she deems significant for the painting.

In the hands of a master, selectivity leads to greatness. Through paint, an artist like Rembrandt van Rijn revealed what he felt was the essential nature of reality. In his later paintings, Rembrandt stripped away the superfluous and showcased only those elements he deemed vital.

The problem of choosing what to select from the infinite options available is one that generates growth in the artist. *What is important?* is not just a painter's question; it's also a human question.

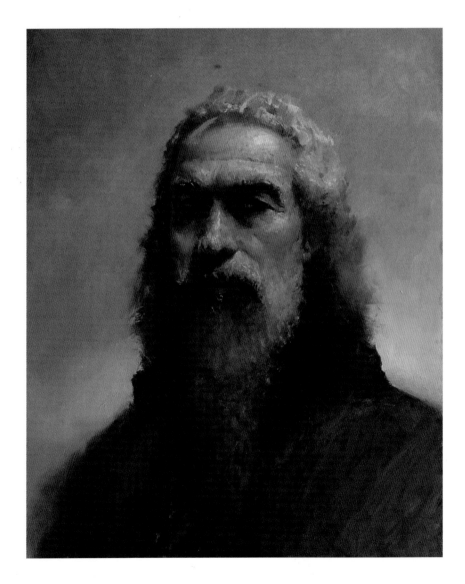

GREGG KREUTZ, *HE WAS PATRICK,* 2015, OIL ON PANEL, 19 X 16 INCHES (48.2 X 40.6 CM).

In this portrait, I could have added much more detail and resolution to the background, jacket, and beard. Instead, I selected the upper face as the only area of high resolution.

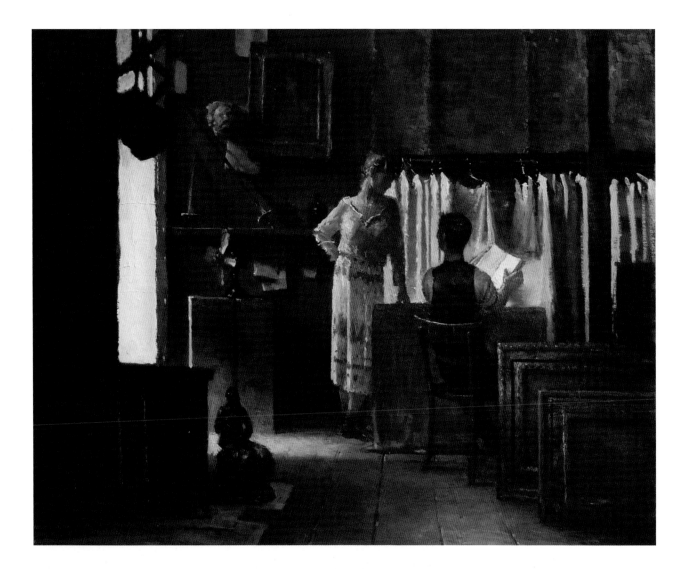

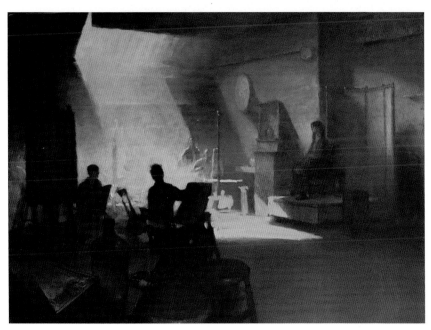

ABOVE: GREGG KREUTZ, *BACKSTAGE*, 2011, OIL ON LINEN, 26 X 30 INCHES (66 X 76.2 CM).

I like backstage scenes. I like the feeling of drama in development. Here my daughter Phoebe and her husband, Matt, portrayed the backstage players. I put them in focus—selected them—by surrounding them with light.

LEFT: GREGG KREUTZ, *ART STUDENTS LEAGUE STUDIO*, 2015, OIL ON LINEN, 28 X 36 INCHES (71.1 X 91.4 CM).

This is a painting of Studio Seven of the Art Students League—the famous venue where all sorts of brilliant artists got their starts.

CE SELECT FOR STRUCTURAL SIGNIFICANCE

Should I paint this tree branch or that tree branch? This wrinkle or that wrinkle? This highlight or that highlight? The questions oil painters face are endless, and what artists pick communicates their priorities. One wrinkle on a shirt might just be a random fabric fold, while another might indicate the size and shape of the underlying shoulder. Selecting structure—in this case, a shoulder-caused wrinkle instead of a random wrinkle—is a better choice because a human shoulder has more meaning than an arbitrary cloth wrinkle.

Ultimately, the choices artists make reveal who they are. If a painting documents lots of little, scattered phenomena, it communicates a piecemeal outlook on the artist's part—maybe even an aversion to commitment. On the other hand, if the painter fills the canvas with one massive item— an enormous rock, a huge face, a giant grape-that possibly communicates a heavy-handed, overly obvious approach to life. Of course, artists have different opinions about what's important, and I am no exception. The concept essentials that follow are a prioritized list of what I feel is significant in visual life.

In both these details, I tried to communicate what was going on under the surface, what was causing fluctuation.

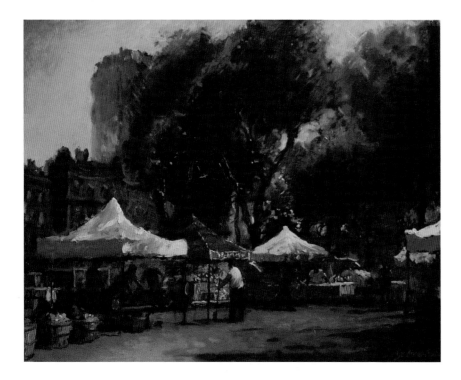

GREGG KREUTZ, *FARMER'S MARKET*,
2012, OIL ON PANEL,
16 X 20 INCHES (40.6 X 50.8 CM).

The people in this painting are what
I wanted the viewer to look at.

CE SELECT FOR HUMANITY

Pictorially speaking, human trumps nonhuman. That's because we humans place ourselves first in the universe's pecking order. We prioritize phenomena according to our human-focused values, and as an artist, you need to be alert to this prioritization.

You could say that everything we see is categorized in terms of its connection to the human mind. This categorization translates to a tree is more significant than a rock, a person more significant than a tree, a person's head more significant than a person's foot. On the head, a mouth is more significant than an ear, and an eye more significant than a mouth. Painters who disregard this hierarchy do so at the risk of losing their audience.

GREGG KREUTZ, *MAYA*, 2008,
OIL ON PANEL, 20 X 16 INCHES
(50.8 X 40.6 CM).

It was the penetrating, probing
look in Maya's eyes that I chose to
emphasize in this painting.

CE SELECT FOR DEPTH

If you are trying to communicate the nature of visual reality, a primary aspect of that reality is a near/far sense of space. You should select phenomena that will increase the illusion of dimension on the canvas. For example, if you're painting a pot of flowers, the flowers in the front of the bouquet need to be more vivid than the ones in the back.

Sometimes, though, you don't want what's nearest to be the most lit. Sometimes you want the lit zone to appear deeper into your picture space. That can be achieved by throwing shadow over the near elements. But there has to be some aspect of the shadowed area that will visually make it come forward. Otherwise the near/far arrangement will be distorted.

But for the depth in the picture opposite, below to be convincing, I wanted the shadowed people to look closer then the non-shadow elements. How to do that? My solution was to push the color elements (pink and red) in the shadowed area as high as I could without changing the shadow value. In other words, I intensified color while keeping the value the same.

GREGG KREUTZ, *PEONIES*, 1998, OIL ON LINEN, 28 X 22 INCHES (71.1 X 55.8 CM).

This painting of one of the world's most paintable flowers was conceived from the outset as a backward curved-C design with a special emphasis on the near flowers.

Details: The most direct way to get something to come forward is to put a lot of light on it. Generally, we perceive brighter as nearer.

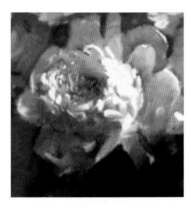

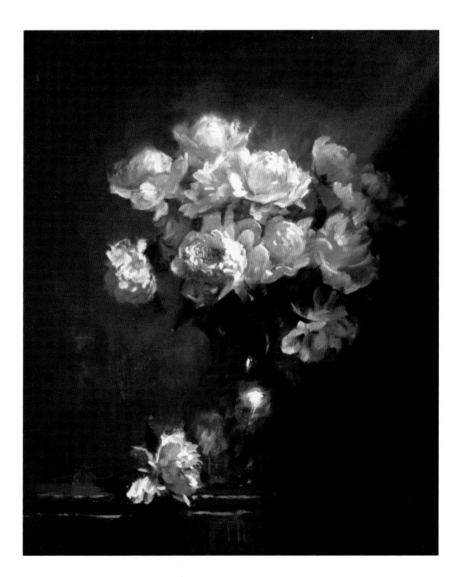

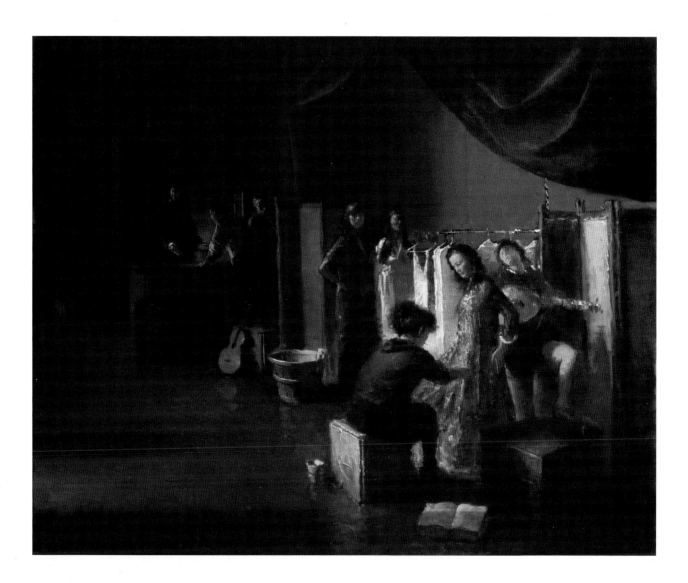

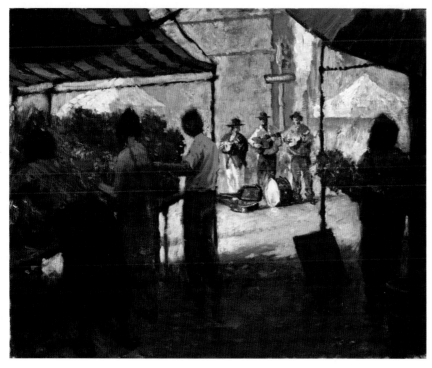

ABOVE: GREGG KREUTZ, *FITTING*, 2012, OIL ON PANEL, 30 X 38 INCHES (76.2 X 96.5 CM).

Here's an interior painting of a costume fitting that shows a near-to-far light intensity progression from the lower right-hand corner—where the most light is—to the dimly lit upper-far-left corner.

LEFT: GREGG KREUTZ, *PERUVIANS*, 1988, OIL ON LINEN, 20 X 24 INCHES (50.8 X 60.9 CM).

In this farmer's market scene, the relatively distant Peruvian band was lit and the nearer flower buyers were in shadow. Generally speaking, what's lit looks closer (because it's more dynamic) than what's in shadow.

Selectivity: Wrap-Up

Whether you're painting a figure in a room or a sunset by the ocean, your choices on what to emphasize should be based on significant criteria. You need to pick things to emphasize that best enhance the accuracy, design, depth, and drama of your canvas, and these selections should fit into the overall scheme of the picture. *Should*, of course, is a controversial word. When artists hear the word *should*, they tend to run as fast as they can in the opposite direction. Obviously, artists can (and will) do anything they want. But if painting is to be about meaningful communication, artists would do well to maximize the tools at their disposal. And that means selecting aspects of the visual world that convey what the artist deems to be the most significant elements of visual life. Selecting what's random or trivial weakens an image.

GREGG KREUTZ, *BRASS AND GOLD*, 1996, OIL ON CANVAS, 12 X 16 INCHES (30.4 X 40.6 CM).

Shadow helps tell the structure story here. The crescent moon shape shadow on the little pot cues the eye that the pot has two facets.

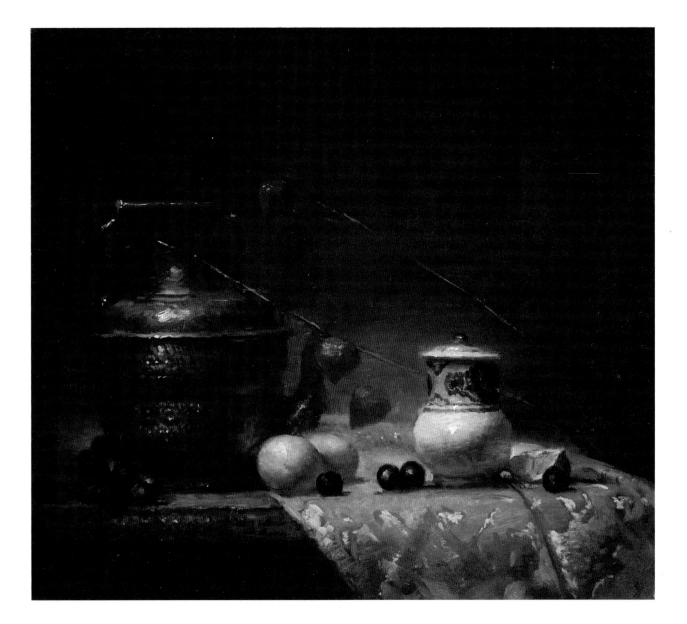

Shadow: Create Drama and Shape Dimensionality

Shadows are a central challenge for oil painters. Not being able to depict them convincingly is a recurring problem that might have its roots in our psychological makeup. We humans instinctively lean toward the bright and sunny and veer away from our shadow side. That tendency could be what prevents full shadow understanding. But a more concrete factor might be optical; the more we look into a shadow, the more our eyes adjust to its darkness, causing us to misread how dark it is. But without figuring out the true nature of shadow, painters can't express the full scope of visual reality.

CE CREATE STRUCTURE WITH SHADOW

Without shadow, form looks flat. To create a feeling of structure, there needs to be a plane in light and a plane in shadow. Then the viewer can tell there are two planes. This may seem self-evident, but if you neglect it—if you only paint the light plane and omit the shadow plane—your picture won't have depth. Showing that there is a shadow side as well as a light side cues the eye to and object's dimensionality.

CE USE SHADOW TO BRIGHTEN THE LIGHT

Shadows also make the light look brighter. Imagine a blank white canvas. It's bright, of course, but the brightness doesn't have impact because there's nothing to measure it against. Shadows tell the eye how intense the light is.

CE USE SHADOW TO ADD EMOTIONAL DEPTH

A final function of shadow is to give emotional resonance to the painting. If a picture is exclusively painted with high-key colors, it can seem frilly and superficial. Putting in dark, rich shadows gives balance to the painting. With shadow, the artist can create the drama of emerging light, the threat of hidden menace, or the eeriness of illusive mystery. The illusive quality of shadow—the subtlety—can, however, make it a difficult phenomenon to paint.

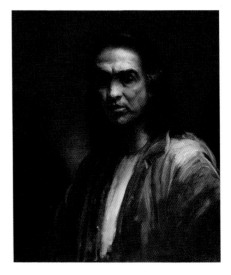

GREGG KREUTZ, *ALFREDO*, 2003, OIL ON LINEN, 25 X 21 INCHES, (63.5 X 53.3 CM).

Shadow plays a strong role in this painting. I wanted Alfredo to look as if he's emerging from the unknown.

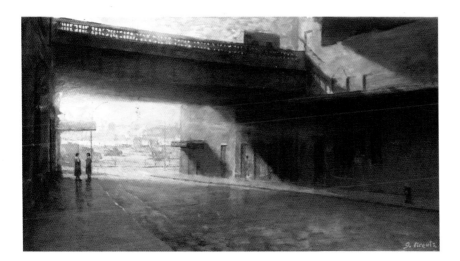

GREGG KREUTZ, *THE CONVERSATION*, 1999, OIL ON CANVAS, 20 X 28 INCHES (50.8 X 71.1 CM).

The slanted dark shadows here make the light look brighter.

HOW *NOT* TO PAINT SHADOWS

In my teaching, I've found it helpful to show six ways *not* to paint shadows, ways that will cause shadows to look un-shadowlike. Showing how shadows shouldn't be painted seems to be more instructive than showing positive examples of how they should. What follows, then, are examples of what *not* to do. Each one is expressly designed to be in flagrant violation of its accompanying rule.

Figuring out how to convert shadow into paint is one of the great challenges of oil painting. In the apple examples (with the exception of the last one), I tried to illustrate how *not* to depict shadows. To remember the six shadow ingredients, try using the acronym PLACED:

Passive • **L**ocal color • **A**rticulation • **C**ontinuity • **E**cho • **D**ark

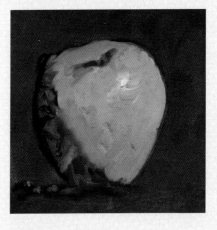

Passive: Shadows should be quiet and undynamic. This one's too busy.

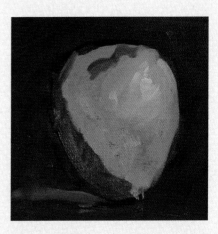

Local color: Shadow needs to be a dark version of the local color. This shadow's color doesn't relate.

Articulation: Shadows should be defined and readable. This shadow's border is too vague.

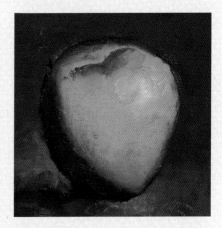

Continuity: Shadow shouldn't change color randomly. The color of the upper indent is too different from the side-plane shadow color.

Echo: The inner edge of the shadow should echoe the outer edge of the object. This shadow's inner border is too random—not parallel enough to the outer edge.

Dark: Shadows need to be substantially darker than the lit plane. This shadow is too subtle to read as shadow.

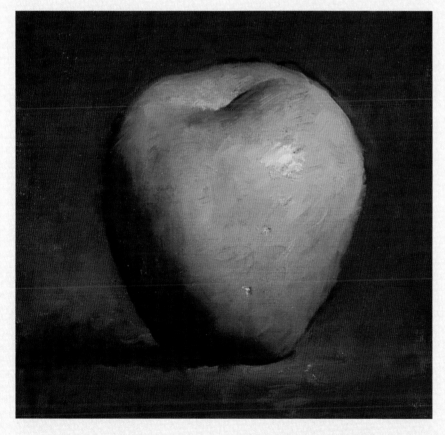

An example of "good shadow": This apple exhibits the six shadow ingredients correctly applied.

Light: Illuminate Your Oil Painting

My first oil painting teacher, Frank Mason, was famous for going around the classroom asking students, "Where's the light effect?" He believed every painting needed some area where the light comes to full fruition—a place where there's a vivid explosion of uninhibited light. That principle, that paintings need a dynamic light effect created has been a core element in almost every painting I've created since.

CE MAKE LIGHT THE MAIN EVENT

It's no surprise that light is at the heart of oil painting. We owe our very existence to light (thank you, sun), so any painting that's going to look true should communicate the vibrancy of real light—the excitement and explosiveness of intense pure light. Translating that into paint means brightening and thickening the impasto as well as lightening whatever dark paint is near it.

Achieving a lit look calls for careful, sensitive observation. To make a convincing illuminated image, you need to become a light connoisseur, someone who can distinguish between *top light* (light from above), *full light* (light from the front), *side light* (light that rakes across the form), and *rim light* (light that only hits the edges of the form). Each type of lighting has its own special quality, and an oil painter needs to be attentive to what's distinctive about each.

The most common kind of light (or I should say the easiest to master) in painting is light that comes from above and that fills out three-quarters of your subject. *Good Apple* (see page 26) is painted in three-quarter light.

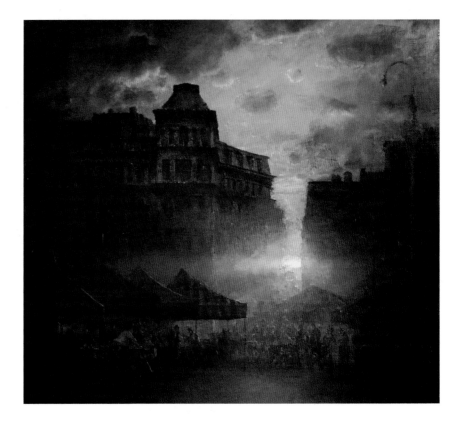

GREGG KREUTZ, *STREET FAIR AT DUSK*, 2003, OIL ON LINEN, 24 X 22 INCHES (60.9 X 55.8 CM).

There's no ambiguity here; my goal is clear: capturing the force of late afternoon light.

Generally, you want the light to fill out as much of the form as possible. Don't let it die halfway across the form. Show that the light has force and is able to push all the way over to the beginning of the shadow. The upper "shoulder" of the apple is where I allowed the light to flow across. In a portrait, the light might flow across the upper forehead.

Massing: Retain the Integrity of Big Shapes

Most artists want their paintings to be imagistic—that is, they want the picture to have a readable, graphic, almost posterlike impact. If it's too subtle, if the shapes are not defined enough and all the edges blur together, there won't be anything visual for the viewer to grab hold of. And that's where massing comes in.

CE MASS THE SHAPES

It's important to mass the light, the shadow, and the background. *Mass* is a key term in painting. Without massing, the picture will look fragmented and piecemeal. What does *mass* mean? It has to do with holding on to the integrity of big shapes. If you're painting a figure, don't let the light on the figure's back be interrupted with pieces of jarring darkness. The lit back needs to hold together as one unit. Mass also refers to grouping; you need to make sure that pieces of light are grouped together and pieces of dark are grouped together. If they're scattered around randomly, the picture will look broken up.

GREGG KREUTZ, *SKETCHING*, 2006, OIL ON LINEN, 22 X 25 INCHES (55.8 X 63.5 CM).

I was trying to capture a mood here, a quiet moment between artist and model. To do that, I had to mass the light and shadow.

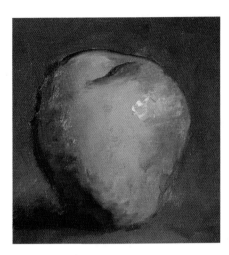

GREGG KREUTZ, *BAD APPLE,* 2015, OIL ON PANEL, 10 X 8 INCHES (25.4 X 20.3 CM).

The way this green apple is only green in its interior makes it look like it's a gray apple with a little green in the center.

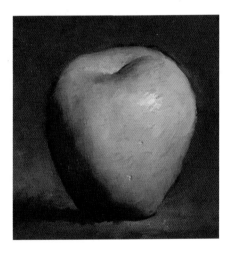

GREGG KREUTZ, *GOOD APPLE,* 2015, OIL ON PANEL, 10 X 8 INCHES (25.4 X 20.3 CM).

In this apple, I've pushed the green out to the starting edge. Now the apple looks fully in color.

Color, Light, and Highlights: Create an Effective Interplay

Realistic oil painting is a magic trick, a fool-the-eye game with lots of smoke and mirrors. Good representational painting, in effect, tricks the viewer into believing that dimensionality is happening on a flat surface and that light is emanating from the canvas. To make that convincing, the artist has to manipulate the viewer's focus by darkening some areas of the canvas while throwing dazzling high-key strokes into the focal area. The artist, in other words, has to make the viewer believe that paint is light. How is that done?

CE LET LIGHT REVEAL THE COLOR

This essential sounds simple, but it can get complicated. That's because light can also burn out color. Hitting the balance between too much color and too little is tricky. Too much color and what's depicted looks unlit; too little color and what's painted looks milky and dull.

CE PLACE THE LOCAL COLOR AT THE STARTING EDGE

Not only is how much color you use important, but where the color is placed also conveys information. Color needs to begin at what I call the *starting edge* of the form, the place where the light first hits the object. That's how (subconsciously) we determine the correct color of the object, by (subconsciously) checking out what color we see along the starting edge.

As *Good Apple* (left) illustrates, *where* the apple color is situated on the form is critical. But where to put the color is not the only color issue that needs attention. There's also the matter of how the color of the light source affects the color of the highlight.

CE MAKE THE HIGHLIGHTS DYNAMIC

Since the color of the light—in the case of *Good Apple,* a cool north light—also needs to be documented, it's a good idea to make sure the highlight, which is a direct reflection of the light source, has a cool quality. As mentioned on page 12, this rule is suspended when gold, copper, or brass are painted (they have warm highlights), but for everything else, when the light source is cool, the highlights must be cool as well. But highlights can bring more than temperature variety to the painting. They can also pull the center of the form forward, show the color of the light, and show the nature of the form depicted (a shiny surface has a crisp highlight and a rough surface has a broken-up highlight.) Best of all, highlights allow the artist to excite the crowds with dazzling brushstrokes.

CE TO MAKE THE LIGHTS LOOK BRIGHTER, BLEACH OUT THE DARKS

Burnout is another way to communicate strong light. By *burnout,* I mean bleaching the elements near the strongest lit areas.

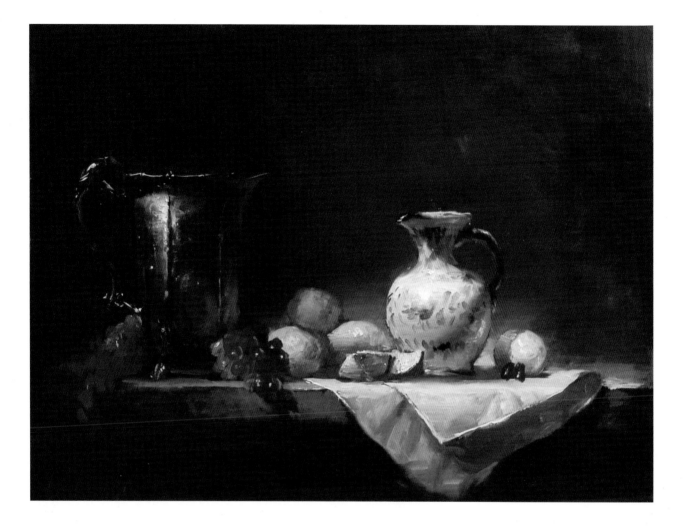

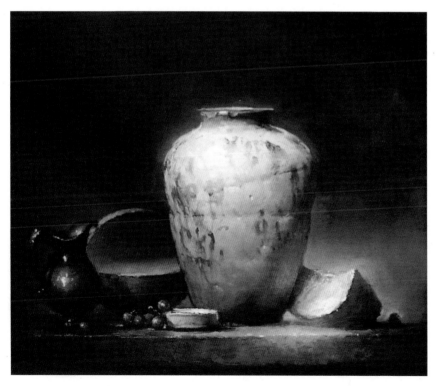

ABOVE: GREGG KREUTZ, *MEXICAN PITCHER*, 2001, OIL ON PANEL, 18 X 24 INCHES (45.7 X 60.9 CM).

Speed was of the essence here. Normally, I take my time with still lifes, but for this one, I wanted to treat it like a plein air painting—getting everything down fast and furious. Note the flashy highlights.

LEFT: GREGG KREUTZ, *PERSIAN POT*, 2014, OIL ON PANEL, 17 X 20 INCHES (43.1 X 50.8 CM).

Here I burned out the pattern on the pot as well as the color of the melon to give the light a more forceful look.

Prioritization: Make the Pictorial Primary

In the same way that a good story makes us follow a character's struggle through conflict to a resolution, in a painting we need to move through the shadowy elements of the canvas to the climax of the picture. In a story, we don't care how well-described, say, a random sunset is; if it's not germane to the plot, we're bored. And so it is with painting. Brilliantly described details that don't contribute to the pictorial meaning of the image are, as far as the big picture is concerned, a hindrance rather than a help.

CE DON'T LOSE SIGHT OF YOUR PICTORIAL IDEA

What you select to include in your painting needs to fit into the overall scheme of the picture and strengthen your pictorial idea. I'm using the term *pictorial idea* here to mean the basic visual structure of the picture. For example, one pictorial idea might be a bright object surrounded by mystery. If that's the idea, don't put a lot of details in the mystery area. If the pictorial idea is a dark silhouette pitted against a bright light, make sure the contrast between light and dark is strong enough to convey that idea.

Whether your painting is a celebration of a beautiful view or a chronicle of an ancient face, the imagery needs to function first and foremost as a picture. Which, of course, raises the question: *what is a picture?*

A tree can be beautifully painted, and yet not look like it's part of a picture. Fruit on a shelf, no matter how well-rendered, can end up looking like only, well, fruit on a shelf.

What distinguishes a picture *from a collection of objects?* Here are some concept essentials—beginning with movement—that may help answer that question.

GREGG KREUTZ, *IRISH COTTAGE*, 2004, OIL ON CANVAS, 8 X 10 INCHES (20.3 X 25.4 CM).

I painted this scene on the spot. I was trying to quickly capture the charm of this picturesque Irish ruin.

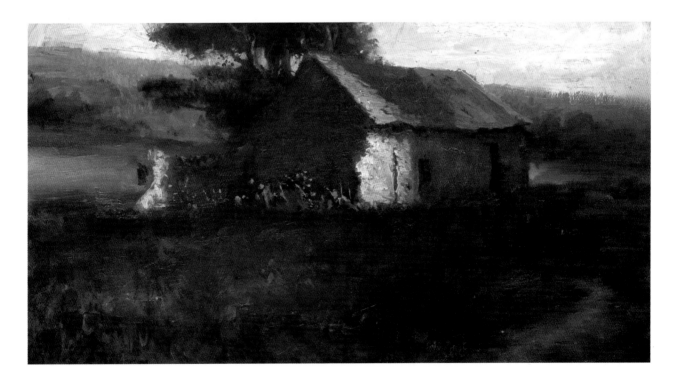

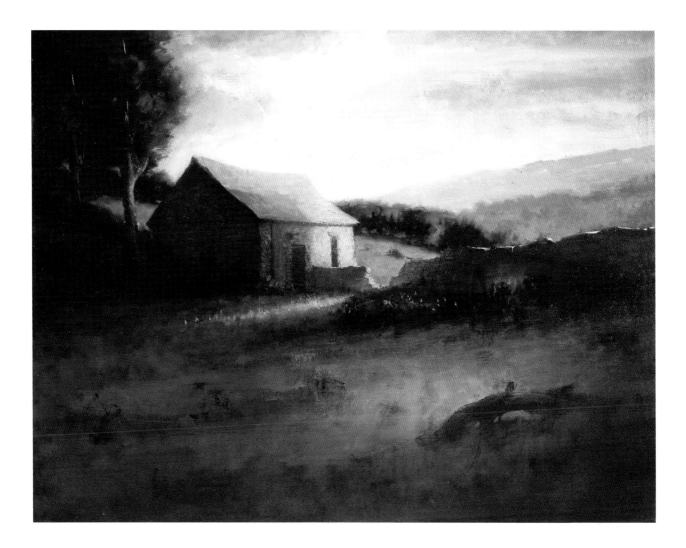

Movement: Capture the Dynamism of Value, Color, and Physicality

Not only do representational oil painters need to turn two dimensions into three, but they also need to make what's static dynamic. The imagery on the canvas should look animated, whether it's a tree bent by the wind or an apple on the shelf. How do you make a static apple look animated? Pulsing color and shifting values are the tools that can make the sedentary come alive.

CE MAKE SURE YOUR PICTURE HAS MOVEMENT

If you want your painting to look like a picture, movement is crucial. The seemingly static quality of a painted surface shouldn't fool the viewer into thinking nothing is in motion. Great paintings are sometimes dizzying in their trajectory from element to element. Ultimately, every aspect of the picture should "move."

There are different ways to establish movement in your painting:

- Value Movement
- Color Movement
- Subject Movement

GREGG KREUTZ, *IRISH COTTAGE*, 2004, OIL ON CANVAS, 25 X 30 INCHES (63.5 X 76.2 CM).

Here's the same subject painted in the studio. I strengthened my pictorial idea of intense light on the center of interest (the cottage) by burning out detail in the sky and intensifying the shadows.

CE MAKE THE VALUE MOVE FROM DARK TO LIGHT OR LIGHT TO DARK

Dark brightening to light is a key movement idea if you want drama in your paintings. Let's say that on the left side of your canvas you place a massed, mysterious-looking dark. As the eye travels across the painting, you start to dimly pick out somewhat lighter objects, until things get bright enough that you can clearly make out what's going on. Finally, as you reach the heart of the painting, the subject becomes a blasting, squint-inducing explosion of light.

If that's the kind of movement you want, there needs to be a full commitment to that vision. The darks must be really dark and the lights really light. Putting a deep dark in the middle of a light climax disrupts the movement, just as putting a light in the middle of the mysterious dark kills the mystery.

There's logic to this dark-to-light movement, beyond just providing drama. Having the background and foreground lighten as they approach the significant elements sends a message to the viewer that what's being showcased is important—so important, in fact, that the surroundings brighten when they near it.

Alternately, you can have light fading into dark. Such a value movement might happen after the main event—for example, after the light completes its blast onto a white pot, the light can start diminishing and darkening as it moves away from that climax.

GREGG KREUTZ, *UNION SQUARE DUSK,* 1989, OIL ON PANEL, 18 X 24 INCHES (45.7 X 60.9 CM).

This painting is all about value movement: light moving from dim to brilliant and back again.

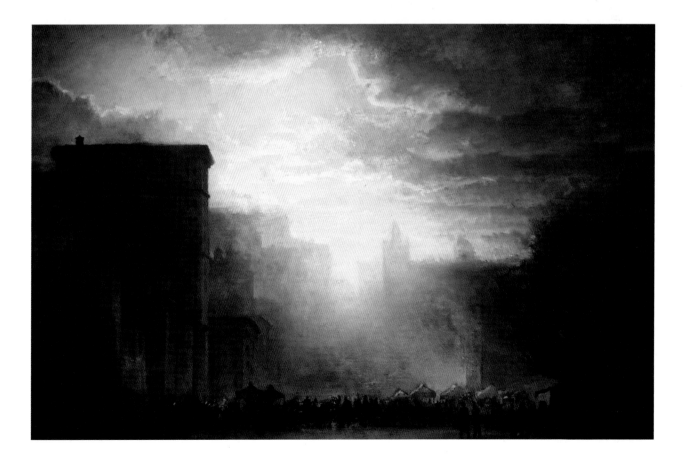

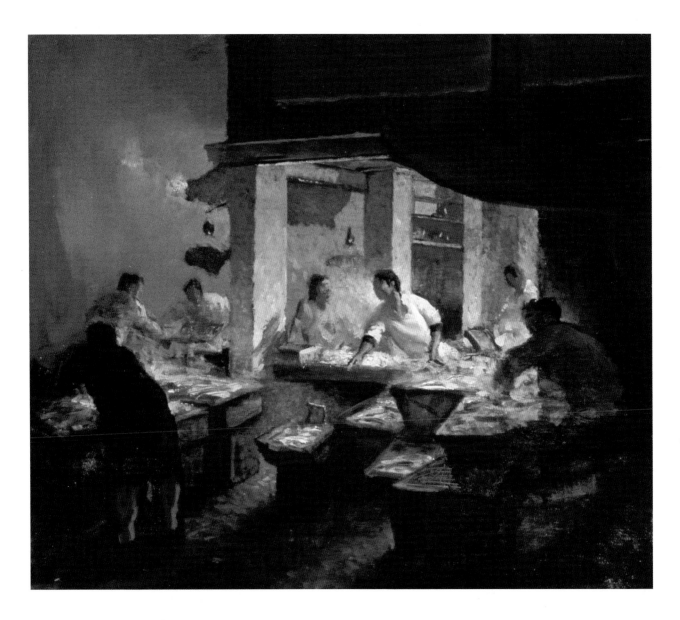

Light fading to dark also occurs in *form*. Returning to the (good) apple example (see the painting *Good Apple* on page 26), as the light heads toward the shadow, it needs to darken somewhat. And right before it reaches the shadow, it darkens considerably.

Rembrandt was the champion of dark-to-light movement, always using the light to lead the viewer to the heart of his painting. In his hands, light didn't just illuminate the subject; it fused with the subject to give meaning to the picture.

A light-to-dark movement can help increase the feeling of depth. For example, in an interior, the floor should probably darken as it heads away from the viewer. In a still life, the table should be bright nearer to the viewer, dark farther farther from the viewer. However, this isn't always true. Shadow, again—like those shadowed flower buyers in front of the Peruvians (page 19)—sometimes falls over the foreground, making it appear darker.

GREGG KREUTZ, *CHINATOWN MARKET*, 1992, OIL ON PANEL, 12 X 16 INCHES (30.4 X 40.6 CM).

In this market scene, I placed the most light on the man in the center. Then by darkening the periphery, I tried to give the feeling of the light intensifying as it headed toward him.

CE MAKE THE COLOR MOVE

Like light, color shouldn't be static. Color can evolve and morph from one hue to another. A background, for instance, can flow as it moves across the canvas, changing from green to red, yellow to purple, or blue to orange.

In landscapes, skies are natural places for color movement. Often the part of the sky closest to the sun can be yellow and then shift into blue or purple, as it moves in the other direction.

Skin color can also "move." The part of the skin that faces the light can be orange, but as the form turns away from the light it can, if the background is cool, evolve into a cooler, background-derived color—like an olive green.

There can also be an evolution from noncolor (something gray and dull) to color. Most of your canvas could be a nondescript grayish brown, and then when some real color is put in the center of interest—*bam!*—you've got impact. In the painting below, I kept the color low until the final punch.

GREGG KREUTZ, *FRENCH SKY*, 1997, OIL ON CANVAS, 30 X 35 INCHES (76.2 X 88.9 CM).

This was painted in my studio from pencil sketches I did in France. The color movement is purple to yellow.

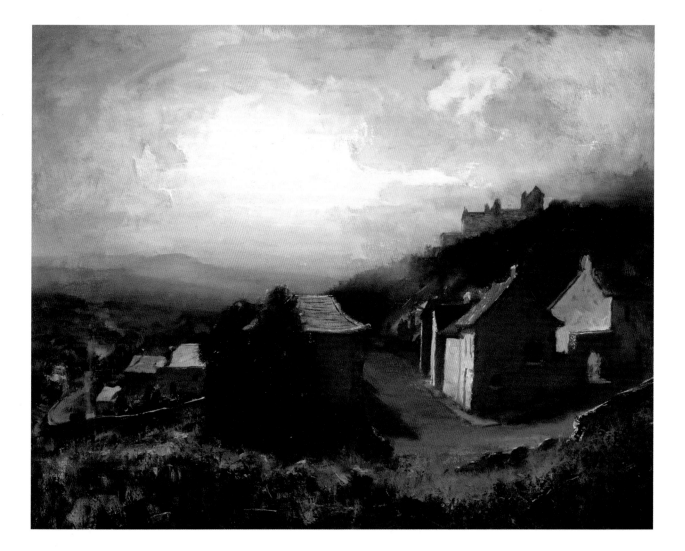

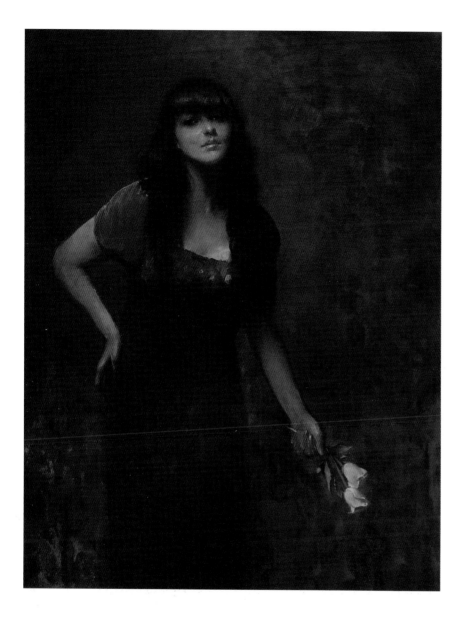

ABOVE: GREGG KREUTZ, *JAMES IN THE YELLOW SHIRT*, 1980, OIL ON CANVAS, 30 X 24 INCHES (76.2 X 60.9 CM).

The color idea here was the vivid yellow of James's shirt pitted against the dark neutral raw umber that surrounds him. It's color versus noncolor.

LEFT: GREGG KREUTZ, *LESLIE*, 2013, 40 X 30 INCHES (101.6 X 76.2 CM).

In this painting, I wanted to capture the feeling of Leslie in motion, as though she was just finishing picking up some roses.

CE MAKE THE SUBJECT MOVE

People in your paintings need to look animated. Unless you're making some pointed comment about dronelike existence, the human subjects you depict shouldn't look like their passport photos.

People need to show the "breath of life," a feeling of action. Even if your subject is doing something as sedentary as sitting on a bed, you can still make her look active by emphasizing the swell of her chest or by having her head turned in a different direction from her shoulders.

A Few Final Concept Essentials: Remember Balance and Variety

As we saw in the last section, movement is crucial in distinguishing a picture from a collection of objects. Balance and variety are also important in making your painting a picture.

CE BALANCE INTEGRATION AND INDEPENDENCE

In painting, there needs to be a balance between the general and the particular, between integration and independence. Just as each genre has within it the unique and the shared, so each *thing* you're painting—lemon, ear, cloud—has qualities in common with other lemons, ears, or clouds. If what you're painting is too specific, it will look isolated and disconnected; if it's too general, it will look generic.

CE MAKE SURE THE PICTURE HAS SIZE VARIETY

If everything's at the same height level, the picture will look repetitive. Using props or people or trees that have varied heights gives drama and visual interest to the picture.

CE MAKE SURE THE PICTURE HAS TEXTURAL VARIETY

Giving the eye a variety of surfaces to look at lends richness to the painting. There needs to be an interplay of different kinds of surfaces.

CE USE A COOL BACKGROUND COLOR TO MAKE FORM RECEDE

This concept is only true if the background is cool. By putting some of this cool color—say a cool blue, or cool green, or cool umber—into an object's local color, the object will seem to go back in space.

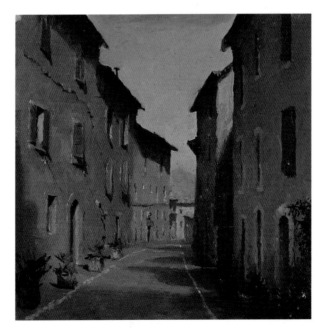

GREGG KREUTZ, *ASSISSI STREET*, 2014, OIL ON PANEL, 14 X 12 INCHES (35.5 X 30.4 CM).

This piece was painted outside on a beautiful Italian day. I used the cool blue sky to create depth, by adding it to the shadows and lights as they receded.

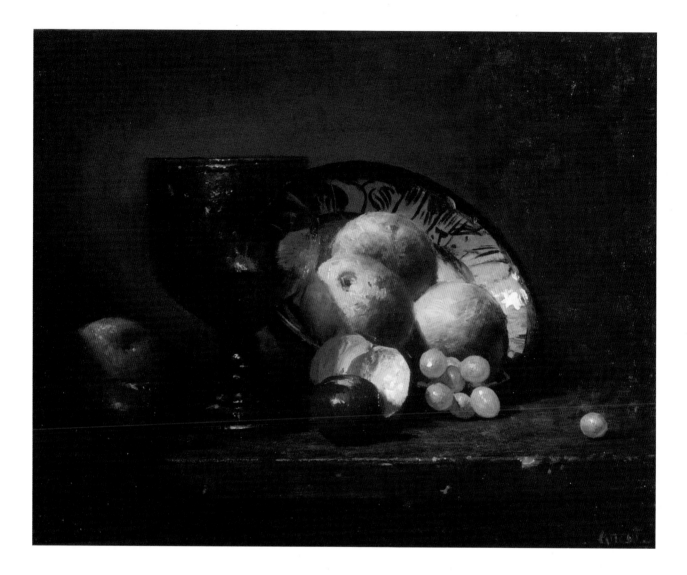

Concept Essentials: Wrap-Up

The concept essentials we've discussed here—reducing visual complexity, making the pictorial primary, creating drama and shaping dimensionality, and many others—work hand in hand with the process essentials that we'll explore in the next section. As you may already have noticed, it's often difficult to separate concept from process. The difficulty in separating them reveals just how central to oil painting both concept and process essentials are. They are, indeed, *essential* because they reflect the *essence*, the intrinsic character, the very nature of oil painting itself.

GREGG KREUTZ, *DARK GLASS*, 1985, OIL ON PANEL, 10 X 12 INCHES (25.4 X 30.4 CM).

How lights interact with different surfaces was part of the concept here.

PROCESS ESSENTIALS: NUTS AND BOLTS OF OIL PAINTING

Process essentials are about physical approaches to painting, ways of maneuvering oil paint to express visual aspects of the subject matter. A little less theoretical than concept essentials, process essentials are concerned with procedures—the nuts and bolts of putting paint on canvas.

Active Creation: Be Sure You Like Oil Paint!

A vital prerequisite to mastering oil painting essentials is liking oil paint. You should like how it feels when you mix it, how it flows off your brush, how you can push it around on the canvas. If you're an oil painter, you need to be an oil *painter*. You should apply the paint with focused vigor. An oil painting is a record of active creation and that sense of *activity* needs to show up on your canvas.

PE USE THE PAINT EXPRESSIVELY

Oil paint has a distinctive, viscous quality, and how it's applied is a measure of the artist's connection to the painting process. Application that's thin and scrubby, for example, yields a stingy, disconnected look. The excitement of translating what you see into passages of wet pigment shouldn't be hidden from viewers. Instead, the wet paint should be celebrated, made part of the visual experience. To put it another way, not using the paint sensuously leads to a coloring book effect—the look of filled-in outlines.

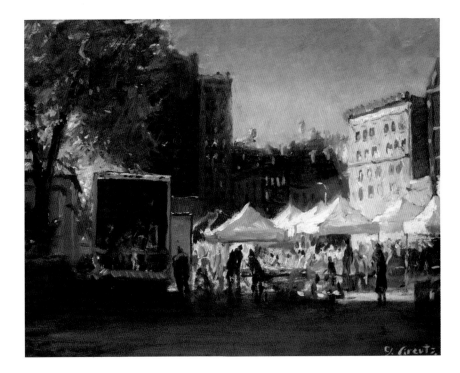

GREGG KREUTZ, *FALL AT THE FARMER'S MARKET*, 2013, OIL ON LINEN, 16 X 20 INCHES (40.6 X 50.8 CM).

In this painting, I tried to use dynamic paint and strong, simplified values to communicate the feeling of a brisk fall day.

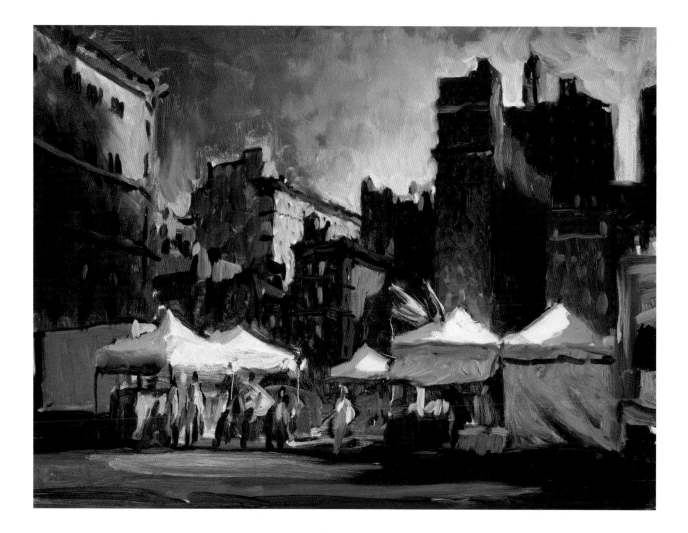

PE USE PAINT STROKES TO DESCRIBE DEPTH

Strokes can also strengthen the feeling of depth on a canvas. A big, thick stroke comes forward. A tiny stroke recedes. Sometimes that optical fact is all you need to create a strong near/far effect. However, if you neglect this phenomenon and put a fat stroke in the background, you'll lose depth. The size of a stroke should be dictated by where it sits in your pictorial space.

The direction of a stroke is also meaningful. If you're painting a flower petal, it's a good idea to start your stroke at the closest end of the petal and lift the brush as you move into the painting. Again, strong equals near, weak equals far.

A note of caution: there is such a thing as too many strokes. If your painting is filled to the brim with globs and accents, the viewer will get a case of visual overload. At a certain point, paint commotion cancels itself out. Imagine, for example, how much stronger a bright accent looks when it's pitted against a solid mass than when it's pitted against lots of other accents. That's why some part of your picture needs to be painted with the strokeless stroke. Because our eyes can only absorb so much activity, the painter needs to be selective with brush effects.

GREGG KREUTZ, *MARKET*, 2009, OIL ON CANVAS, 16 X 20 INCHES (40.6 X 50.8 CM).

The stronger, more energetic strokes in the foreground make that area come forward.

GREGG KREUTZ, *PHYLLIS*, 1998,
OIL ON LINEN, 24 X 20 INCHES
(60.9 X 50.8 CM).

My hope in this painting was to
resolve enough of Phyllis's features
and what she's wearing so that
I could leave the rest of the image
vague. All the while, of course,
I wanted to make the brushwork
evident on the canvas.

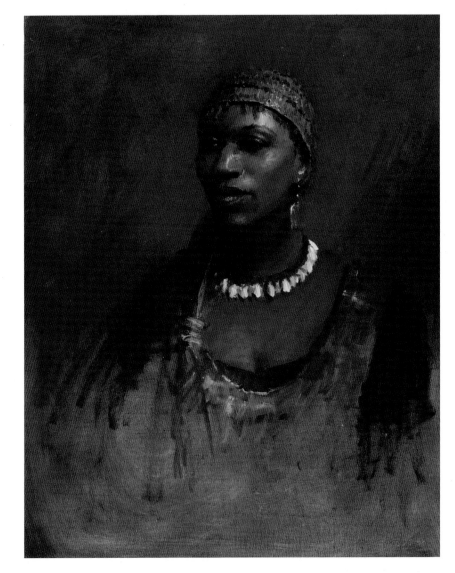

PE FILL THE PAINTING WITH A VARIETY OF STROKES

There are roughly five ways to apply oil paint. You may use some or all of these in a single painting.

1. A *scumble stroke* pulls light paint across dry darker paint in such a way that the darker paint subtly flickers through the stroke.

2. A *glaze stroke* floats a darker transparent tone over a lighter value.

3. An *accent stroke* is made with a flicking motion—the artist lifts the brush at the end of the stroke.

4. A *slather stroke* is produced when the loaded brush releases a big glob of paint onto the canvas.

5. A *strokeless stroke* means no brushwork is visible. It's used when you want a seamless passage.

A single painting might showcase all five types of strokes. For example, the landscape below has a shadowy glazed foreground, some scumbled clouds in the sky, a passage of strokeless strokes on the distant mountains, and slather and accent strokes on the center of interest. Using only one type of stoke throughout the painting would have resulted in a monotonous effect. Stroke variety makes the picture as much about the abstract beauty of form as it is about content. Ideally, of course, the beauty of the paint is in perfect synchronization with the beauty of the subject.

GREGG KREUTZ, *IRISH FARM HOUSE*, 2015, OIL ON LINEN, 36 X 38 INCHES (91.4 X 96.5 CM).

Light effect was the goal here. I pushed the blast of light as far as I could, and subordinated the rest.

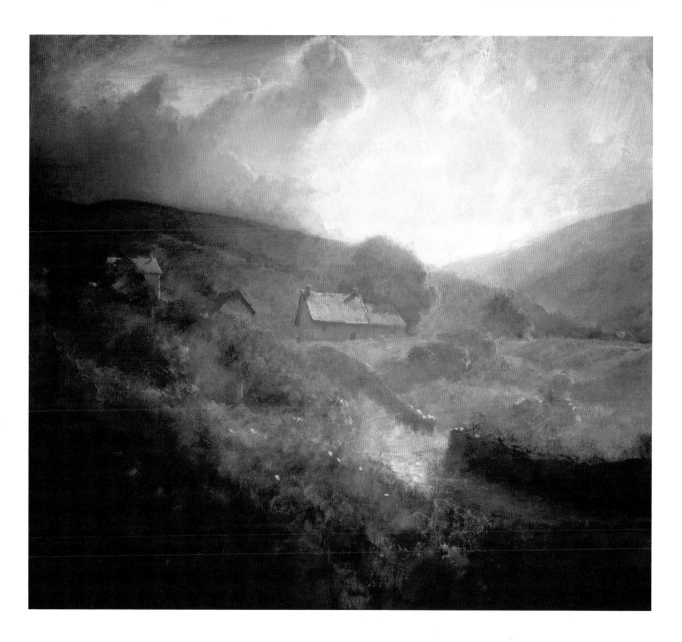

Beginning a Picture: Use *Active* Oil Paint

Getting comfortable with— even enjoying—oil paint is an important characteristic of a successful oil painter. Not only does *active oil paint* (brushwork applied with vigor and intensity) give energy to whatever you depict, it is also the best way for you to begin each painting.

A few years ago in New Mexico, I set up my easel in front of an amazing vista—jagged mountains, mighty clouds, roaring river—and after taking it all in, turned to my puny nine by twelve-inch canvas, and felt seriously underarmed. It suddenly seemed ridiculous to think that all that depth and majesty could possibly be jammed onto such a tiny, flat surface. I hung in there though, made a few tentative strokes, picked up some more paint, pushed it around, and somehow, after a while, got an angle on what the painting could look like—what, besides information, it could be *about*. In other words, I let the paint lead the way.

GREGG KREUTZ, *NEW MEXICAN VIEW,* 1999, OIL ON CANVAS, 9 X 12 INCHES (22.8 X 30.4 CM).

This quick, on-the-spot painting was all about capturing the near/far effect of the expansive scene.

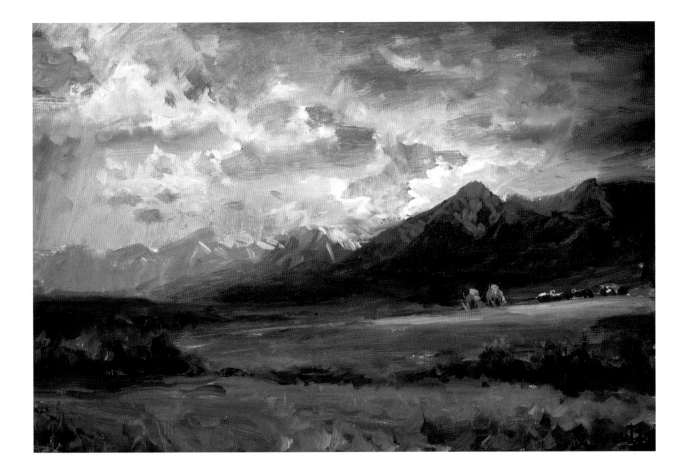

PE USE ABSTRACT PAINT TO BEGIN YOUR PAINTING

Beginning a painting is an opportunity not only to get acquainted with the subject, but also to get acquainted with your paint and the terrain of your canvas. It offers you a chance to put your arm in motion and physically go after the abstract design of the picture. Design is critical. The start of the painting shouldn't be about careful rendering. It should be about how you want the viewer to read your canvas—where the subject begins, where it ends, what kind of movement is going on. These design issues need to be addressed at the beginning. They should supersede complicated rendering problems. If you want your painting to be *painterly*—not linear, not thin and tentative, but a painting full of expressive strokes—you shouldn't start with an outline. You should start with abstraction. How the painting begins dictates how it finishes.

Often, in our insecurity, we think we need a precisely laid foundation before we can cut loose. But precision at the beginning typically leads to more and more precision until ultimately concerns like paint energy and light effects never rise to the surface.

After all, accuracy is just one of the four prime essentials in painting (see introduction). The others—design, depth, and drama—also need to be evident on the canvas. Too often, artists feel that heightened accuracy will solve their problems. If a painting doesn't look "right," they might decide it's because the foot, say, isn't anatomically correct, or that the tree in the distance doesn't look accurate enough. While those issues are important, they're much easier to solve if considered as part of a greater whole. Accuracy is not an end unto itself, but a quality that has to merge with design, depth, and drama. A beautiful head in a portrait needs to be part of a beautiful design.

PE PAINT THE PICTURE IN A LOGICAL SEQUENCE

To make sure the painting stays on track in terms of design, and to keep the other prime essentials in full operation, the artist needs to paint in a logical sequence. I've broken my process down to four distinct steps: placement, background, shadow, and light.

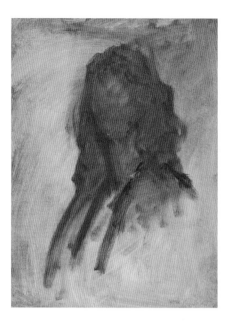

Here's the rough, abstract way I like to begin a painting.

GREGG KREUTZ, *VICTORIA*, 2014, OIL ON LINEN, 24 X 18 INCHES (60.9 X 45.7 CM).

This is a quick read of a striking-looking model. No time for finesse. I tried to make each stroke count.

OPTIMAL SEQUENCE STEP BY STEP

What should you do and when? Do you resolve difficult issues at the beginning of the painting or deal with them at the end? Do you start with details and then expand or begin with big issues and fine-tune later? Here is the sequence of steps that I think most effectively address those questions: placement, background, shadow, and light.

Step 1 (Placement): I use a blurry beginning here to establish my placement. The start of the painting is when the paint can be aggressively thrown around. This is the stage when you can get physically acquainted with your paint and canvas. Instead of fastidiously drawing in information, now is when you can maneuver the paint into an abstraction of your vision. If, instead of starting abstractly, you start with a careful drawing of the head and then discover that the placement is off, starting over can be discouraging. Restarting a blur, on the other hand, doesn't take as much of a toll on your spirits. Blurs can be cheerfully pushed around for as long as necessary.

Step 2 (Background): It's important to paint in your background early. I find it best to do it right after placement. Whatever your genre, the background establishes the tone of the painting. It's the environment in which your subject resides. To neglect it, to rush right into painting the subject matter before the background is in place, would be like arranging a room's furniture before you've put up the walls.

One important aspect of background, however, is that it needs to *be background*—by which I mean, it's under no obligation to be interesting, pretty, or intricate. Its sole purpose is to make the subject of your painting look good. Whenever I think that a picture will improve if I make the background more interesting—more folds in the fabric, more detail in the clouds—I'm really sending a message to myself to make the *subject matter* more compelling. If your star attraction doesn't hold center stage, things aren't helped by adding bells and whistles to what's behind it.

Step 3 (Shadow): Once the background is painted, it's time to put in the shadows. As discussed in the good apple/bad apple coverage (pages 22–23, 26), you need to focus attention on the shape of the shadow, the color of the shadow, and the value of the shadow (how dark it is). In my experience, it's a good idea at this point to make your shadows as dark as possible (without, of course, letting them get inky). Dark shadows give the picture a graphic readability and will make the lights look bright and vibrant when it's time to put them in. If you want to lighten the shadows with some reflected light, that can be done later when there's more information about how bright the light is. If you lay in the darks firmly with correct value and color at this early stage, afterward the lights flow in much more easily. Putting shadows in now—after establishing the background but before applying the lights—also gives you a chance to give them your full attention and to make sure they hit their marks.

Step 4 (Light): Now you've reached the heart of the painting. It's time to put in nice, thick painterly lights. Here you can get some real energy onto the canvas. After patiently holding back, it's time to go after the main event: light. Adding the light is the final step of my four-step process. Once the light is established, in theory, I've got my picture figured out. The design, the *value range* (*How dark are the darks? How light are the lights?*), and the *color world* (*Is it a dynamic of complementary colors or color against noncolor?*) are now in place. Even though there's more to be done, I can see on the canvas the essential nature of the picture.

OPPOSITE, BOTTOM: GREGG KREUTZ, *COPPER POT,* 2015, OIL ON CANVAS, 18 X 24 INCHES (45.7 X 60.9 CM).

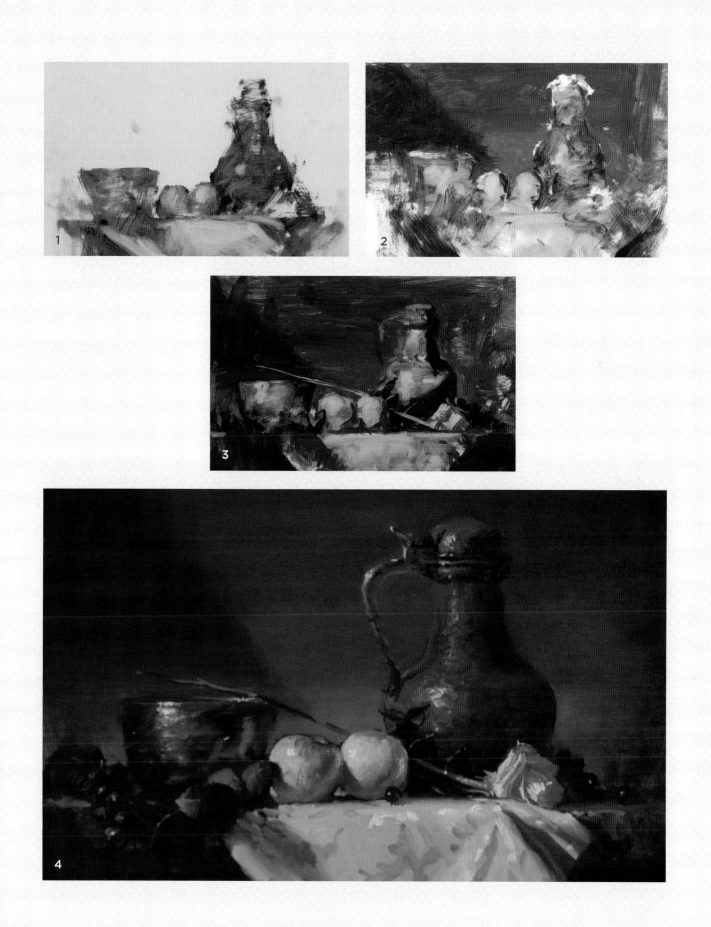

PE DON'T LOCK INTO ANY PROCESS TOO RIGIDLY

The sequence described on page 42—placement, background, shadow, light—has been helpful to me over the years, but I'm not married to it. There have been times when, for various reasons, I've mixed it up and rearranged these steps. That's because I'm wary of committing too rigidly to a formula. You will find examples of these rearranged steps in the step-by-step examples ahead.

When I was just starting to paint, somebody told me, "Don't use the color black." *Ah-ha!* I thought, *A painting truth!* Since I wanted to paint well and didn't know any other painting "truths," I clung to this one like a drowning man. Whether I was painting a woman in a black dress or a black cat at midnight, it didn't matter. I was resolute—I would not use black. What I made of the glorious use of black by Rembrandt, Rubens, and Sargent I can't remember. (Maybe I thought they didn't know any better.) However, my loyalty—to what I now know was a misguided rule—was unwavering.

Here are four "truths" of painting that aren't true:

- You shouldn't use black.
- Shadows should be the complement of the local color.
- You shouldn't put the subject in the middle of the canvas.
- *Big* creates impact.

None of these rules are valid, yet I constantly run into students who believe them. As Mark Twain once said, "A lie can travel halfway around the world while the truth is putting on its shoes."

Process Essentials: Wrap-Up

For whatever subject you happen to be painting, all the essentials outlined in this chapter can be useful, but if your painting has slipped into some sort of a visual catatonic state (no spark, no reason to live), the essentials that I began the book with—the prime essentials—can provide major assistance.

- *Accuracy*: Make sure you accurately depict the subject.
- *Design*: Arrange the material in a dynamic pattern.
- *Depth*: Make sure the near/far feeling of space is convincing.
- *Drama*: Intensify the visual energy.

When, as sometimes happens, even *these* have been checked and utilized and there's still no sign of life, then I advise radical intervention. With loaded brush go into attack mode and push the light way past what you think is acceptable, then hurl the darks deeper into the lower depths, then pump up the color, and then thoroughly mass all the forms. And if you have trouble getting that radical, if you lack the nerve or the passion to paint with that much intensity, a little well-directed rage at the canvas and/or universe may be in order.

OPPOSITE PAGE: GREGG KREUTZ, *THE FRAMER*, 1988, OIL ON LINEN, 28 X 24 INCHES (71.2 X 60.9 CM).

I've painted this model in many guises—overweight trash burner, dumpy Sabrett man, beer-bellied bartender. It was a sad day for me when he went on a diet. Note the "rule" violations: he's placed in the middle of the canvas; straight black was used on his beret; and the shadow, instead of being a complement of the local color, is a dark version of it.

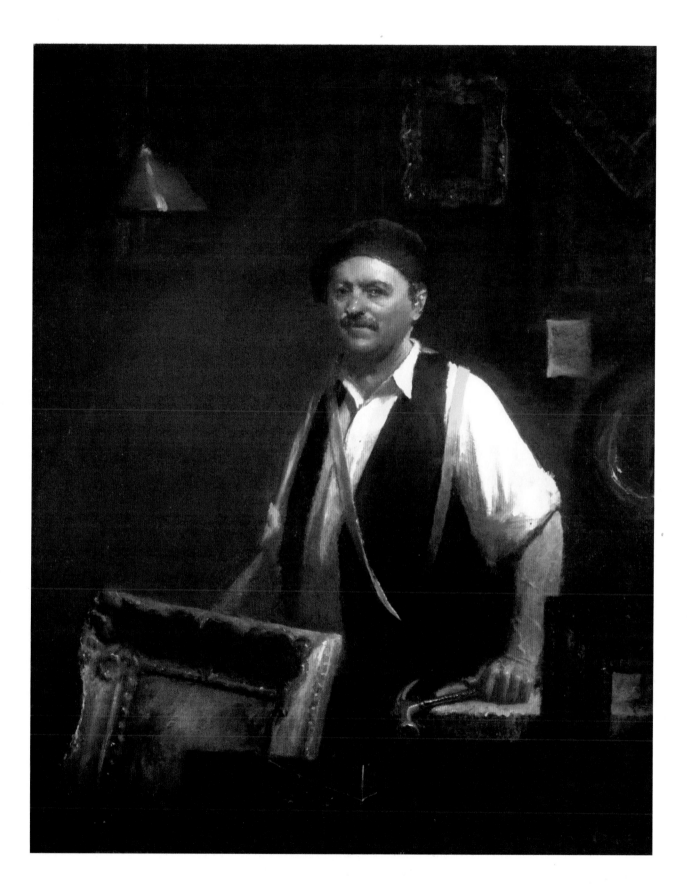

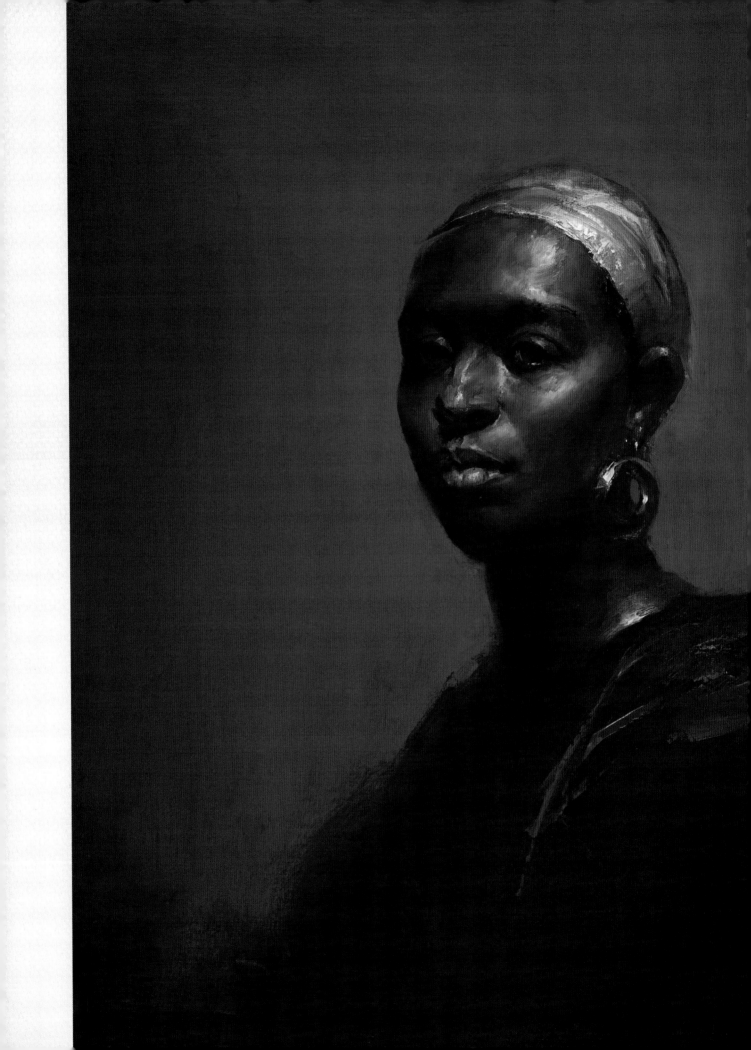

PORTRAITS

Painting portraits is an effective way to learn who we are. By studying another person with the care and attention that's needed for a convincing depiction, you can learn how the skull manifests itself under the skin, the physiognomy of a facial expression, the real color of skin, what gives eyes depth, what makes someone beautiful, what makes someone ugly (and whether there is such a thing), and much more. All of these can be achieved through trying to get a truthful image of a person on your canvas. If you paint empathetically—that is, if you try to capture the *feeling* of what you're looking at, as well as the substance—you can have a deep connection. Who you're painting becomes not just an isolated entity but a fellow human.

GREGG KREUTZ, *GOLDEN EARRING*, 2009, OIL ON CANVAS, 24 X 20 INCHES (60.9 X 50.8 CM).

THE ESSENTIALS IN ACTION: PORTRAIT OIL PAINTING

It's been said that all paintings are self-portraits, no matter the subject, because how artists express their vision on the canvas tells the viewer who they are. This seems especially true when artists paint other people. If they glamorize their subjects—make everyone look like fashion models—that tells one thing about how they see the world; if they hunt for oddities and distortions, that tells another. I think the great portrait painters—Rembrandt, John Singer Sargent, and Anthony van Dyck—are great because they were inspired by their subjects. Their commitment to excellence made them seek excellence—beauty, dignity, sensitivity—in the people they painted, and that synergy between artist and subject is what lifts their creations into high art. The following essentials are my humble attempt to find core principles that can—at least somewhat—guide us to that kind of synergy.

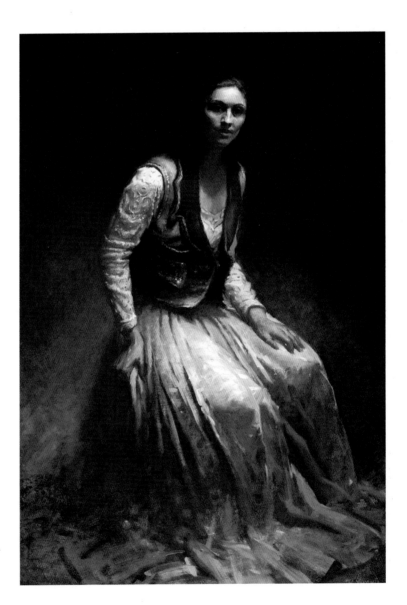

GREGG KREUTZ, *BIG SKIRT*, 2001, OIL ON CANVAS, 40 X 30 INCHES (101.6 X 76.2 CM).

Here's a full-length portrait painted in my studio almost directly under the skylight. I liked the way the light raked over her arms and torso and more or less exploded on her skirt.

Each of the essentials covered in the previous chapter are true whatever the subject, but I've found several to be especially useful when painting a portrait. You'll see that I name a mix of both concept and process essentials. Here's a closer look at them.

PE USE ABSTRACT PAINT TO BEGIN YOUR PAINTING

For a portrait, this process essential refers to a wash-in abstraction of the subject. It can be an oily mix of, say, burnt sienna and ultramarine blue. Keeping the wash-in vague allows you to focus on how the portrait's image size relates to your canvas. If it's too big, it will look oppressive; too small and the person won't look significant; too low and the subject will look unimportant; too high (that is, too close to the top of the painting surface) and the subject will look hemmed in.

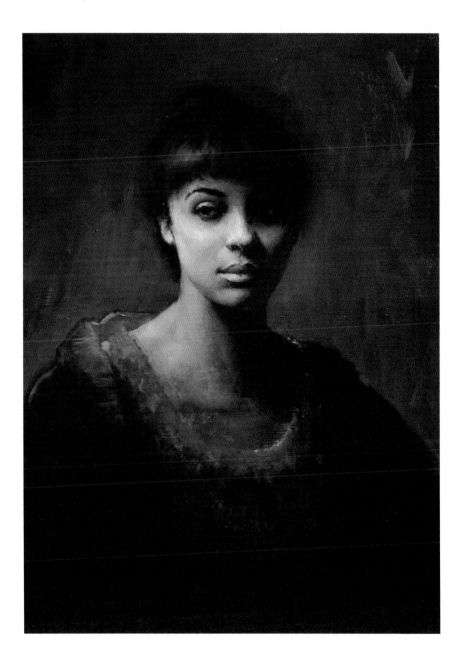

GREGG KREUTZ, *ALAHANA*, 2013, OIL ON PANEL, 20 X 18 INCHES (50.8 X 45.7 CM).

Getting Alahana well situated in the canvas was a vital part of the process. I felt it was important that there be enough space around her that we're invited into the picture rather than Alahana needing to come out at us.

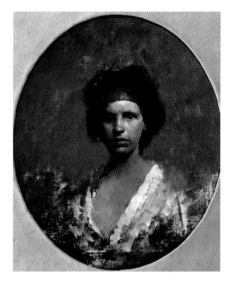

GREGG KREUTZ, *DENISE*, 1984,
OIL ON CANVAS, OVAL 20 X 16 INCHES
(50.8 X 40.6 CM).

Initially, I'd planned to finish more
of this canvas, but eventually I
decided that I liked the reduced, raw
look. The painting can be seen as a
study in simple light, simple dark.

MAKE SURE YOUR PICTURE HAS MOVEMENT

The people in your painting shouldn't look static. That they're alive needs to
be evident on the canvas. One way to communicate that is to have different
parts of the body face different directions. This is especially true of the head
and the shoulders; the head needs to face one way, the shoulders another.

REDUCE THE AMOUNT OF COLORS AND VALUES IN THE PICTURE

Reducing the amount of colors and values adds intensity to the portrait.
There's great power in simplicity.

SELECT FOR HUMANITY

For portraiture, what's human should trump what's nonhuman. Don't let
the costume or surroundings overpower the face. However beautiful the
costume or the setting may be, the person in that costume or setting is
what's important.

SELECT FOR DEPTH

Whatever else a portrait needs to be about—likeness, personality, gesture—if
it's to be effective, it literally needs depth. *Depth* here means not so much the
emotional range of the person being painted, but how he or she fills physical
space—how big or small your subject is or how near or far. And while the

GREGG KREUTZ, *MAHO* (DETAIL),
1989, OIL ON CANVAS, 24 X 18 INCHES
(60.9 X 45.7 CM).

Here the light flows right across
the bridge of Maho's nose, thereby
communicating that she has a small
nasal bridge.

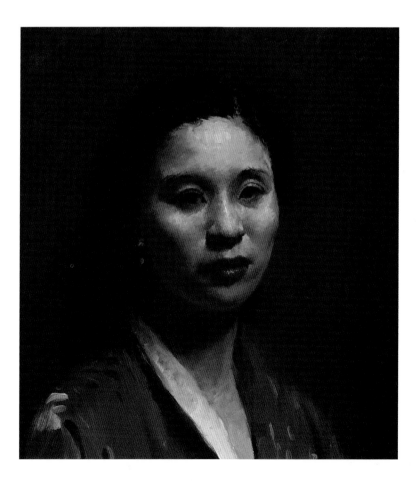

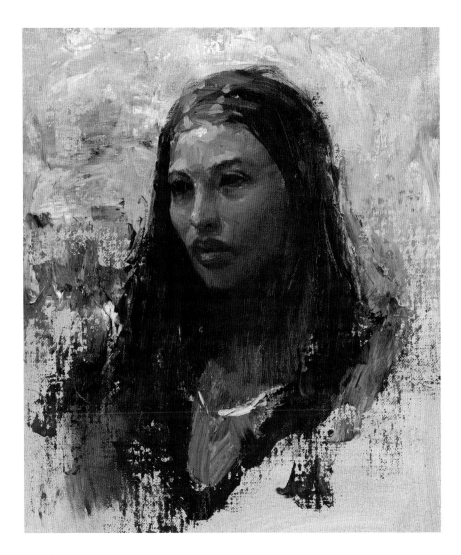

GREGG KREUTZ, *KIM*, 1992,
OIL ON CANVAS, 16 X 12 INCHES
(40.6 X 30.4 CM).

The shape of Kim's nose causes a
little more light/dark articulation than
Maho's. That's how we know she has
a slightly bigger bridge.

flatness of the canvas presents a continuous challenge to the oil painter, in a portrait especially, inattention to dimensionality can weaken the image. This is true for the portrait as a whole as well as for its individual parts.

For example, a nose can best be understood as a form projecting into space. While we tend to associate visual depth with big vistas or spacious interiors, something as small as a nose, if it's to be painted accurately, needs to be analyzed in terms of near/far. After all, how far the nose projects into space tells you a lot about what kind of nose it is. Documenting that projection calls upon your dimension-depicting skills. Ask yourself these questions: *How do I really know how big a nose is? What cues my perception?*

If it's a short nose, it might cast a smaller shadow on the adjacent cheek. Maybe its small size reveals more of the far side of the face than a larger form would. These kinds of cues—size of shadow, how much adjacent area is obscured, even how quickly the light flows—enable the brain to process size determinations. And, of course, because the determinations are all happening instantaneously at the subconscious level, the artist's job is to, in effect, slow down that process and make the subliminal overt.

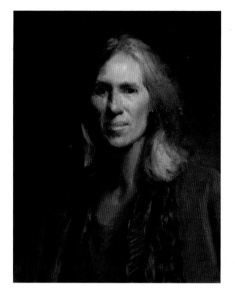

ABOVE: GREGG KREUTZ, *ANNIE*, 1995, OIL ON CANVAS, 20 X 16 INCHES (50.8 X 40.6 CM).

Here I made sure the light filled out Annie's face. To give it full force, I pulled it all the way across the forehead.

OPPOSITE PAGE, TOP ROW: GREGG KREUTZ, *BETHANY*, 2008, OIL ON CANVAS, 24 X 19 INCHES (60.9 X 48.2 CM).

OPPOSITE PAGE, BOTTOM ROW: GREGG KREUTZ, *NINA*, 2001, OIL ON PANEL, 24 X 20 INCHES (60.9 X 50.8 CM).

CE MAKE LIGHT THE MAIN EVENT

In a portrait, light has to behave on the canvas the way light behaves in real life. It needs to fill out the plane facing the light source and come to a stop at the shadow edge. If the light on a form fades prematurely into a middle-tone, the form will look tentative and unlit.

CE CREATE STRUCTURE WITH SHADOW

Shadow gives the head a feeling of structure. By showing that the forehead, cheek, and jaw have not just a light side but a shadow side as well, the viewer can tell that the head has different facets. For this structural dimensionality to be communicated to the viewer, shadow needs to behave like shadow (see the shadow on the apple on page 26). Shadow needs to be (1) true to its local color, (2) passive, and (3) shaped so that it helps describe the form. Making those elements readable to the viewer will give the picture richness and structure.

How much shadow depends, of course, on the subject. It seems to be true that a delicate, female face requires less shadow (maybe a bigger light shape with soft transitions) and a chiseled male face needs more (maybe a deeper contrast where light meets shadow). The degree of shadow intensity, then, is somewhat determined by who's being painted.

CE BALANCE INTEGRATION AND INDEPENDENCE

Harmonizing duality—balancing integration and independence—of course, applies to whatever you're painting, but it is especially significant when painting portraits. Every human is both an individual and a member of collective humanity. Each one of us has distinctive qualities that set us apart, but—just as significantly—each one of us has qualities we all share. Opposite you see stage 1 and stage 2 for two different portraits I painted, *Bethany* and *Nina*.

In a portrait, the head needs to be both a *specific head* and a *generalized head*. If you are inattentive to what makes a particular head distinct, the result will take on a generic—possibly Barbie doll–like—look. On the other hand, if the depiction is too specific, it can become a caricature of the person—a collection of visual quirks.

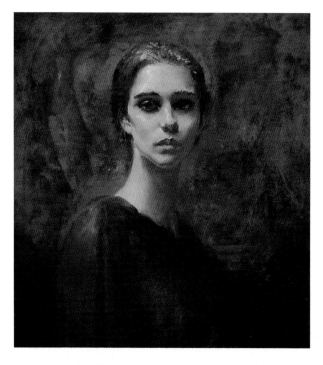

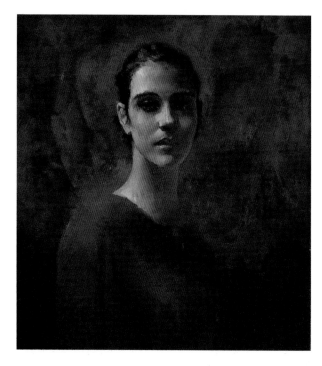

Stage 1 looked a little generic to me, so I shifted the lighting and tried to capture more of Bethany's individuality.

Now, in stage 2, I think I've got a more truthful depiction of what's distinctive about Bethany.

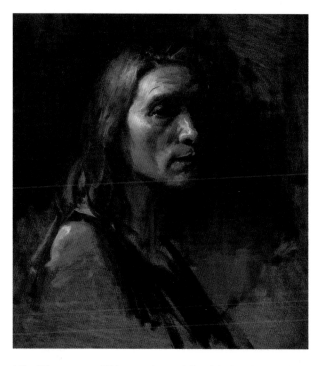

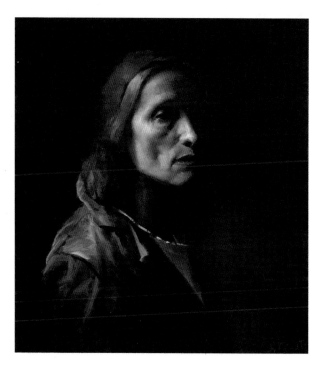

I liked the energy of this start (stage 1) but felt that the subtlety of Nina's look was missing.

In stage 2, by more carefully exploring the structural nuances of her facial planes using gentler brushstrokes and softer transitions (lower contrast, blurrier edges) between darks and lights, I think I better approximated the delicacy of Nina's look.

CHALLENGES

Painting heads *should* be easy. After all, we spend most of our waking hours looking at heads—studying them, reading facial expressions, evaluating attractiveness. Each of us is, in effect, a head expert, and consequently painting them should present no problems. Right?

Wrong.

Dealing with Preconceived Notions Versus Reality

Not only is it hard making the head on your canvas resemble the head you're painting, but sometimes it's hard making it resemble a head at all. Why? Obviously, one reason is that because we're so familiar with exactly what heads look like, the subtlest deviation seems flagrantly off.

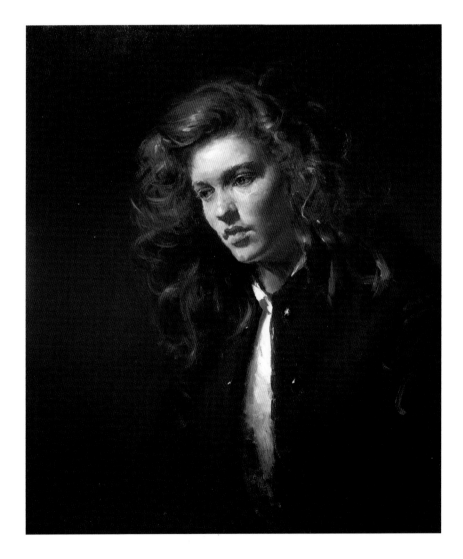

GREGG KREUTZ, *REDHEAD*, 1988, OIL ON LINEN, 24 X 20 INCHES (60.9 X 50.8 CM).

The challenge here was to communicate the subject's delicate coloring, while also trying to communicate her pensive expression. Wild red hair and youthful beauty added to the difficulties.

The great portrait painter John Singer Sargent defined a portrait as "a painting where something's wrong with the mouth." And that was *Sargent,* a painter who never seemed to miss a step. If *he* was catching depiction-discrepancy criticism (and his definition sounds like he was catching a lot), what hope is there for the rest of us?

And speaking of mouths . . . there's no such thing as a mouth. That's not to say you can't point to the opening in the lower part of a face and say, "That's a mouth." The problem is that a mouth is not a thing. It's not an entity. More importantly, the more you think of it as a separate entity, the harder it will be to paint.

What is a mouth then? Is it the lips? No, a mouth is more than that. Is it the opening between the lips? No, that's just the opening. Is it what's inside the mouth—the teeth, the tongue, and so on? No, that's just the inside of the mouth.

If you try to draw a mouth while thinking of the word *mouth,* you will inevitably end up with a wax lip look (see above). That's because words isolate. They push you into seeing reality as individual fragments—a knee, an elbow, a chin, and so on. None of those are isolated phenomena. They're part of a continuum. A mouth is a junction point where jaw meets skull, where cheek muscles converge, and where flesh morphs into mucus membrane. Trying to paint the isolated concept of *mouth* is doomed to failure.

Painting the word—such as, in this case, *mouth*—instead of the reality is a recurring problem in painting. Words are symbols. They enable us to store information, to study problems, to make comparisons. But they also get in the way of clear observation and of seeing *directly.*

The word *head,* for example, conjures up a preconceived image that we carry around with us, and often, when it comes time to paint a real head, we will paint that image instead of the actual observed head. The preconceived notion gets in the way of actually seeing.

In the illustration below, you'll notice that the head faces forward. Our mental conceptions of both heads and torsos tend to be frontal. So when we think of a head, we think symmetrically—eyes equidistant from each other, nose in the center, ears on either side, and so on. If you do happen to have a frontal view, this conception is helpful. The problem is, as often as not, your model is seen at an angle. To absolutely nail whatever angle you're looking at, I recommend using the technique in the sidebar on the following page.

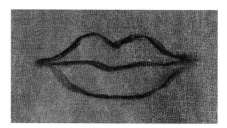

GREGG KREUTZ, *BAD LIPS,* 2015, OIL ON PANEL, 9 X 12 INCHES (22.8 X 30.4 CM).

Here's a misguided attempt at depicting a mouth. It's more symbolic than real, and it's too isolated in the sense that the severity of the outline makes it too separate from the face.

GREGG KREUTZ, *GOOD LIPS,* 2015, OIL ON CANVAS, 19 X 12 INCHES (48.2 X 30.4 CM).

Here I tried to make the mouth relate to what surrounds it, to make it more of a continuum with the muzzle area.

Here is an image of what might be conjured up when thinking about the word *head.* The choices are made according to preconceived imagery— eyes too big, nose too isolated, mouth too big.

HOW TO SOLVE FACIAL ANGLE PROBLEMS

To make the turned head look true in your painting, study to what extent the inner corner of the far eye is obscured by the nose. Placing the far eye in the correct place relative to the nose allows you to accurately calculate the outer edge of the face. Then you can move into the interior knowing that you've correctly gauged the face's parameter. Using this technique as a way to find the far edge can also help you calculate where the *center line* (the imaginary line running down the center of the face) should be. My discovery of this eye-nose approach has helped me solve fundamental facial angle problems.

It's also helpful to know that the more the face is turned, the more the nose will angle away from the vertical. The more turn, the more nasal angle.

If the center line is not in the center—say if the head's in three-quarter position—then the nose *must* be angled. Without angling the nose as the face turns, you will end up with a frontal nose on a three-quarter face.

THIS PAGE: GREGG KREUTZ, *MODEL FROM THE LEAGUE*, 2014, OIL ON PANEL, 16 X 12 INCHES (40.6 X 30.4 CM).

When you observe the model, note to what extent the inner corner of the far eye is obscured by the nose.

OPPOSITE PAGE, TOP LEFT: GREGG KREUTZ, *PHOEBE* (DETAIL), 2003, OIL ON CANVAS, 24 X 18 INCHES (60.9 BY 45.7 CM).

If the inner corner of the eye is fully hidden, you're seeing close to profile.

OPPOSITE PAGE, TOP RIGHT: GREGG KREUTZ, *ANDY'S FRIEND*, 2008, OIL ON PANEL, 20 X 16 INCHES (50.8 X 40.6 CM).

If it's only slightly hidden, you're seeing three-quarters.

OPPOSITE PAGE, BOTTOM LEFT: GREGG KREUTZ, *RED SCARF*, 1989, OIL ON CANVAS, 20 X 18 INCHES (50.8 X 45.7 CM).

If the center line is not hidden at all, you're seeing a frontal view.

OPPOSITE PAGE, BOTTOM RIGHT: GREGG KREUTZ, *ACTOR*, 2015, OIL ON CANVAS, 24 X 18 INCHES (60.9 X 45.7 CM).

The turn of the actor's head meant that I had to angle the nose.

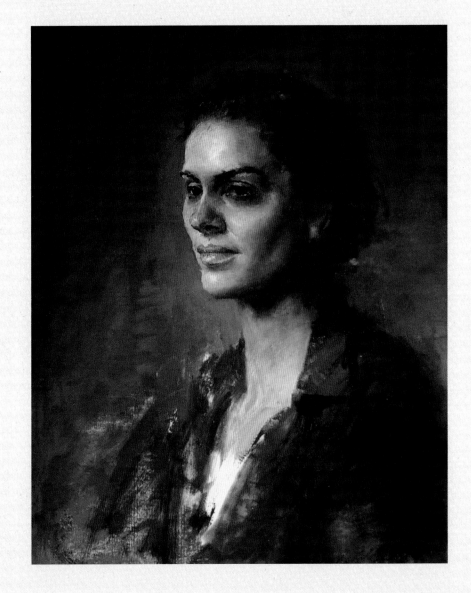

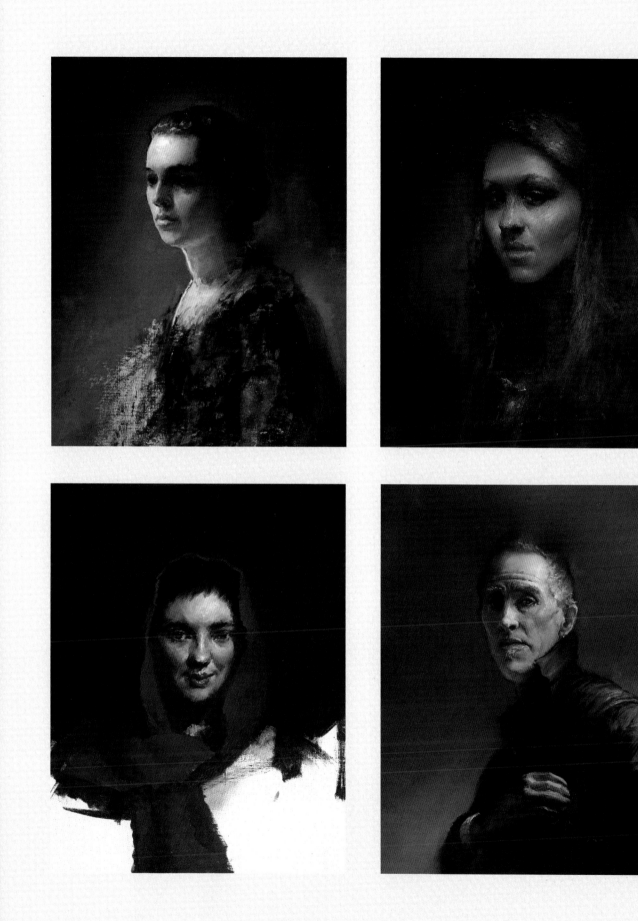

Creating Likeness

Creating likeness in a portrait is another challenge oil painters face. To get a painted head to look like something that's part of the human family is one thing, but to get it to convincingly look like the person being painted, now that's an achievement! But it should be said that likeness by itself shouldn't be the goal of the painting. If all the artist is trying to achieve is the creation of a convincing likeness, the painting will suffer. As in all other genres, the picture is primary. The main goal should be creating a vivid work of art, and in my experience, if you keep your eye on that prize—the conjunction of art and beauty—issues like likeness will fall into place on their own.

Likenesses are notoriously tricky. Capturing the certain *something* that distinguishes person A from person B can be a serious challenge. One portrait painter I know advises that if you're painting a commissioned portrait of, say, Aunt Martha, the second you hear, "That looks just like Aunt Martha!" stop painting and reach for the check. Once I was painting a portrait of my daughter Lucy and as we were both carrying on about how much the portrait looked like her, I made an enthusiastic gesture with a paper towel and accidently swiped the wet canvas. No matter how hard I tried, I could not get that likeness back.

I'm against measuring. Measuring, instead of making the subject easier to translate, erects a barrier between artist and subject. I recommend, rather than trying to mechanically calculate distance and size, using observation to get a feel for the topography of your subject's face. *How articulated are the planes? How evident is the bone structure? Is it a round face or a narrow face? Are the eyes buried in the sockets or flush with the surface?* In other words, to get a good likeness you need to look with openness and sensitivity at the subject, to shake off preconceptions and try to look freshly at who you're painting.

GREGG KREUTZ, *MARY*, 1986, OIL ON CANVAS, 16 X 12 INCHES (40.6 X 30.4 CM).

The model's age made her easier for me to paint. I find that someone with a little wear and tear, a little mileage, is much easier to capture than, say, a smooth-skinned youth. On the other hand, if you've gotten yourself an expensive commission, you may want to minimize the mileage.

PORTRAITS: OTHER OIL PAINTING ISSUES

Other issues you'll face when painting a portrait include structure, flesh color, and the full portrait. Let's look first at a very basic structural issue: the difference between female and male heads.

Structure

How do you make a female head look different from a male head? For one thing, a female head has a thinner jaw and a thinner brow. More than that, if you want to get a woman's head to look properly feminine, stress the egg—that is, emphasize aspects of the shape of the head that are egglike. A woman's head has fewer in-and-out angles, less zig zagging along the perimeter.

With a male head, the forms are more geometric. You might, for example, treat the forehead and brow as a box, the cheekbones as triangles, and the jaw as a two-pronged wedge.

Obviously, each person's head/face has different degrees of boxlike or egglike tendencies. Children, for example, regardless of their gender, generally fall into the egg category. And as we age, we all tend to get more geometric.

BELOW, LEFT: GREGG KREUTZ, *FEMALE HEAD*, 2015, OIL ON CANVAS, 12 X 9 INCHES (30.4 X 22.8 CM).

The egg is emphasized here.

BELOW, RIGHT: GREGG KREUTZ, *MALE HEAD*, 2015, OIL ON CANVAS, 12 X 9 INCHES (30.4 X 22.8 CM).

The geometry is emphasized for the male head.

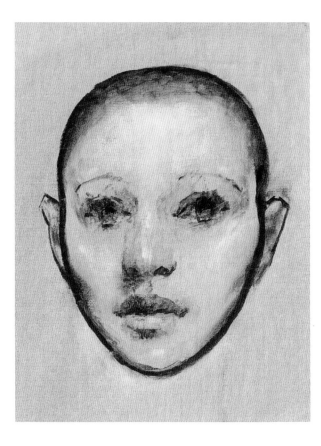

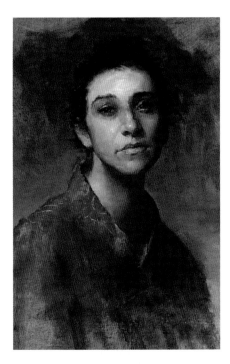

Flesh Color

The idea that there's a specific color called "flesh" is obviously inaccurate and racist. Not only are we all different colors, each portion of our particular flesh changes color from spot to spot. Even those people whose flesh perfectly matches the hue we see on, say, Band-Aids, don't have a uniform flesh color. Their foreheads might be a little greener, their noses and cheeks may be a little redder, and so on.

Each individual layer you paint requires a different mix of colors. Someone of African descent might require burnt sienna and yellow, somebody with a pale complexion—maybe of Irish-English background—might need cadmium yellow pale and cadmium red light. For someone of Middle Eastern descent, you may need yellow ocher and Venetian red. And those are just for the generalized local colors. Within each hue, there could be many variations; sometimes the color gets warmer, sometimes cooler. Sometimes the color is bleached out by the highlight, sometimes it's intensified as it

ABOVE: GREGG KREUTZ, *RED KIMONO*, 2013, OIL ON CANVAS, 24 X 18 INCHES (60.9 X 45.7 CM).

This flesh color was made of cadmium red light, cadmium yellow pale, white, and a little blue.

RIGHT: GREGG KREUTZ, *RALPH*, 2007, OIL ON CANVAS, 24 X 18 INCHES (60.9 X 45.7 CM).

To get Ralph's complexion color, I used burnt sienna and yellow with gray (black and white) as the highlight color.

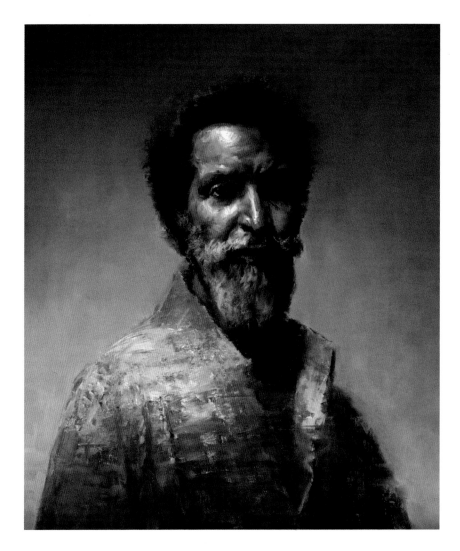

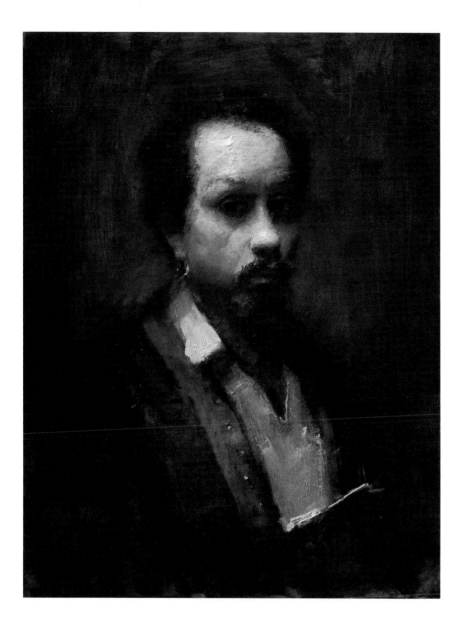

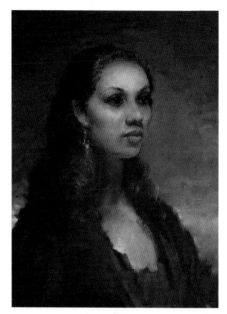

ABOVE: GREGG KREUTZ,
MEDITERRANEAN MODEL, 2001,
OIL ON CANVAS, 20 X 16 INCHES
(50.8 X 40.6 CM).

For this flesh color, I used yellow
ocher, Venetian red, and white.

LEFT: GREGG KREUTZ, *THAT MAN
FROM TUNIS*, 2012, OIL ON PANEL,
20 X 16 INCHES (50.8 X 40.6 CM).

To capture this model's coloring,
I used cadmium yellow deep,
Venetian red, and white.

heads toward the shadow. That's why I like to undermix my colors. That
is to say, I don't use a palette knife to grind the colors into a homogenous
puddle. I only lightly mix them with my brush, allowing little trails of
the relevant colors to flicker on the brush. Then, when I apply the stroke,
the paint can approximate the color variability one sees in real skin. To
homogenize too much can result in plastic-looking skin.

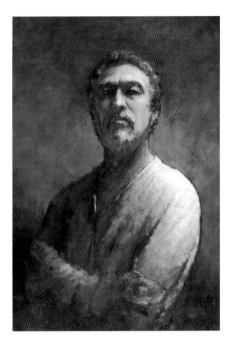

Painting the subject from below
strengthened his air of authority.
Note how the torso faces a different
direction from the head.

The model turning her head helped
animate the pose.

Here the color idea is green against
orange. The drama of the picture is
about the model's reaction to the
painting. I used color and lighting
to intensify that reaction.

The Full Portrait

Of course, heads aren't the only elements in a portrait. There are also necks,
shoulders, torsos, hands, and so on.

Like the mouth, the head needs to be conceived as part of a continuum.
You shouldn't finish the head, then move on to the neck, then the
shoulders, and so on. Not only is that a tedious, piecemeal way to operate,
but also, ultimately, it won't work. As you paint the head, if you don't take
into account how it relates to its supporting column, the head won't look
true. For instance, if you want the portrait to look animated—remember
the concept essential "Make the Subject Move"—you may want to have
the head face a different direction from the shoulders to the pose from
looking stiff.

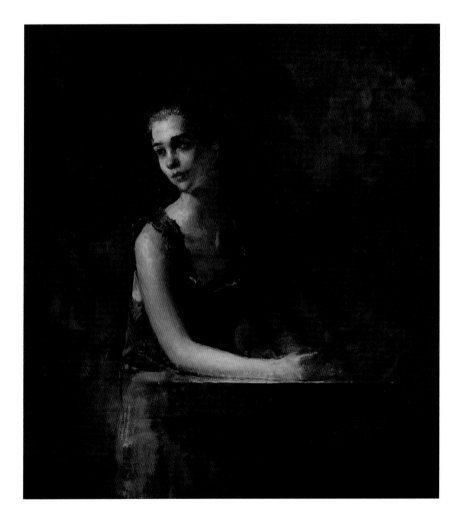

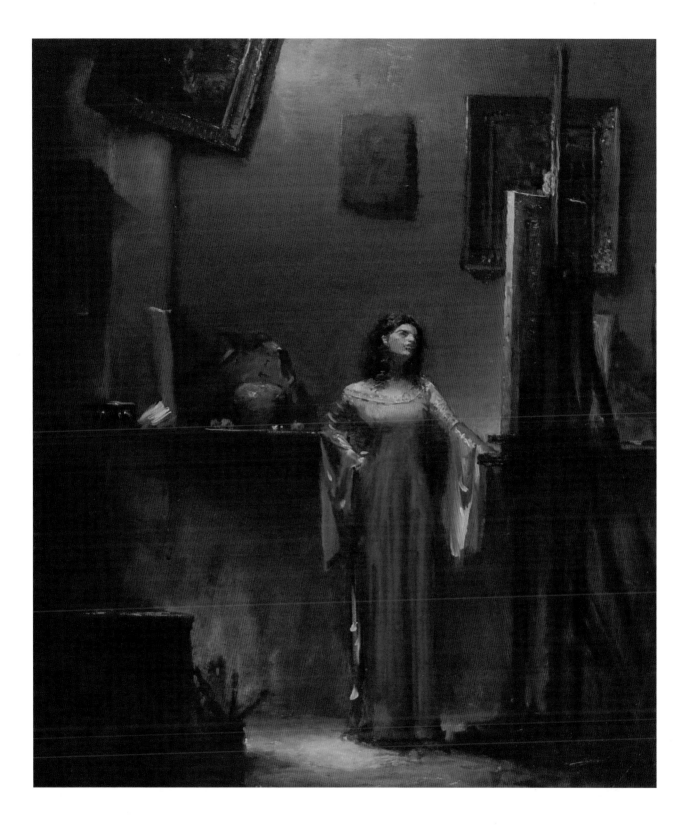

PORTRAIT STEP BY STEP

Here's a step-by-step sequence of a portrait I painted of Enrico.

Step 1 (Placement): As with almost all my paintings, I started this one as a blur of burnt sienna and ultramarine blue, using a lot of medium to loosen up the paint. Using the same initial color combination, I refined the drawing and solidified the structure.

Step 2 (Background): Putting in the background here helped establish the color world of the painting.

Steps 3 (Shadow) and 4 (Light): I added shadow and then washed in the flesh color with thicker paint.

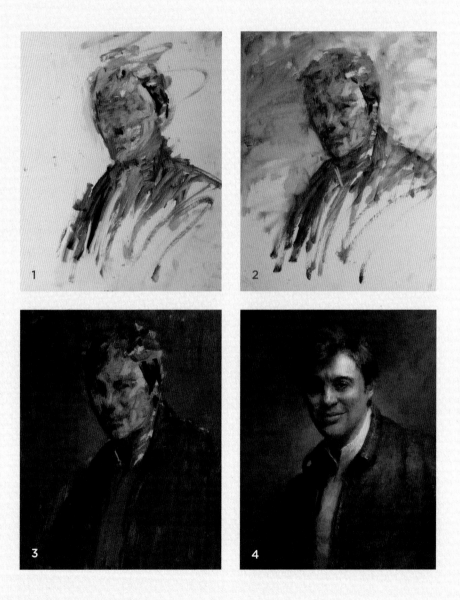

GREGG KREUTZ, *ENRICO*, 2013, OIL ON CANVAS, 20 X 16 INCHES (50.8 X 40.6 CM).

The design of the picture pits a lot of nothing against the *something* of the face.

PAINTING THE PORTRAIT

All the essentials—concept and process—come together as you begin to paint the portrait itself. It's important to approach your painting in a consistent manner.

As in all the other genres, portraits seem to work best when you make your process follow a logical sequence. For me, that sequence is generally placement, background, shadow, and light. You'll notice in the step-by-step example, however, that my background step follows the shadow and light steps. Keep your sequence logical but not slavish. Vary it as needed for each individual painting.

REWARDS

For me, all possible subject matter—boats, trees, apples—people are by far the most interesting. They're certainly the most challenging, and if I can get them on the canvas with the right amount of precision and flair, they make the most compelling pictures.

I should say, though, that I'm slightly less excited about being *commissioned* to paint people. I'll do it—rent must be paid—but because of issues of vanity and identity, commissioned portraits can sometimes spiral out of control and make you wish you were painting a boat. With commissions, if you're not careful, you can become a slave to someone's personal demons. When that happens—when you're told the subject of your picture needs more chin or less chin or a bigger smile or a handsomer expression—I recommend hanging onto your integrity and rushing out the door.

PORTRAITS: WRAP-UP

A final note on essentials as they apply to painting a portrait in oils: In my view, a beautifully painted head is the summit of visual art. A great Rembrandt self-portrait, for example, has profound things to express about the human condition. To look at such a work of art is to connect to a fellow human who passionately explored what it is to be alive.

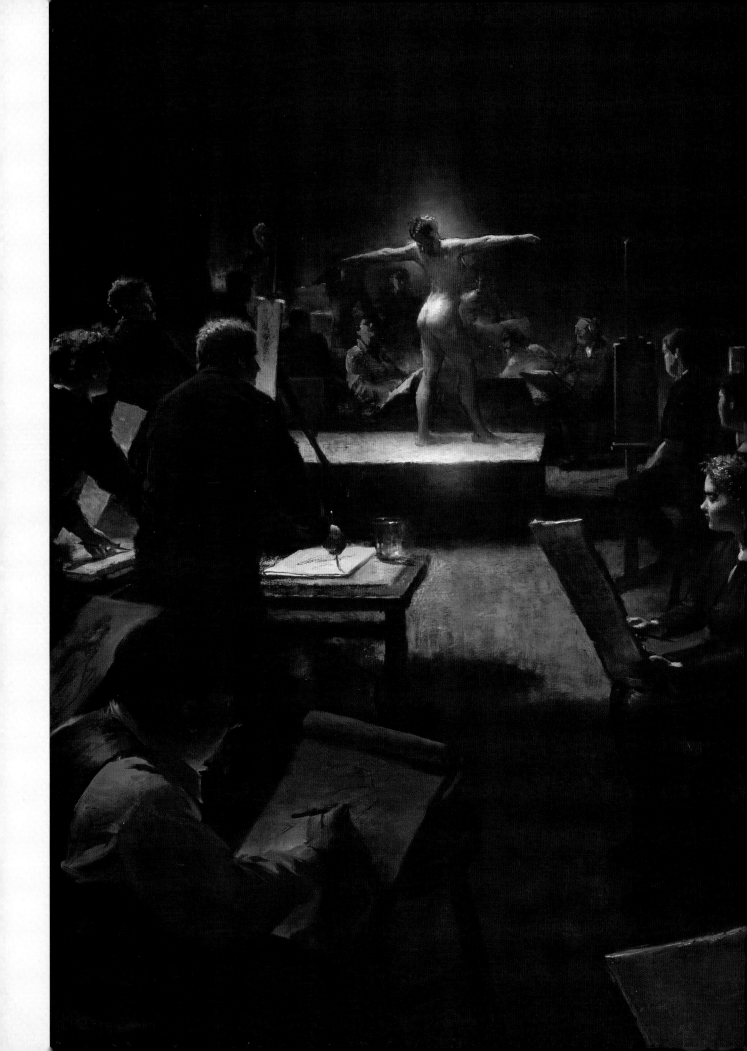

FIGURES

What could be more primary, compelling, and celebration-worthy than the human body? Becoming sensitive to the dynamically graceful balance of a nude figure heightens one's awareness of how humanity connects to nature's inherent harmony. Oil painters are blessed in that they are positively encouraged to study and learn about the human form in all its unclothed glory, and art schools all over the world make mastering the figure an essential part of their curricula.

But we shouldn't take this state of affairs for granted. It's not as if depicting the nude has always been an approved activity. Until recently, artists who wanted to paint the unclothed figure had to get official nudity clearance from the powers that be. Throughout most of Western history, a painter's only acceptable justification for exploring such a shocking subject was that he or she was illustrating a scene from the Bible. With that as their excuse, artists like Rembrandt and van Dyck pored over the approved text looking for stories where somebody—preferably somebody young and attractive—took all their clothes off. That way, if anyone objected, an artist could point a reverent finger to Scripture.

Nowadays, thankfully, artists don't have to seek permission to paint the nude. In fact, the nude as subject matter is enjoying something of a renaissance. One reason for the growing interest is that such a subject has timeless appeal. Since no costume is involved, when you see a nude you are seeing humanity in its pre- or post-cultural state. This lack of societal specificity places a painting of a nude in a timeless, universal realm.

GREGG KREUTZ, *FIGURE DRAWING CLASS*, 1999, OIL ON CANVAS, 40 X 30 INCHES (101.6 X 76.2 CM).

THE ESSENTIALS IN ACTION: FIGURE OIL PAINTING

Issues that turn up when painting the nude, of course, parallel and echo issues that can be found in all other genres. How light behaves, how shadow functions, how form recedes—these are not nude-specific but inherent in all visual life. It seems to be true, though, that flesh inspires extra focus on big universal issues. Maybe it's because the very substance of human flesh is like oil paint—shiny, fluid, and viscous. And consequently, painting flesh in oil has an integrated feel to it, a sense of material and subject uniting. Whatever the reason, the essentials that we see in visual life seem to be extra relevant when painting the nude. With that in mind, I've selected oil painting essentials from chapter 1 that seem particularly helpful when painting the figure.

CE MAKE THE SUBJECT MOVE

Movement in this sense doesn't mean full-on action—you probably don't want subjects sprinting across your canvas—but when you're painting the figure, there should be an implied feeling of motion. It could be just an indication that the subject is about to move, or maybe a hint that he or she has just moved.

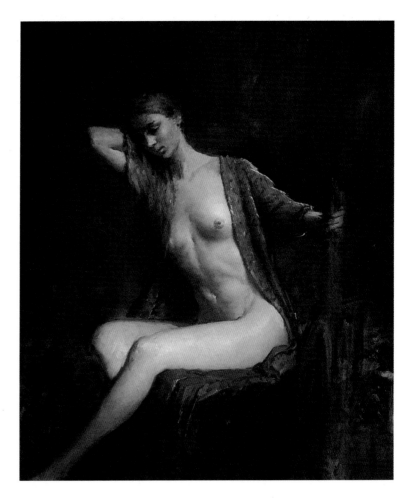

GREGG KREUTZ, *ON THE BED*, 2014, OIL ON CANVAS, 30 X 24 INCHES (76.2 X 60.9 CM).

In this painting, I wanted to give the feeling that the model is in mid-motion, as though she's not fully settled on that bed.

PE FILL THE PAINTING WITH A VARIETY OF STROKES

Stroke variety helps strengthen the feeling of movement mentioned in the previous section. Dynamic paint strokes can contribute to the impression that the figure is active.

CE CREATE STRUCTURE WITH SHADOW

Shadow plays a vital role in painting the figure. Without it, you'll have a flat, cutout representation. Sometimes the vibrancy of lit flesh makes you shy away from rich shadows, but without such contrast the lights won't look truly lit.

CE MAKE LIGHT THE MAIN EVENT

This is true for all subjects, of course, but keeping it in mind when painting the figure will help pull the work into focus. Figure paintings shouldn't be dry anatomical studies; they need to be dynamic explorations of how light traverses form.

CE TO MAKE THE LIGHTS LOOK BRIGHTER, BLEACH OUT THE DARKS

This can be helpful when you're trying to get the torso, say, to hold together. It's important not to make the shadows within the lit front plane of the torso too bright. If you want a lit look in the frontal flesh, lighten (bleach) the shadows under the breasts and on the underplanes of the arm.

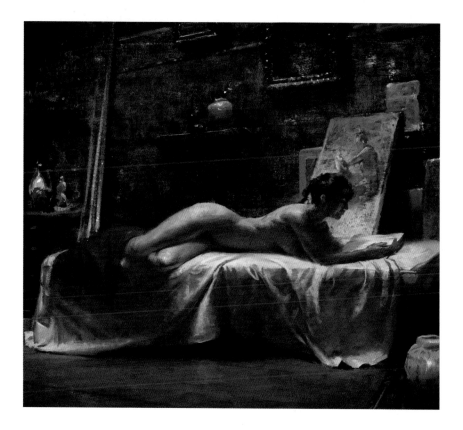

GREGG KREUTZ, *ON BREAK*, 1989, OIL ON CANVAS, 18 X 24 INCHES (45.7 X 60.9 CM).

In this painting, I gave the model's body form by contrasting the lit back against the shadowed front. I also used shadow to silhouette the face against the canvas behind it.

PE PAINT THE PICTURE IN A LOGICAL SEQUENCE

Because the figure is the hardest of all subjects to make look true, it's tempting sometimes to spend the preliminary phase fussing with the drawing and putting in the flesh color right away. With this approach, it's also tempting to leave out the background till the end. But the complexity and subtlety of the figure makes it even more important that you follow the process sequence: placement, background, shadow, light. Placement, in this context, shouldn't be about meticulous drawing or resolved flesh painting; it should be about making sure your picture is beautifully designed. And background shouldn't be left till the end. It should go in right after placement because background sets up the contrast you'll need when it comes time to making the flesh look lit.

Let's look at bit more closely at the painting *In the Red* (below). I'm using it to illustrate the essentials that follow.

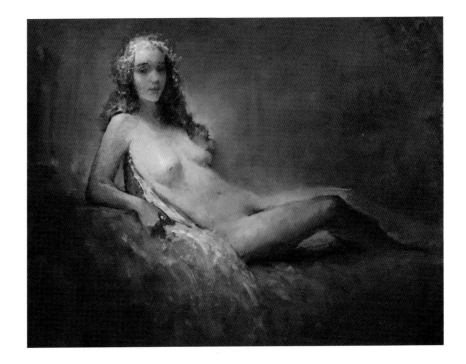

GREGG KREUTZ, *IN THE RED*, 2015, OIL ON PANEL, 18 X 24 INCHES (45.7 X 60.9 CM).

In this painting, I subordinated everything to the lit center of interest. Background, bed, and cloth were all kept underlit so our eye would go exclusively to the figure. I used the light, in other words, to lead us to the significant.

CE USE A COOL BACKGROUND COLOR TO MAKE FORM RECEDE

You can make flesh go back in space by adding a bit of background color to the local color—the logic being that, of course, that which is farther away from us takes on the color of what's farthest away. A warning though: this concept doesn't work if the background is warm and/or colorful. Such a color, if added to the flesh color, would make it come forward, but a cool background color will make the flesh recede.

CE REDUCE THE AMOUNT OF COLORS AND VALUES IN THE PICTURE

Keeping the amount of values down to a bare minimum will give the picture more force. A multivalue figure looks busy and unstable, as though the imagery is in flux.

CE PLACE THE LOCAL COLOR AT THE STARTING EDGE

The figure needs to begin with a clear edge full of lit local color. Like an apple or a pot, the figure has to have a readable starting point where the form commences. In the figure on the previous page, the starting point is the hair and the arm. Those two lit zones are where the visual journey through the figure begins.

CE SELECT FOR DEPTH

Sometimes in painting, it's helpful to think like a sculptor, expanding and contracting form. Instead of copying colors and shapes and values, for example, the oil painter can make, say, this part of the body come forward by intensifying the color, and send this part back by cooling off the color. Even the brushwork can be depth sensitive. You might, for example, use a strong thick stroke on the near knee and then a weak, strokeless stroke on the far.

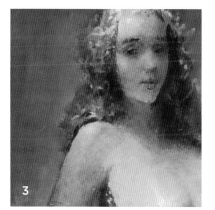

1: My flesh color in this painting consisted of cadmium yellow deep, cadmium red medium, white, and a little ultramarine blue. Where I needed the flesh to recede, I mixed in the raw umber I was using in the background.

2: Here I've tried to keep the values down to four: local value, highlight value, halftone value, and shadow value.

3: Here's a close-up of the starting edges, the hair and arm. Note how they are both in full local color—not middletone, not highlight—but what I deemed to be the model's essential flesh color.

4: Since intensity comes forward, that which is most lit will often appear nearest to us. Here I used that optical phenomenon to bring the near breast closer.

CHALLENGES

The challenges of painting the figure are many and varied. To meet them, the artist shouldn't feel that massive anatomy study and muscle memorization is required. For one thing, painters would do well to be wary of any time-consuming activities that keep them from painting. I'm not sure why, but oil painters seem to be particularly susceptible to getting sidetracked by preliminary activities. Things like taking anatomy classes, arranging color charts, doing complicated value studies, reading how-to books (oh wait . . . skip that last one)—all of these tempt the artist away from the easel and keep him or her from directly meeting the challenges.

In this section, I'll show you some of the specific difficulties figure painters encounter.

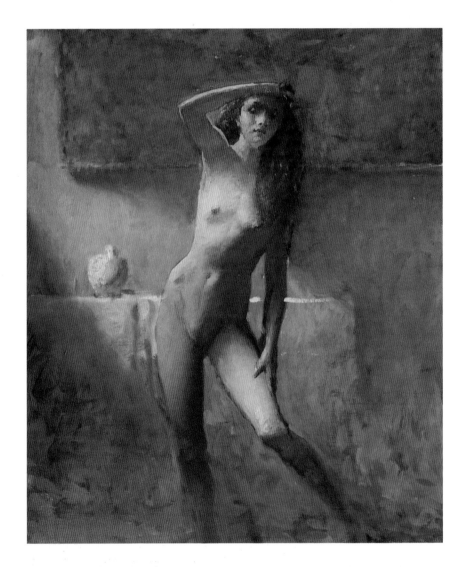

GREGG KREUTZ, *IN THE STUDIO*,
2006, OIL ON PANEL, 16 X 12 INCHES
(40.6 X 30.4 CM).

In this painting, I was trying to match the movement of the figure with a dynamic, quick treatment of the background.

LEFT: GREGG KREUTZ, *MOVEMENT*, 2015, CHARCOAL ON PAPER, 12 X 9 INCHES (30.4 X 22.8 CM).

Ultimately, movement is the best way to communicate life force.

RIGHT: GREGG KREUTZ, *SEATED NUDE*, 2014, CHARCOAL ON PAPER, 12 X 9 INCHES (30.4 X 22.8 CM).

Even someone in a seated pose is engaged in dynamic movement, keeping, say, her upper body in place by counterbalancing it against her hips.

Capturing a Vibrant Life Force

Just as there is no greater painting challenge than depicting the human figure, so there is no greater incentive for a canvas to be pulled off its easel and Frisbeed across the studio. Not only does the complexity of the human form require a clear sense of structure, flesh tone, and gesture, but also, if the image is to be convincing, a vibrant life force needs to show up on the canvas. And trying to get all those elements to coalesce into one readable image can often result in flying canvasses.

Note: For the movement illustrations below and for those in the accompanying sidebar, "How to Make Your Subjects Move" on pages 76–77, I'll be using drawings instead of paintings so as to reduce and simplify the relevant energy thrusts. To make the figure you're depicting look like a living entity, you have to track the essential movement of every part of the subject's body.

This movement concept is more important than specific anatomy issues. Artists are often lured to their doom by the dogma that they must learn anatomy before they learn to draw. But often, after years of studying all the muscle and bone names and memorizing their functions, aspiring artists discover that they still don't know how to draw. While anatomy is helpful, it isn't the critical factor. After all, even though cadavers have all the same parts living people do, their anatomy doesn't add up to a live human. It's movement that separates life from nonlife, quick from dead.

The questions that the artist needs to answer are essential questions about the model's life force: *What's holding this up? What's pulling against this? How rapid is this movement?* These are the questions to ask yourself—not rendering questions, not measuring questions, not *How many heads long is the arm?* My experience is that being attentive to energy provides a deeper sense of reality to the image. Ultimately, even if the representation is a little proportionally inaccurate, empathetically depicted energy looks more lifelike than something painstakingly measured.

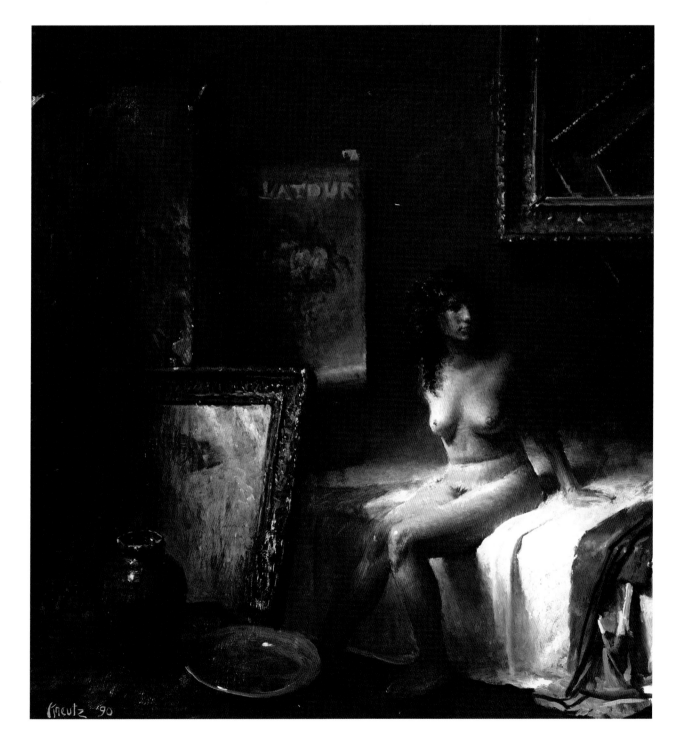

Observing Empathetically, Not Measuring Meticulously

Empathy is the critical part of all realistic painting and drawing. The artist needs to have a visceral feel for what the subject is doing. Developing this visceral feel can be challenging.

Why? Because this empathetic approach is sometimes counterintuitive. Since artists want their efforts to look true, often they will mistakenly try to measure their way to accuracy. But measuring can make the picture look artificial. Why? Because to measure is to distance yourself from what you're measuring. Holding up a pencil or brush to gauge the length of an arm, say, literally puts a barrier between you and the subject. By trying to measure the arm, you're no longer sensitively looking at what the arm is doing; you're treating it as a shape, a disembodied piece that you're hoping to accurately copy. To instead look at the arm in terms of what it's doing, to look with openness and sensitivity at the arm's action, has much more potential for insight. Empathetic observation brings attention to the weight of the form, the strain of the muscles, and how the form is situated in space.

The temptation to measure is strong. And the situation isn't helped by the fact that some artists who measure do so very well. If the model stays still enough and the pose is held long enough, some artists can measure their way to something that looks impressive (damn them!). But my feeling is that if slavish measuring is how representational art gets made, then maybe it's not that meaningful to make.

Of course, measuring isn't the answer. Measuring is drudgery. Measuring is laborious. And its end product will always have an inherent deadness. A much more dynamic approach is to capture the *feeling* of what's going on and transfer that feeling onto the canvas.

GREGG KREUTZ, *STANDING NUDE*, 1998, OIL ON CANVAS, 20 X 16 INCHES (50.8 X 40.6 CM).

Energy was the goal here; I was trying to correctly capture the dynamic of the model's stance.

PAINTING THE FIGURE

In theory, converting the human figure into an oil-painted image should be no more difficult than any other conversion from three dimensions to two dimensions. In reality, making a credibly convincing depiction of the human figure can be an oil painter's greatest challenge. To try and meet that challenge, I usually stick like glue to my process sequence—placement, background, shadow, light.

HOW TO MAKE YOUR SUBJECTS MOVE: THE CURVED TUBE SOLUTION

How do we manifest movement on the canvas? It's all very well to say depictions of living humans need to show movement, but since an image on a canvas is static, how can that movement be communicated?

Answer: the curved tube.

The *curved tube* is a discovery I made several years ago that allowed me to change my imagery from static renderings to expressive approximations of living energy.

In developing this approach, I discovered that the upper chest is the key starting point. The upper chest—because it houses the heart and lungs—gives us a dynamic kick off to capturing the subject's life energy. And in order to correctly nail that part of the body, the first order of business is to figure out which way the upper chest is turned: Is it facing left or right? This is important, because the tube needs to curve in the direction the chest is facing.

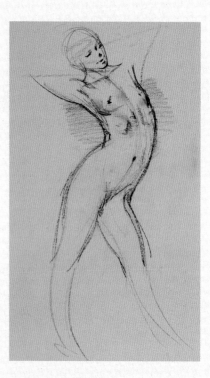

1: Once the directional thrust of the chest curved tube is established, the rest of the process is (relatively!) easy because each curve will always be met by a tube curving the other direction.

2: Below the chest curved tube, for example, there's the curved tube of the pelvic area curving in the opposite direction. That sequence of curve and countercurve is what keeps the body balanced. One thrust met by a counterthrust.

3: Because the living body is not static, each part has an energy that is balanced by an opposite energy.

THE CURVED TUBE IN ACTION

Here are some examples of figure drawing where using the curved tube helped me capture the dynamic energy of the body's thrusts and counterthrusts.

If the model would pose rigidly in a frontal, vertical position and stay there without moving for as long as possible, figure painters would have a lot less to worry about. Then they could just stack up the body parts on the canvas and make sure everything was symmetrical.

Unfortunately (or actually fortunately), models, being alive, rarely strike such static poses. More typically they go for a dynamic arrangement of thrusts and counterthrusts. A beautiful pose, after all, is a form of dynamic three-dimensional design—a contrast of one flow of energy against another. The observant artist will analyze the pose not in terms of bone or muscle names, but in terms of weight and balance.

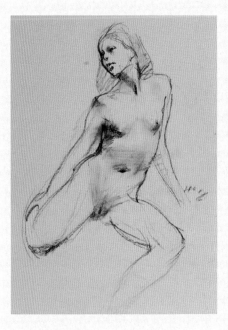

ABOVE: GREGG KREUTZ, *SEATED NUDE*, 2014, CHARCOAL ON PAPER, 12 X 9 INCHES (30.4 X 22.8 CM).

Seated doesn't have to mean inactive. I used the curved tube to get the torso to look dynamic.

MIDDLE, LEFT: GREGG KREUTZ, *PIGEON*, 2013, CHARCOAL ON PAPER, 12 X 9 INCHES (30.4 X 22.8 CM).

Very lightly, I figured out Pigeon's curved tube chest thrust, even though it was hidden behind her leg.

MIDDLE, RIGHT: GREGG KREUTZ, *DEPTH*, 2013, CHARCOAL ON PAPER, 12 X 9 INCHES (30.4 X 22.8 CM).

Here I tried to capture the energy of the model's pose and create depth, using sienna charcoal to pull the knees forward.

BOTTOM: GREGG KREUTZ, *UPSIDE DOWN*, 2015, CHARCOAL ON PAPER, 9 X 12 INCHES (22.8 X 30.4) CM).

The more complicated the pose, the more the curved tube is helpful. Here I started with the torso and made sure the tube curved correctly.

FIGURE STEP BY STEP

Once again my preferred sequence—placement, background, shadow, and light—informs the painting process for this example.

Step 1 (Placement): Here's how I used the curved tube idea in an oil painting. I started with the upper chest, curving the tube to the right, and then in the hip area I reversed the tube so that it curved to the left. That gave me some good starting energy for the picture.

Step 2 (Background): I put in the background color—ultramarine blue, cadmium yellow, and white—surrounding the figure with it and not worrying at this point about how active or passive I wanted it to be. I then filled out the figure, putting a lot of the background color in the flesh. After a pause, I decided it looked a little cold and the background seemed busy. I warmed up the flesh a bit and pacified the background.

Step 3 (Shadow): Now all the parts of the body that weren't facing the light needed to be put into shadow. I made this shadow with burnt sienna, white, cadmium yellow, and a little blue, trying to get a dark version of the flesh color.

Step 4 (Light): Time to put in the light. For the model's flesh, I used cadmium yellow pale, cadmium red medium, white, and ultramarine blue.

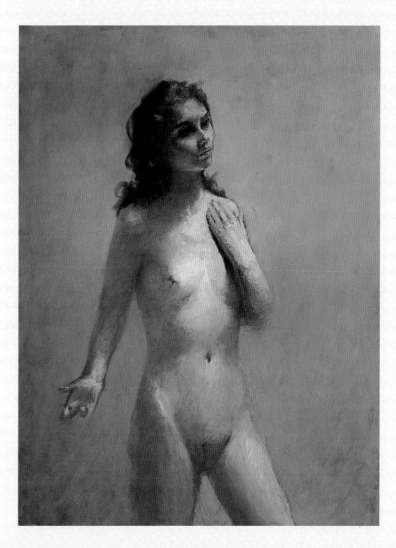

GREGG KREUTZ, *STANDING NUDE*, 2014, OIL ON PANEL, 16 X 12 INCHES (40.6 X 30.4 CM).

Here's the finished painting. Being attentive to which part is thrusting where (thanks to the curved tube idea) gives (I hope) a general feeling of movement to the painting.

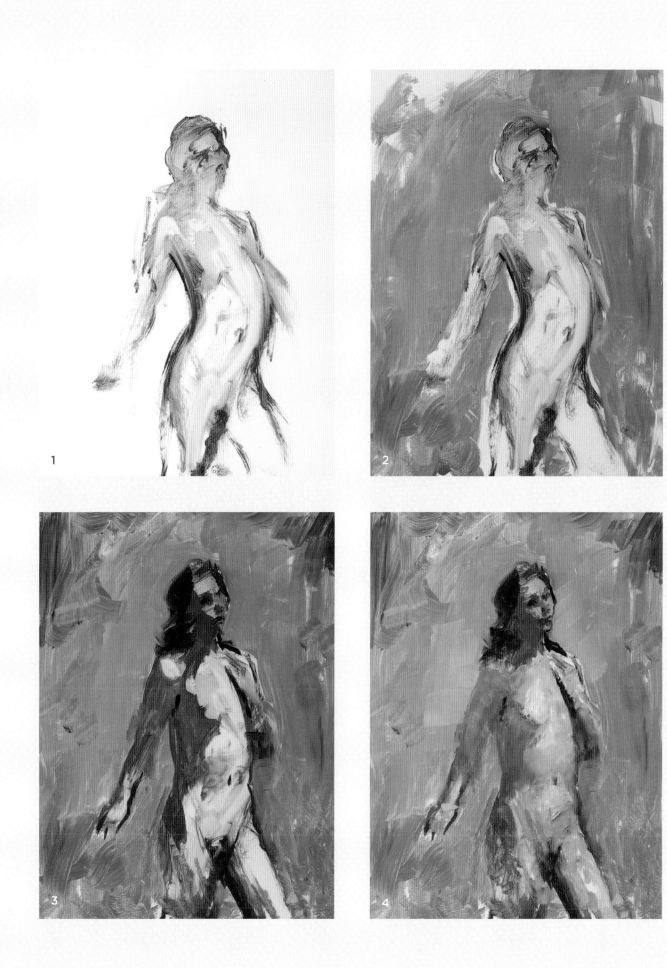

REWARDS

Painting the nude is an opportunity to explore the physical dynamic of what it is to be human. The human body, after all, is a maze of interconnections and a balancing act of flexibility and stability, movement and support, action and repose. To depict it is to learn about the miraculous ingenuity of our shared structure.

With the nude, I don't believe it's necessary to pictorially account for why the subject doesn't have any clothes on—that is, you don't need to place the subject on an unmade bed or in front of a gym locker. In fact, with nudes, sometimes the less context, the better.

Occasionally however, I do allow myself overt context—especially if it adds to the dynamic of the picture. When I deem that where the model is situated should be part of the picture's story, I still try and make sure the context doesn't overpower the figure. That is, if the figure's in a room, you don't want the props in the room to upstage the figure. Furniture shouldn't trump humanity.

BELOW, LEFT: This image seemed a little broken up at this point. I felt I needed to figure out a way to make a bigger lighter shape.

BELOW, RIGHT: GREGG KREUTZ, JULIE, 1990, OIL ON CANVAS, 24 X 19 INCHES (60.9 X 45.7 CM).

I decided to add some white cloth to the picture. Does it look better? I'm still not sure.

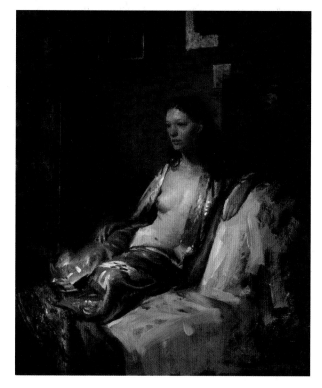

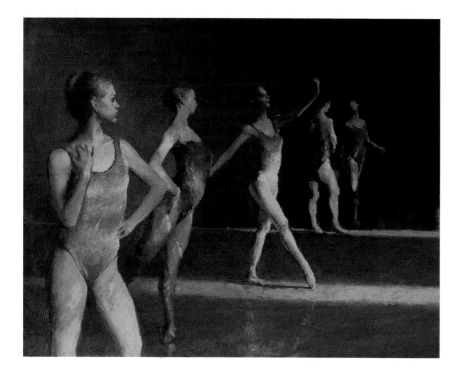

GREGG KREUTZ, *DANCERS*, 2014,
OIL ON PANEL, 16 X 20 INCHES
(40.6 X 50.8 CM).

This painting was greatly assisted by
my curved tube concept. With it, I
was able to make the dancers—who,
by the way, were all played by the
same person—look active.

We've been talking about the unclothed figure here, but the skills that are
developed by painting the nude will be helpful when painting clothed
figures as well, which is another reward of this genre. The curved swell of
the upper chest, the countercurve of the pelvis, the juxtaposition of the
head facing one way and the shoulders another—all those crucial elements
that can make the figure look alive are just as crucial whether the figure is
dressed or undressed

FIGURES: WRAP-UP

I believe the rewards and challenges of painting the figure push the artist
forward and help with all the other subjects he or she might paint. For
example, a tree in a field might manifest thrust-counterthrust energy as
its trunk ascends and leans one direction and then another. That kind of
dynamic direction change might be more easily captured by an artist who
has had experience painting the figure than someone who has only painted
landscapes. Once again, having broader subject-matter familiarity expands
your range as an artist.

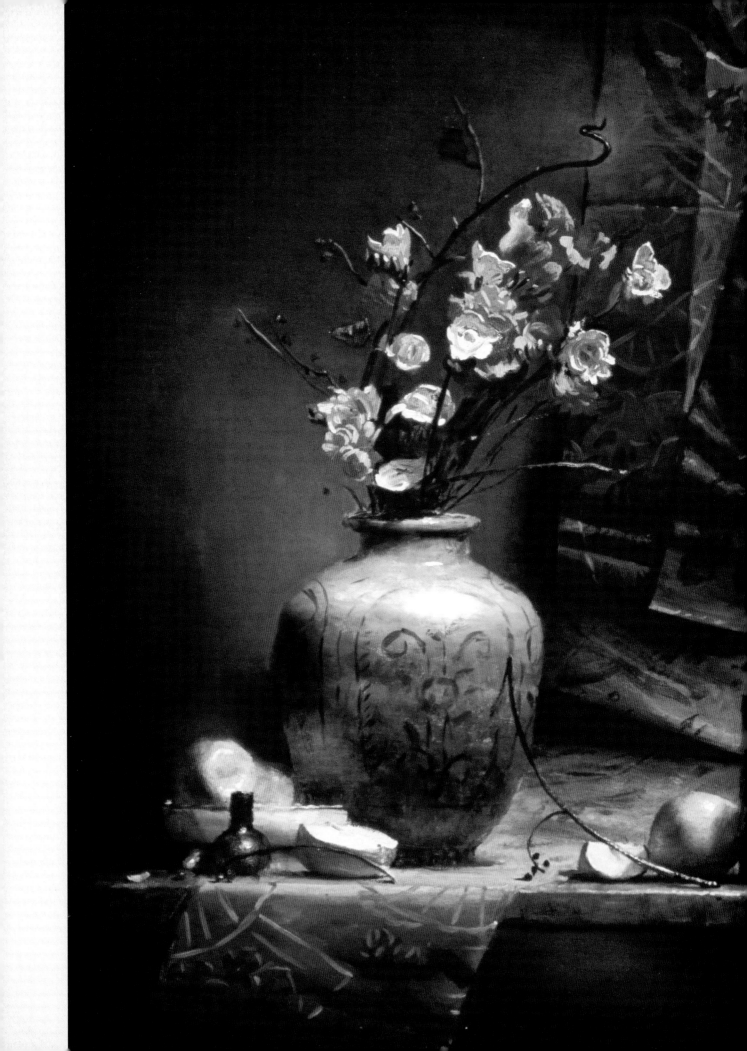

CHAPTER 4

STILL LIFES

Like figures, still lifes provide an effective training ground for every kind of oil painter. The simplicity of the props, the narrowness of the space, and the lack of movement on the part of the subject (apples don't take breaks)—all allow you to explore essential issues at your own pace. How light behaves, the true nature of shadow, how color moves, and so on are easier to get a handle on away from the frenzy, say, of painting outdoors or the stimulation of trying to capture a person's likeness.

GREGG KREUTZ, *GOLDEN OBI*, 1996,
OIL ON CANVAS, 24 X 28 INCHES
(60.9 X 71.1 CM).

THE ESSENTIALS IN ACTION: STILL LIFE OIL PAINTING

In this chapter, I'll present the essentials a little differently than in previous chapters. In this section, I've included the essentials from chapter 1 that most directly apply to the actual painting of the still life. Later in the chapter, you'll find a sidebar called "How to Enhance Your Still Life Setup" (pages 92–95) with a checklist of essentials that are particularly helpful as you prepare the setup for your still life painting. Using all of these essentials—those listed here and those listed later—should give you a better handle on the vagaries of still life oil painting. Let's start with those essentials that are crucial for your painting.

CE MAKE LIGHT THE MAIN EVENT

As in all representational art, light is the essential subject of a still life. A beautiful still life tells the story of light's journey across space.

Without careful consideration of the drama of light, a still life can become just a collection of objects, an inventory. When that happens, my policy is to try to figure out how to increase the canvas's luminosity. *Could the lights be brighter? Could the darks be darker? Could there be more emanating glow from the lit areas?* Strengthening the light happens when pragmatic questions like these are asked and answered.

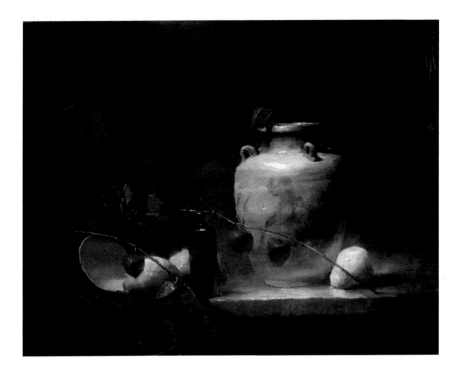

GREGG KREUTZ, *STILL LIFE WITH CHINESE SCREEN*, 1996, OIL ON CANVAS, 24 X 28 INCHES (60.9 X 71.1 CM).

Here I tried to show the light shimmering on the bowl at the left side of my canvas. Then I tracked it as it traveled across, letting it reach full intensity on the pot and pear on the right side.

CE TO MAKE THE LIGHTS LOOK BRIGHTER, BLEACH OUT THE DARKS

Sometimes, though, bleaching out darks can be a little tricky. You don't want to brighten them so much that there's no contrast left with the light. We need darks to give drama to the painting, so you have to figure out a way to balance those two needs: dark enough for drama, light enough for glow.

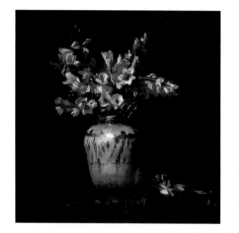 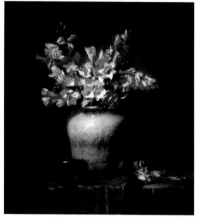

LEFT: GREGG KREUTZ, *STILL LIFE WITH PURPLE FLOWERS*, 1997, OIL ON CANVAS, 18 X 20 INCHES (45.7 X 50.8 CM).

In this first version of a floral still life, I depicted what I saw as faithfully as possible. Looking at it later, though, I felt that the picture as a whole lacked resonance. It seemed too grounded, too literal.

RIGHT: GREGG KREUTZ, *STILL LIFE WITH PURPLE FLOWERS, PART TWO*, 1997, OIL ON CANVAS, 20 X 18 INCHES (50.8 X 45.7 CM).

In the second version, using *burnout* (bleaching out the darks near the light), I blasted more light on the pot, put some glow in the background, and added a dark jar in the foreground to provide contrast—thereby, I hope, giving the painting more edge, more drama, more luminosity.

CE SELECT FOR HUMANITY

Since, by definition, a painting of a still life doesn't have people in it, it may sound contradictory to say that humanity should be present in a setup, but the humanity I'm thinking of is implied rather than overt. Objects made by people can give the necessary human touch to a still life. And if the objects were dented or cracked through frequent use, that's even better. On the right is an example of a prop with character:

Props in a still life need to look like they've had some history. When picking out still life objects to paint, I much prefer an aged pot to a plastic bucket, a tarnished tin coffee pot to a state-of-the-art percolator, a tarnished silver cup to a new Coke can. Why? Not because I like to live in the past, but because objects like an old pot have lived a little. Objects that are squeaky-clean and new, on the other hand, communicate coldness, isolation, sterility. Props with the appearance of history can generate a more human feeling.

Of course, props have to be placed somewhere—either on a shelf top or a tabletop. Both of these settings offers their own challenges and possibilities. For more on shelf-top and tabletop settings, see "Still Lifes: Other Oil Painting Issues" (page 90).

GREGG KREUTZ, *DAFFODILS* (DETAIL), 2011, OIL ON CANVAS, 16 X 20 INCHES (40.6 X 50.8 CM).

CHALLENGES

In a sense, the biggest barrier to successful still life painting is still lifes themselves. A majestic vista, a fascinating face, a beautiful nude—these are subjects with inherent interest, subjects that can stir an artist's blood. It's sometimes hard to feel similar excitement when confronted with a pot and two lemons. But that very lack of electricity can also lead you to beauty.

GREGG KREUTZ, *TEAPOT AND LEMONS*, 1989, OIL ON CANVAS, 14 X 18 INCHES (35.5 X 45.7 CM).

Here I tried to create a circular kind of pattern for the props with the little cup as the center of the circle.

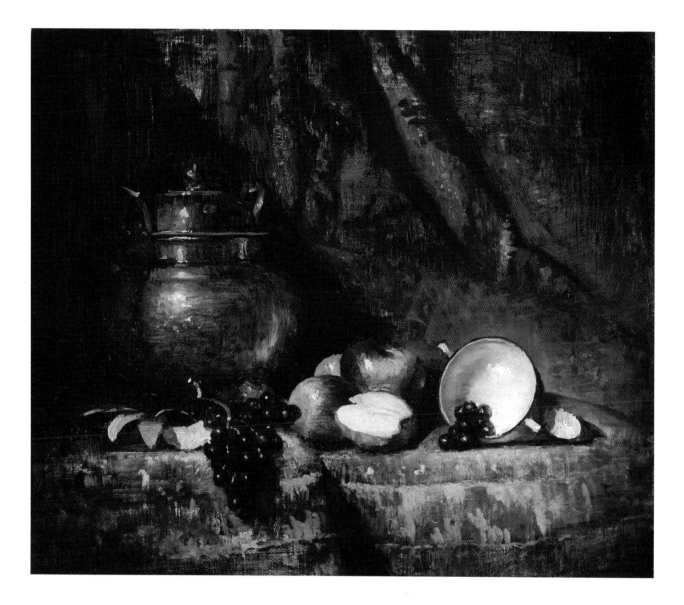

Adding Drama to the Mundane

When you are forced to convert mundane subject matter into a dynamic pictorial statement, you must think through what makes a picture, what makes drama, what makes something compelling, and, ultimately, what makes art. Since you are not able to lean on inherent interest, you must instead think and paint creatively—in short, you must figure out strategies to give excitement to your painting.

How do you turn a pot sitting next to two lemons into a work of art? Obviously, just doing a fastidious copy won't do the job. Artists need to bring something fresh to the event—some vision, some idea about how they want the viewer to experience the picture.

GREGG KREUTZ, *STILL LIFE ON RUG*, 1997, OIL ON CANVAS, 16 X 20 INCHES (40.6 X 50.8 CM).

Here I'm using light and placement to try and pull drama out of the mundane.

ABOVE: GREGG KREUTZ, *ON THE TABLECLOTH*, 1987, OIL ON CANVAS, 27 X 22 INCHES (68.5 X 55.8 CM).

Here are multiple still life props arranged in an S curve. The challenge here was to hit the balance between formal and casual.

RIGHT: GREGG KREUTZ, *STILL LIFE WITH CHINESE SCREEN*, 1989, OIL ON PANEL, 22 X 26 INCHES (55.8 X 66 CM).

In this shelf-top painting, I used the screen and the twig to move the eye across the painting.

Placing the Props for an Effective Picture

The nature of that visual experience, of course, is largely dictated by the arrangement of the subject matter. How the artist assembles still life props is a major factor in how effective the picture is. Props need to be sequenced in a compelling drama of light.

When you're trying to decide how to arrange your props, it's sometimes helpful to organize them around big, simple shapes. Maybe collectively the objects could describe a triangle. Or a sideways trapezoid. Or a big circle. Arranging props into large geometric shapes keeps the still life from looking like a lot of scattered objects. Here again, massing is key. (For more on massing, see "How to Enhance Your Still Life," pages 92–95.)

Painting Your Perceptions

For representational oil painters, the nature of visual reality is not a given. Instead, it's a complex intersection of the external and the internal. To a realist artist, *how* we see is just as important as *what* we see. Developing as a painter means probing our perceptions as well as what's perceived and taking nothing for granted.

Because still life is the least rigorous of genres—no easels to lug, no hunting for models, no getting rained on—the oil painter has time to dig deep into the big, challenging issues. For example, suppose you're painting a peach and you want to make clear to the viewer that it isn't a nectarine. In person, you don't have any trouble knowing which is a peach and which is a

nectarine. However, if you're trying to *paint* that distinction, you have to figure out how you know. You must identify the visual cues that tell you which is which. Making such a determination is about pulling up to your conscious thought what your unconscious mind has already figured out. In this case, you know that the peach has a fuzzy surface, while the nectarine has a shiny one. How do you know which one is fuzzy and which one is shiny? You know because the fuzziness of a peach eliminates highlights and causes a gray fringe at the turning edge. A nectarine, on the other hand, has a shiny surface, which results in no fringe and a distinct highlight. In order to communicate to the viewer that you've painted a peach, put a gray fringe on the edge of the object and don't paint in a highlight.

To be a representational oil painter means that you are always investigating the essential characteristic of whatever you're painting. It's about figuring out what your perceptions of the subject are based upon. That doesn't mean you must memorize lots of rules (nectarines have highlights, peaches don't) that would be endless. Learning to paint is about breaking down your reactions. Below the surface of consciousness, the intelligence of your perception is hard at work. All you have to do to become an artist is tap into it.

Escaping from Middletone

If you're painting a still life and you've hit all your marks—gone through the checklist in "How to Enhance Your Still Life" on pages 92–95—and you're still not excited, that doesn't mean still life painting isn't for you. Nine times out of ten, what it means is that you're stuck in middletone. Middletone is the enemy of still life painting. In fact, it's the enemy of painting in general. Middletone—that is, tonally in the center of things: not too dark, not too light, not too much paint, not too little—is when painting, and a painter, can lose vitality. Underdeveloped darks and lights tend to weaken your resolve and make you want to put down your brushes.

The problem is that once you're in middletone, it's hard to get out. Your eyes grow accustomed to the low value range and anything you put down on the canvas that's not within that value range looks, by comparison, wrong. To escape from that tonal gridlock, you sometimes have to just smash some white on your canvas and/or hit your darks with some extra dark paint. A strong picture is strong, typically, because its value range is high—bright lights, deep darks. Like a symphony that moves from barely audible to a kettle drum crescendo, a painting is powerful when the eye travels from a mysterious dark to a blazing light. Too much middletone bogs down that journey.

The muted highlights and gray fringe tells us these are peaches.

The highlight and the lack of gray fringe tells the eye that this is a nectarine.

STILL LIFES: OTHER OIL PAINTING ISSUES

One of the key steps in still life arrangement is deciding whether you're doing a shelf-top or a tabletop setup. A *shelf-top setup* is one placed at eye level. Props in this mode are placed left to right because, at least in Western culture, we read in that direction. That means the main focal point should be situated on the right side of your setup. With this kind of arrangement, there's not much top plane, and, in general, not much perspective to worry about. In a shelf-top setup, the near/far space is shallow, so near/far issues are minimal.

A *tabletop arrangement* is all about depth. It's about moving the eye into the space toward the climax. It's not a left-to-right arrangement; it's a near-to-far one.

Deciding on and committing to whether you're depicting a shelf-top or a tabletop still life is important, because each has different requirements. The shelf-top setup moves from side to side and has shallow perspective, while the tabletop setup moves from near to far and has deep perspective.

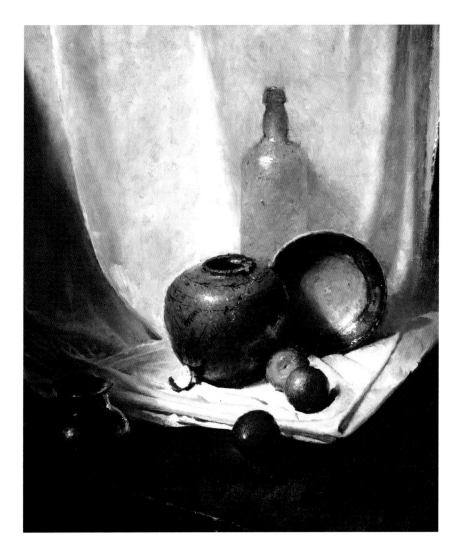

GREGG KREUTZ, *ALISON'S STILL LIFE*, 1996, OIL ON CANVAS, 27 X 22 INCHES (68.5 X 55.8 CM).

Here's a tabletop arrangement. Props are arranged so that the eye moves not left to right but from near to far.

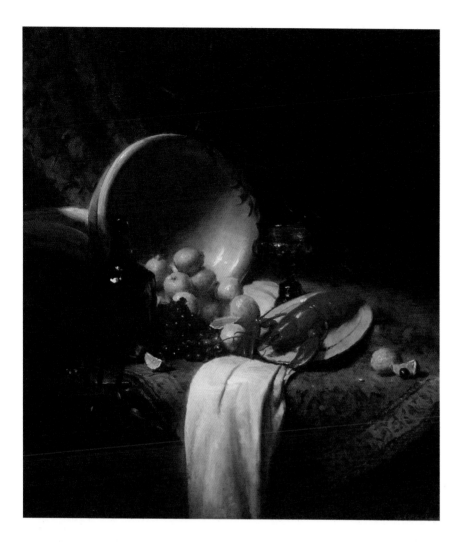

GREGG KREUTZ, *LOBSTER ZIG-ZAG*,
2003, OIL ON CANVAS, 34 X 25 INCHES
(86.3 X 63.5 CM).

In this tabletop arrangement, I made
the sequence go in a zig zagging,
top-to-bottom direction, thereby
moving the viewer's eye fluidly
through the canvas.

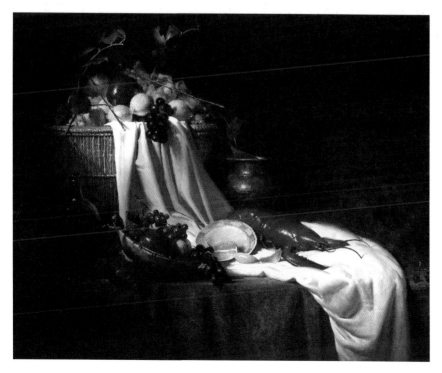

GREGG KREUTZ, *LOBSTER STILL LIFE*,
1997, OIL ON CANVAS, 28 X 35 INCHES
(71.1 X 88.9 CM).

Here I organized the material to be
read from left to right on a shelf top.

HOW TO ENHANCE YOUR STILL LIFE

Here's a checklist of essentials that can enhance a still life setup:

CE MAKE SURE THE PICTURE HAS TEXTURAL VARIETY

In still life, having different types of surfaces is important. You should have a mix of textures: glass, metal, organic matter, porcelain, and so on. Having only, say, three ceramic pots and nothing else gives a stark effect.

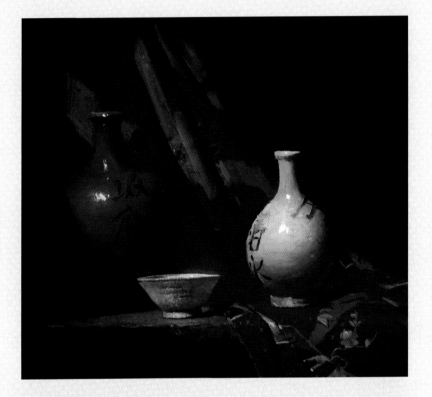

GREGG KREUTZ, *CERAMIC*, 1980, OIL ON CANVAS, 14 X 18 INCHES (35.5 X 45.7 CM).

By having such limited typed of substances in my set-up here, I violated my texture variety rule. Does the painting consequently have a slightly sterile look? Your call.

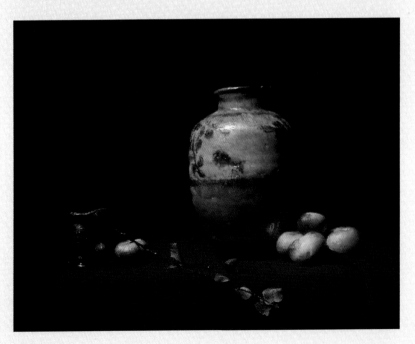

GREGG KREUTZ, *POT AND APPLES*, 1987, OIL ON CANVAS, 16 X 20 INCHES (40.6 X 50.8 CM).

This one is about textural variety—I tried to contrast the softness of the apples against the hard, dented surface of the pot.

CE MAKE SURE THE PICTURE HAS SIZE VARIETY

Size is a key part of the drama in a painting. In the case of still lifes, the drama might be the dynamic between a large pot and little apples, or in the contrast of a solid little pot against an expansive, shimmering fabric.

GREGG KREUTZ, *A GATHERING OF PEARS*, 1988, OIL ON CANVAS, 14 X 18 INCHES (35.5 X 45.7 CM).

I emphasized the range in sizes by juxtaposing the big pot with the little grapes.

CE MASS THE SHAPES

Scattering lights and darks around randomly weakens the image. Put the lights together and put the darks together. Mass them. Of course, there can be some interplay: a dark grape in front of a cluster of lemons, an orange slice in front of a group of dark plums; however, generally the values should be kept separate— lights together, darks together.

GREGG KREUTZ, *FLORAL*, 2004, OIL ON CANVAS, 14 X 18 INCHES (35.5 X 45.7 CM).

In this still life, I made sure the light was centered on the pot and basket, keeping the near flowers in shadow so they wouldn't distract.

CE MAKE LIGHT THE MAIN EVENT

The main event of a still life should always be light. No matter how interesting an object is, if it's not brightly lit, it won't hold the viewer's attention.

The human eye is designed to focus on light. That's how it's wired. Knowing that, use light to pull the viewer's focus to the place in the painting where you want attention. That's why it's important to keep the light on what's deemed most meaningful. An oil painting, from that perspective, can be seen as an optical device that guides the eye to the significant.

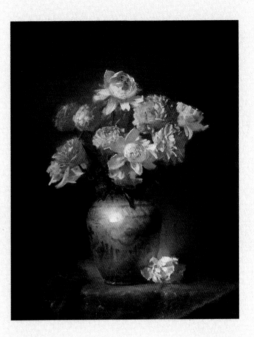

GREGG KREUTZ, *PEONY SEASON*, 2008, OIL ON CANVAS, 28 X 24 INCHES (71.1 X 60.9 CM).

As you can see here, the light is pushed to the max—glowing in the background at the base of the pot.

CE MAKE THE COLOR MOVE

There needs to be a discernible color idea in the painting. It could be complements (like green against orange), or it could be a noncolor against a color. (*Noncolor* here means an unidentifiable color—dull brown, dingy gray.) Whatever the particulars, the colors need to move on the canvas.

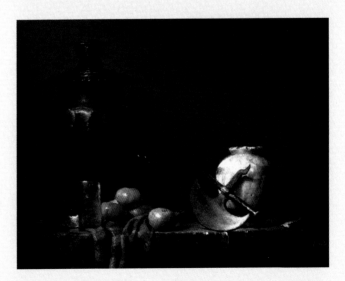

GREGG KREUTZ, *STILL LIFE WITH AX*, 1996, OIL ON CANVAS, 22 X 26 INCHES (55.8 X 66 CM).

Orange and purple were the key colors here.

CE MAKE THE VALUE MOVE FROM DARK TO LIGHT OR FROM LIGHT TO DARK

It's a good idea *not* to spread the light around evenly. There should be a progression of light intensity, usually climaxing at the center of interest. After that, there should be a "light stopper," a small object—a grape, a lemon peel, or similar—that visually signals the end of the sequence. I like to think of the "light stopper" as a period at the end of a sentence.

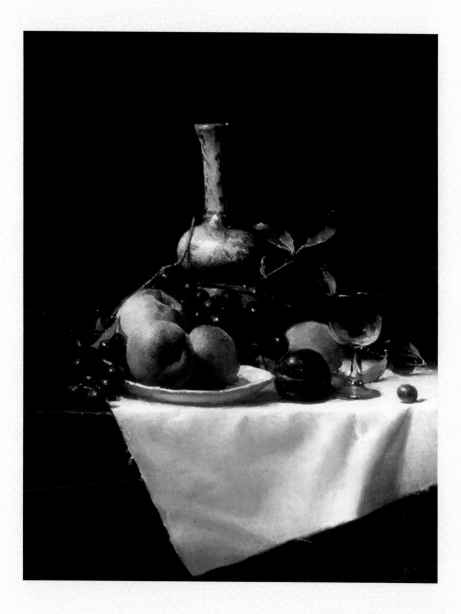

GREGG KREUTZ, *BLACK AND WHITE*, 1987, OIL ON CANVAS, 20 X 16 INCHES (50.8 X 40.6 CM).

I felt that the complexity of the arrangement here required a simple conclusion at the end— hence, the grape.

PAINTING THE STILL LIFE

Settling down and getting started on painting a still life is sometimes the toughest part of the job. Artists are often very good at thinking of ways to put that kind of thing off. But fully commited to the project, they can be pulled into what can only be described as a meditative state. Focusing on external reality with the necessary attention and at such close range connects the artist to the external world in a way that's not common in everyday life.

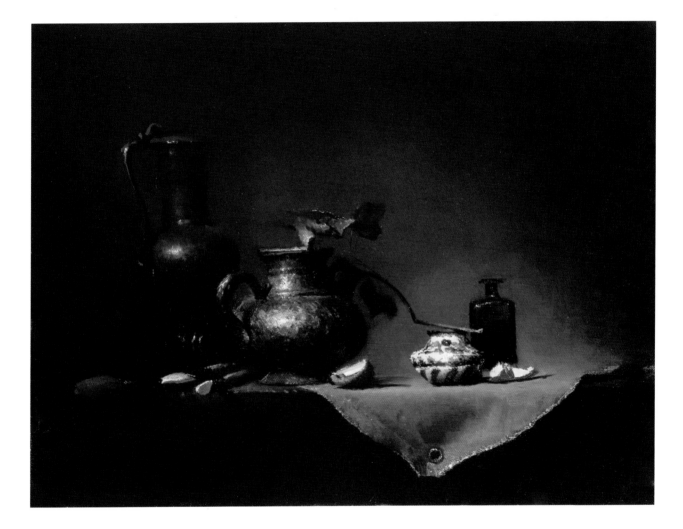

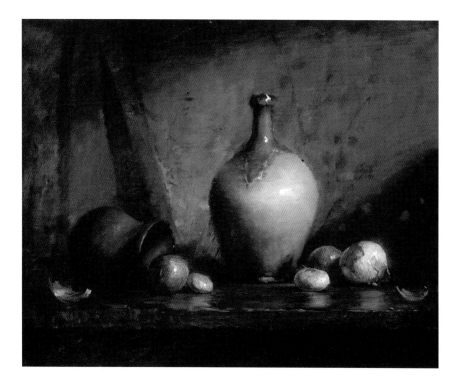

GREGG KREUTZ, *ONIONS*, 2001,
OIL ON CANVAS, 16 X 20 INCHES
(40.6 X 50.8 CM).

Since there's not much color here,
the picture's strength depended on
how attentively I could depict the
delicacy of the onions' surfaces.

REWARDS

In museums all over the world, galleries are filled with epic depictions
of giant battle scenes, majestic landscapes, and striking portraits, while
off in obscure rooms, still lifes are often huddled together, neglected and
unnoticed. But their semiobscure status shouldn't mislead us. Because of still
lifes, artists can learn not only how to create drama but also how to explore
the deeper, quieter, less fleeting aspects of visual life.

While still life props by themselves usually can't compete with a magnificent
vista or a beautiful face, a skillful artist can arrange those props into
something equally compelling. In addition to teaching you how to create
drama, still lifes also reveal aspects of what's being painted that might be
normally overlooked. For example, if the artist paints an onion with absolute
attention and sensitivity, he or she might discover nuances to the shape of
the onion, or color shifts on the surface, or a certain delicate quality of the
skin that would never be appreciated otherwise.

STILL LIFES: WRAP-UP

A still life not only teaches about the nature of perception. It can also teach
you about drama. What makes one image exciting and another humdrum?
Those lessons, if well-learned, will help you no matter what subject you paint.

STILL LIFE STEP BY STEP

For more complex subject matter—like this complicated arrangement of flowers—your approach needs to be simplified.

Step 1 (Placement): To start this painting, I silhouetted in the big shapes of the setup using burnt sienna and ultramarine blue. The composition is built around the letter C.

Step 2 (Background): Now I wash in the background using a mix of raw umber, cadmium yellow, and a little white.

Step 3 (Shadow): Now I put in the shadow, making sure that each shadow color is a dark version of the local color.

Step 4 (Light): I paint in the lights now, loading the brush more and thereby, I hope, intensifying the drama.

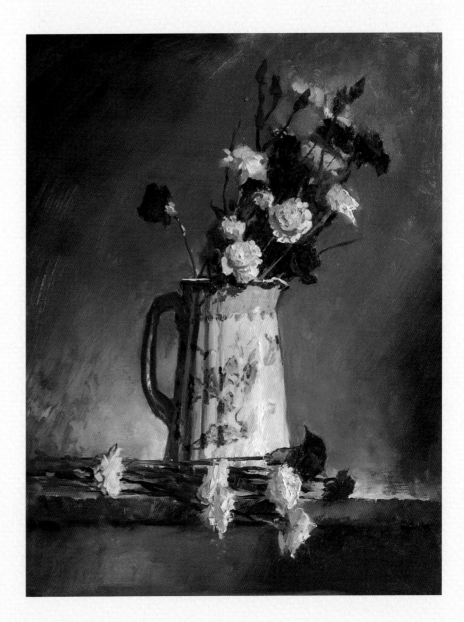

GREGG KREUTZ, *MARKET FLOWERS*, 2015, OIL ON CANVAS, 14 X 11 INCHES (35.5 X 27.9 CM).

Obviously, there's more detail here, but I tried to subordinate it to the big design idea.

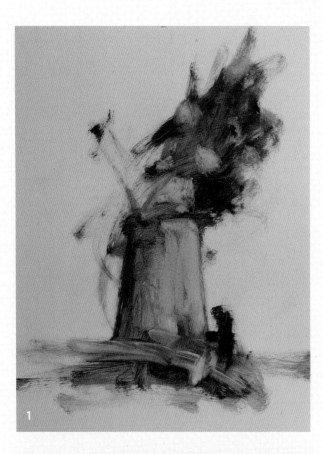

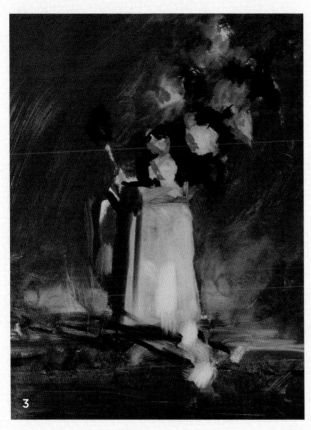

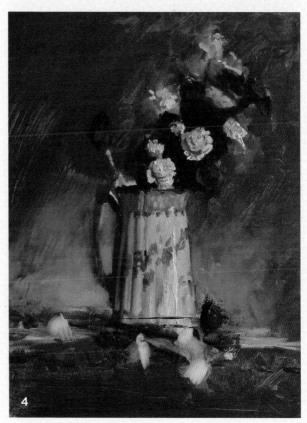

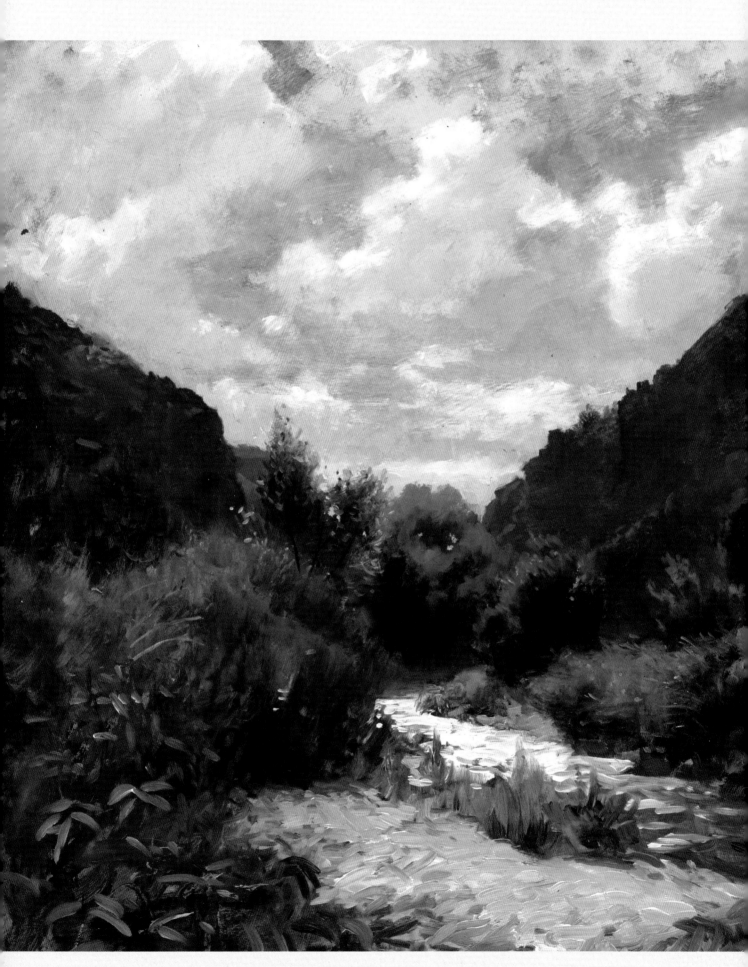

GREGG KREUTZ, *DOWN IN THE GORGE*, 1988, OIL ON PANEL, 18 X 20 INCHES (45.7 X 50.8 CM).

LANDSCAPES

Prior to the seventeenth century, oil painters thought of landscapes as background—background for religious scenes, background for portraits, background for battles. But around 1600, landscapes started to be appreciated for their own intrinsic beauty. Artists like Meindert Hobbema and Claude Lorrain revealed to the world the poetry and depth that dramatic outdoor scenes could convey. And things really heated up in 1840 with the invention of the paint tube. Prior to that, having to lug around heavy supplies made outdoor painting too laborious. With paint tubes, artists were suddenly released from the studio. As we shall see in this chapter, that wasn't entirely a good thing. While painting outside can generate exciting, bravura paintings, there are quieter painting effects that can only be achieved in the studio.

In the following pages, I'll explore both the positives and negatives of plein air painting and studio painting. But first, let's look at the essentials that are important in landscape oil painting in general.

GREGG KREUTZ, *DOWN IN THE GORGE* (DETAIL), 1988, OIL ON PANEL, 18 X 20 INCHES (45.7 X 50.8 CM).

Here I'm trying to give some feeling of form to these clouds

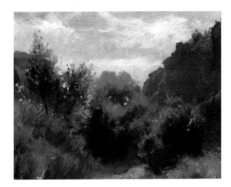

GREGG KREUTZ, *DOWN IN THE GORGE* (DETAIL), 1988, OIL ON PANEL, 18 X 20 INCHES (45.7 X 50.8 CM).

Vague as they are, I hope these loosely indicated trees communicate form in space.

GREGG KREUTZ, *DOWN THE STREET*, 2014, OIL ON PANEL, 20 X 24 INCHES (50.8 X 60.9 CM).

This was done on the spot in the Lower East Side of New York City. Throughout, I tried to keep the bigger strokes near and smaller stokes far.

THE ESSENTIALS IN ACTION: LANDSCAPE OIL PAINTING

As I said earlier in the book, the essentials apply across various genres. Though plein air and studio landscape oil painting are not totally different genres, they do differ in the painting process itself. When it comes to concept and process essentials, however, we find several that are relevant to *all* landscape painting.

CE SELECT FOR STRUCTURAL SIGNIFICANCE

Sometimes when you're outside painting, you can get so caught up in keeping the sun off your canvas, holding your palette down, and fighting off hostile insects that issues like form and structure get neglected. In the frenzy of keeping your equipment from blowing away, it's easy to lose sight of the structural concerns that need to underpin your image.

Clouds, for example, as airy and insubstantial as they may seem, still have structure. One side faces one direction, the other side another. These are the light side and the shadow side. Without showing the form of these clouds, your painted skies can end up looking like wallpaper.

Trees also need to manifest structure. Just dabbing the canvas with lots of little green strokes won't convey the true dimensionality of a tree. You need to figure out which side of the tree is lit, and which is in shadow. Trees aren't haphazard collections of accents. Each one is a complex arrangement that needs to be analyzed and shaped into a readable structure. Find the big shapes of the tree, in other words, before focusing on the little pieces.

PE FILL THE PAINTING WITH A VARIETY OF STROKES

Paintings of landscapes, like all other subjects, should be a mosaic of different kinds of strokes. This is especially true if you're trying to create the illusion of deep space. For that, you need to juxtapose near big strokes with tiny far strokes.

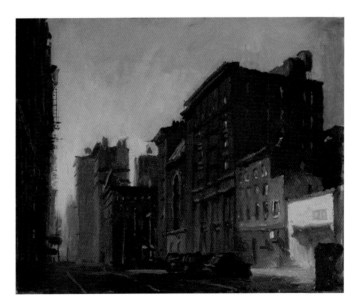

PE PAINT THE PICTURE IN A LOGICAL SEQUENCE

Placement, background, shadow, light is, to my mind, the best, clearest way to paint a painting, and this process is especially helpful with complicated subjects like landscapes.

CE DON'T JUST COPY, *SELECT* WHAT'S IMPORTANT

There's so much information outside—trees, blades of grass, distant mountains, telephone poles—that it's easy to be overwhelmed. But selecting what you deem to be important narrows the field. That selection should be based on depth, design, and drama.

In landscape painting, that means breaking down the information to simple, readable pictorial elements. And one of the best ways to learn how to do that is to paint still lifes (see chapter 4). The techniques employed in good still life painting—most specifically the showcasing of the significant—work just as well for landscape painting.

How do you showcase what's important? Here is where a hands-on familiarity with still life painting is helpful. As described in the still life chapter, prop arrangement falls into one of two organizational categories: shelf top and tabletop (see "Still Lifes: Other Painting Issues," page 90).

In landscape oil painting, as in still life oil painting, light is your primary subject. Because light attracts the eye, you need to envelop the star of the show in luminosity. This will ensure that your focal selection is where the viewer will look.

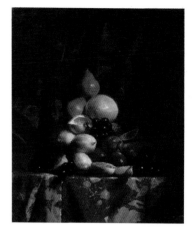

GREGG KREUTZ, *PYRAMID*, 1991, OIL ON CANVAS, 20 X 16 INCHES (50.8 X 40.6 CM).

Here's a typical shelf-top set-up. Notice the narrow top plane.

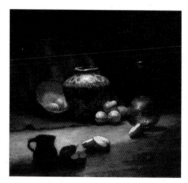

ABOVE: GREGG KREUTZ, *ON THE TABLE*, 2015, OIL ON LINEN, 25 X 27 INCHES (63.5 X 68.5 CM).

In this tabletop composition, the props are seen from above and are organized in a rightward curving movement, starting in the lower left corner and climaxing at the upper left.

LEFT: GREGG KREUTZ, *ARLES CAFÉ*, 1993, OIL ON LINEN, 23 X 29 INCHES (58.4 X 73.6 CM).

For this dusk café scene, I used a shelf-top composition as my guide—getting material on the left side of the canvas to lead the eye from darkness to the cluster of lit umbrellas, tables, and people on the right side.

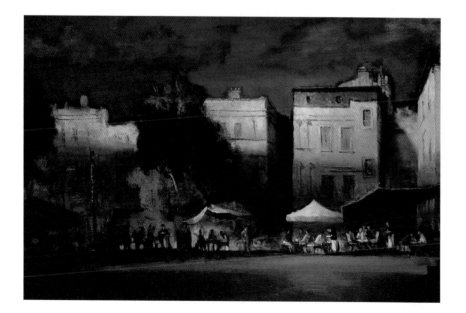

RIGHT: GREGG KREUTZ, *UP FIFTH*,
1998, OIL ON LINEN, 25 X 30 INCHES
(63.5 X 76.2 CM).

In this cityscape, I used a tabletop
composition (where we're somewhat
looking down on the action) to get
the eye to move into the canvas.
Like the still life illustration *On the
Table* (page 103) that used a dark
form (the black pitcher in the lower
left corner) as the pivot-point of the
action, for this cityscape I used a hot
dog vendor's stand as the picture's
kickoff. A dark shape in the lower
left-hand corner forces the eye into
the interior of the picture.

BELOW: GREGG KREUTZ, *FRENCH
SQUARE*, 1999, OIL ON CANVAS,
16 X 20 INCHES (40.6 X 50.8 CM).

In this painting, I made the lit areas
brighter by darkening the buildings
on the right.

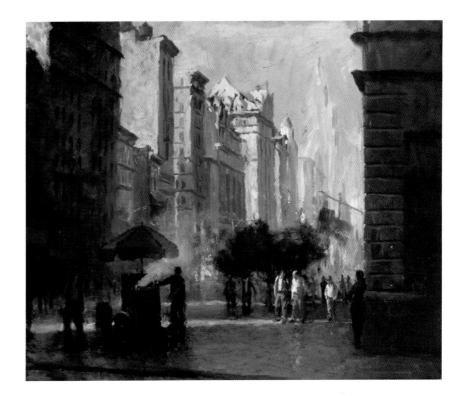

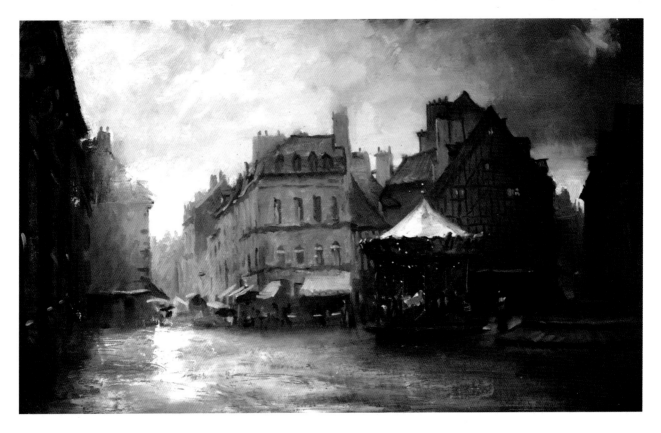

CE USE SHADOW TO BRIGHTEN THE LIGHT

In the same way that a still life painter might put shadow over a background cloth to make what's in the back less engaging, so too might a landscape painter throw a shadow over some foreground area so that it doesn't compete with the main event.

If everything in the landscape looks lit, nothing looks lit. Putting in shadow strengthens the light. And more often than not with landscape, the source of the shadow doesn't need to be explained. A foreground shadow could be caused by a passing cloud or an unseen hill or a big tree. The main thing is, because the eye is drawn toward light, foreground shadow helps pull the eye away from the bottom of the canvas.

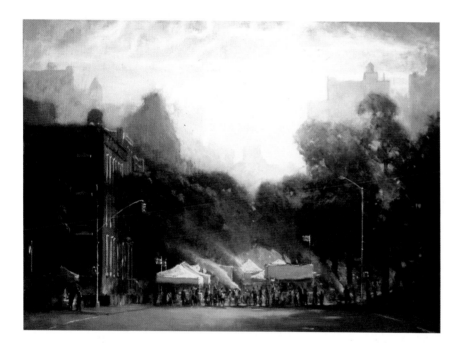

GREGG KREUTZ, *STREET FAIR*, 1998, OIL ON LINEN, 24 X 30 INCHES (60.9 X 76.2 CM).

Just as I would in a still life, I used shadow here to hold the eye in the center of interest.

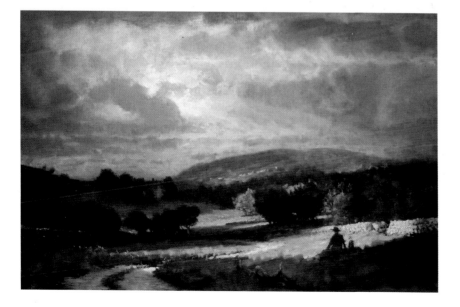

GREGG KREUTZ, *IRISH HILLS*, 2014, OIL ON CANVAS, 27 X 36 INCHES (68.5 X 91.4 CM).

Here I'm using shadow to showcase the significant. Because of the foreground shadow, our eye goes to the interior of the picture.

CE MAKE LIGHT THE MAIN EVENT

Like still life, portrait, and figure, what's important in a landscape needs to be celebrated with light. And not only that, but since the sun is the light source outside, you have to be alert to the characteristics of light at the time of day you are depicting. The quality of late afternoon light, for example, is different from midday light—it's oranger and more horizontal—and that kind of variation has to be correctly depicted.

PE DON'T LOCK INTO ANY PROCESS TOO RIGIDLY

A landscape example of this warning is the rule "if you want something to recede, make it cool." Even though cooling things as they recede is generally a good idea, white clouds as they recede, instead of getting cooler, get warmer. In terms of your painting process, that means you need to put more orange in faraway clouds. This warming effect is due (I'm told) to the cumulative density of dust particles in the air. It serves as a good reminder that we shouldn't follow rules too slavishly.

GREGG KREUTZ, *MARKET AFTERNOON*, 2001, OIL ON CANVAS, 24 X 32 INCHES (60.9 X 81.2 CM).

Here are some heated clouds—they were warmed with yellow and orange—in the far distance.

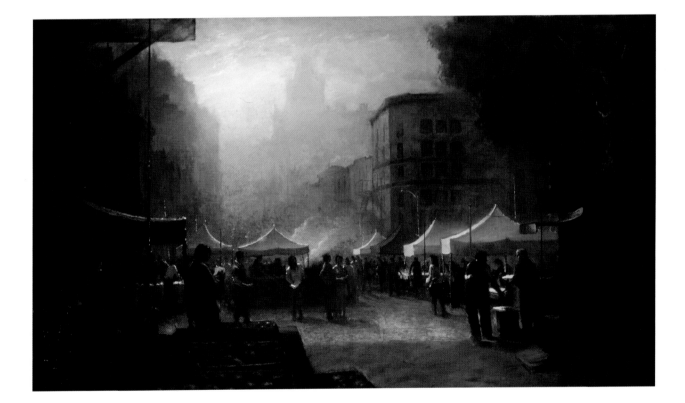

TWO TYPES OF LANDSCAPE OIL PAINTING: PLEIN AIR AND STUDIO

The rest of this chapter is divided into two parts: plein air landscapes and studio landscapes. They are different animals. Plein air painting demands a speedy, roll-with-the-punches approach that, if the conditions are favorable, can create an exciting look on your canvas. With a studio landscape, on the other hand, you can pursue a quieter, moodier effect with more time to fine-tune the drama. Both types of landscape are worthy, and both can be compelling, but each has its own distinct process.

PLEIN AIR LANDSCAPES

In my experience, there are two types of plein air painters: Equipment Aces and Improvisation Specialists. Equipment Aces have an all-purpose collapsible umbrella, a light weight wheeled carrying rig, back up supplies, and a state-of-the-art easel for locking in their canvas. Improvisation Specialists tie their canvas to a tree. Unfortunately, I fall more into the tree-tying category. I say "unfortunately" because following that approach has caused me, in my plein air painting excursions, to find a way to forget at least one thing every time I go out. Once, for example, in Nepal I spent hours carrying my equipment up to what was supposed to be one of the great paintable views of the Himalayas only to discover that I'd forgotten my canvas.

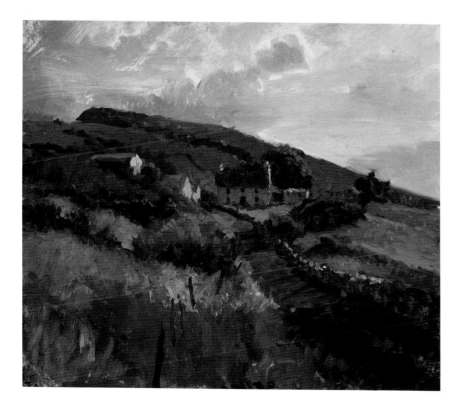

GREGG KREUTZ, *UP THE LANE*, 2006, OIL ON PANEL. 12 X 14 INCHES (30.4 X 33 CM).

This piece was painted on the spot in Ireland. I painted a variation of this subject as a larger studio landscape (see page 39).

PLEIN AIR LANDSCAPE CHALLENGES

The biggest challenge to plein air painters is finding a spot. Unlike a still life where you can organize the props to your liking, or a portrait where you can tell the subject to, say, lean on one arm, in outdoor painting you can't physically rearrange what you're looking at; you've got to go out there and hunt for the perfect site. My advice after forty years of plein air experience is—and this is important—whenever you find something that looks like it could be a painting, paint that. Don't be fooled into thinking *This looks good, but there must be even better stuff around the bend*. There never is. If you go trudging off, wandering around trying to find something even more paintable, you'll eventually trudge back to the first site. Every time. The first one's always the best.

GREGG KREUTZ, *NOTRE DAME*, 2003, OIL ON LINEN, 18 X 24 INCHES (45.7 X 60.9 CM).

This was done on the spot right next to the Seine. While I was there, I was determined to not be bothered by the fact that this very scene has been painted thousands of times. I just painted away. The biggest challenge here was getting the wet painting back to my hotel.

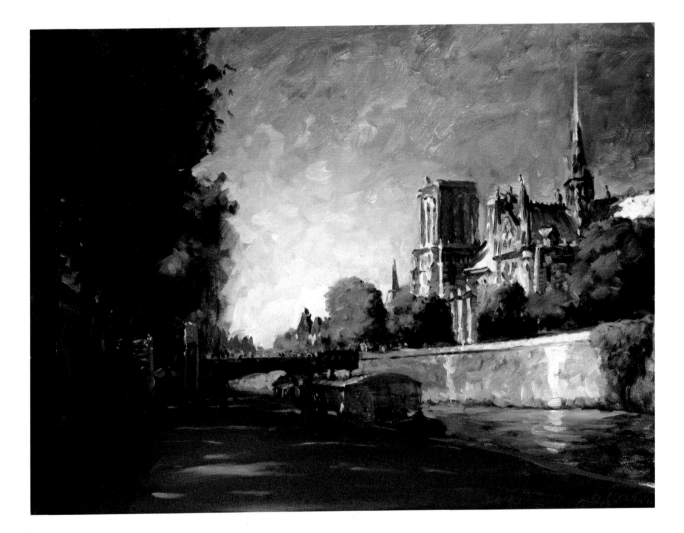

Dealing with Physical Demands

In the world of oil painting, plein air painting is the most physically demanding. Lugging equipment to the site, dealing with chatty people, not getting blown over by wind—these and many other challenges can make aspiring outdoor painters throw up their hands and head back to the studio. However, in my experience, if you can keep your spirits up, the rewards of painting outside well outweigh its discomforts.

Coping with and Utilizing Outdoor Light

Lighting is one of the biggest challenges for plein air painting. If it's a sunny day, you want good light on your subject matter; however, you also need good light on your canvas—but not too much light. Sun directly on canvas causes trouble because it distorts how brightly you're painting. What you think is a bright piece of paint when lit by the sun may turn out to be middletone when you get it indoors. To avoid this, you need to turn your canvas away from the sun. Putting it in shadow, though, can make your canvas too dark to see what you're doing. A shade tree or awning can solve the problem, but sometimes they're unavailable. Umbrellas might help, but in my experience, umbrellas can too easily blow over. What it boils down to is that each new outdoor painting is a logistical challenge that needs to be met with spontaneous creativity—or to put it another way, good luck!

GREGG KREUTZ, *ASSISI*, 2013, OIL ON PANEL, 12 X 16 INCHES (30.4 X 40.6 CM).

Here I found a perfect spot—in the shade, off to the side, and with a nice view of this beautiful Italian town. For this one, I used a limited palette: alizarin, ultramarine blue, cadmium yellow, and white.

GREGG KREUTZ, *PARIS STREET*, 1997, OIL ON CANVAS, 18 X 22 INCHES (45.7 X 55.8 CM).

In this overcast scene, I zeroed in on the awnings and the light shimmering off them from above, making sure that areas directly below them were pushed into dark shadow.

GREGG KREUTZ, *TREE IN THE CITY*, 2009, OIL ON PANEL, 9 X 14 INCHES (22.8 X 35.5 CM).

This painting was done on the spot, and in it, I tried to capture the dynamic of the tree against the building while staying within the necessarily low drama of steady overcast light.

Overcast light, while helpful for keeping a steady, cool light on your canvas, does present challenges to the plein air painter. Unlike sunlight, which you can use to showcase primary subject matter, overcast light has an evenness that doesn't allow for a lot of dramatic contrast. Instead, if what you're painting is lit by a cloudy sky, the best strategy is to simply showcase the steadiness of the light from above. That look of calm, even illumination, while not as dramatic, has its own subtle power. This is an especially effective strategy when painting cityscapes.

Selecting a Subject

Another challenge for plein air painters is, of course, figuring out *what to paint*. Because there are so many options—beautiful trees, picturesque rocks, interesting houses, dynamic mountains, and so on—you can easily be overwhelmed and stand there, brush in hand, unable to make a decision. This is where a still life background is useful. Instead of being shut down by the amount of options, a still life veteran prioritizes the movement of light and makes *it* the main event. Then the field can be narrowed. With capturing the drama of light as your goal, no matter how interesting a tree or a rock or a building may be, if it doesn't contribute to the light excitement, it won't make the cut. "Interesting" isn't enough; the painter wants things that dynamically contribute to the light intensity.

GREGG KREUTZ, *SIXTH AVENUE*, 2013, OIL ON PANEL, 16 X 18 INCHES (40.6 X 45.7 CM).

The dark sky helped intensify the look of the lit buildings.

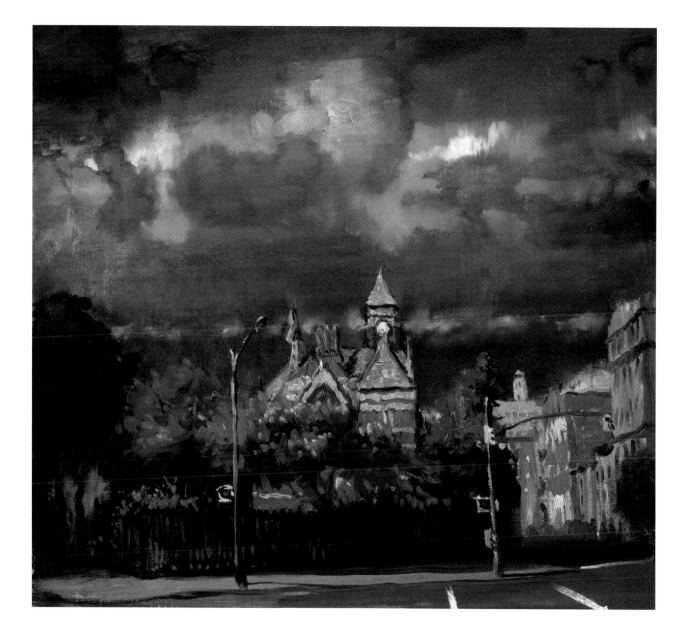

PAINTING THE PLEIN AIR LANDSCAPE

Going outside to paint takes a fair amount of nerve. It is, after all, a public act, and as such the painter can become subject to all sorts of intrusions, including but not limited to people making artistic suggestions, showing you their portfolios, asking directions, telling you their uncle used to paint, and, most common of all (but least likely to lead to anything lucrative), asking how much you want for the picture.

PLEIN AIR LANDSCAPE REWARDS

For one thing, you're outside! In today's insulated culture, it's good to have an excuse to be out in the fresh air. Yes, the conditions are ever-changing; yes, the sun might go right behind a cloud when you least want it to; and yes, people may rush over to tell you that their uncle used to paint. However, none of that outweighs the excitement of getting a beautiful piece of outdoor reality onto your canvas. It's the thrill of the chase. Ultimately, asking plein air painters why they want to paint outside is like asking marathon runners why they don't take a bus.

GREGG KREUTZ, *FARMER'S MARKET*, 1993, OIL ON LINEN, 18 X 24 INCHES (45.7 X 60.9 CM).

Here's another view of my favorite painting site—the Union Square Farmer's Market. This time I was trying to capture a moody dusk effect.

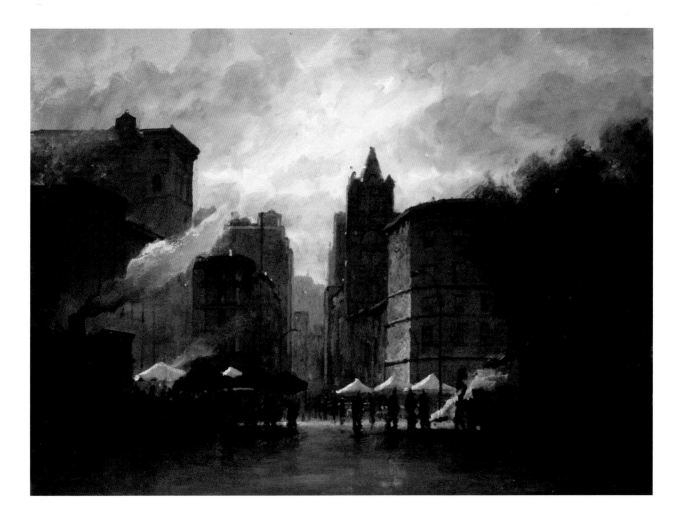

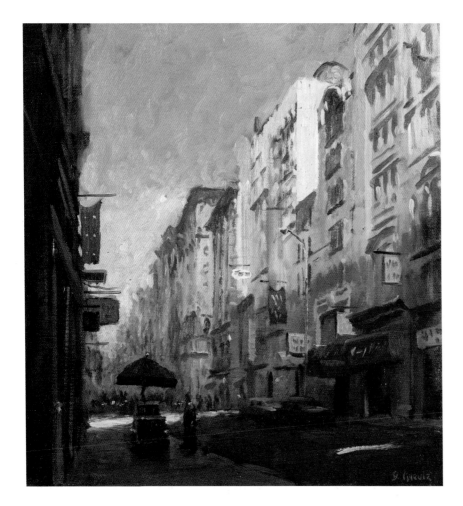

GREGG KREUTZ, *EAST SEVENTEENTH STREET*, 1994, OIL ON LINEN, 20 X 16 INCHES (50.8 X 40.6 CM).

What could be a better plein air site than what I see when I step out of my building?

Given all the challenges I mentioned earlier—wind, insects, sun (I didn't even mention sudden downpours)—you might well ask, *Why not just paint from photographs?* The answer is that photographs kill inspiration. They're either so dull and flat that they're uninspiring, or they're so beautiful (rarer) that they don't look like they can be improved upon. They're a closed system. Yes, it's easy to copy from them, but there's a price to pay.

In today's mechanized world, a world increasingly dominated by computers, tablets, smart phones, widescreen TVs, drones, and so on, we're in danger of becoming just an adjunct to technology, a tagalong. Painting directly from life helps to sever that connection; it helps to, in effect, pull the plug. In a world of secondhand thrills and secondhand emotion, plein air painting is a way to access firsthand experience. It's you and your subject matter. With photographs, it's you, the photograph, and the subject of the photograph.

I've found that the very trickiness of the conditions in outdoor painting can intensify what shows up on my canvas. Because time is limited and every stroke needs to count, I paint more deliberately and more urgently when I'm outdoors. That strengthened focus can pay off in picture intensity. What might be missing in terms of finesse is often outweighed by the focused energy on my canvas, which is a reward in and of itself.

PLEIN AIR LANDSCAPE STEP BY STEP

Sometimes outdoor conditions force you to compress the sequence. In the following example, I had to jam together a few steps.

Step 1 (Placement): I painted this plein air landscape at the South Street Seaport in New York City, standing out on a pier looking back at the boat and dock. With burnt umber, ultramarine blue, and Venetian red, I roughed in the big shapes and established the color world. (*Color world* here means the general color tonality to be used. In this painting, I'm keeping it in the rusty-orange-brown earth-tone family as opposed to a cool blue-purple family.)

Steps 2, 3, and 4 (Background, Shadow, and Light): Next, I went after the heart of the painting. I got the red—a modified cadmium red medium—of the boat in place and put in the bright lights. This is something of a combination of three steps—background, shadow, and light. Because of time constraints, I wasn't able to articulate them as individually as I usually do.

Step 5 (Finishing): Now I tried to intensify what was on the canvas. I realized that the red of the boat needed to be pushed even farther, so I hit it with everything I had (now straight-out-of-the-tube red). To finish the painting, I tried to hang on to that initial energy and not defuse its impact by throwing in a lot of competing elements. For example, when it was time to paint the row of buildings on the wharf, I threw a made-up shadow over the upper part of the buildings to hold the eye closer to the boat.

GREGG KREUTZ, *SOUTH STREET SEAPORT*, 1995, OIL ON LINEN, 16 X 20 INCHES (40.6 X 50.8 CM).

1

2-4

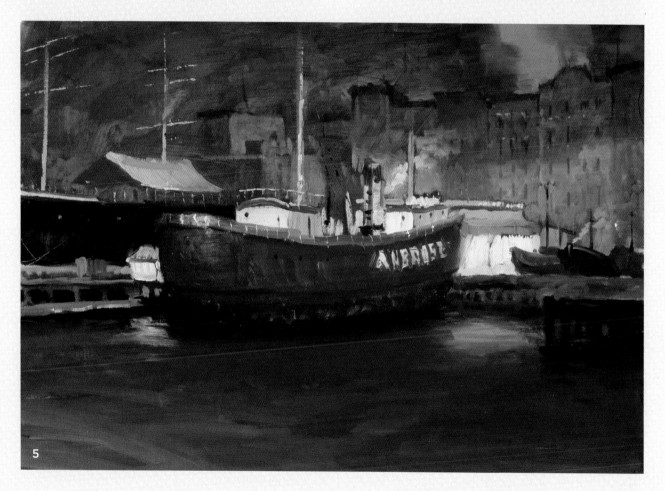

5

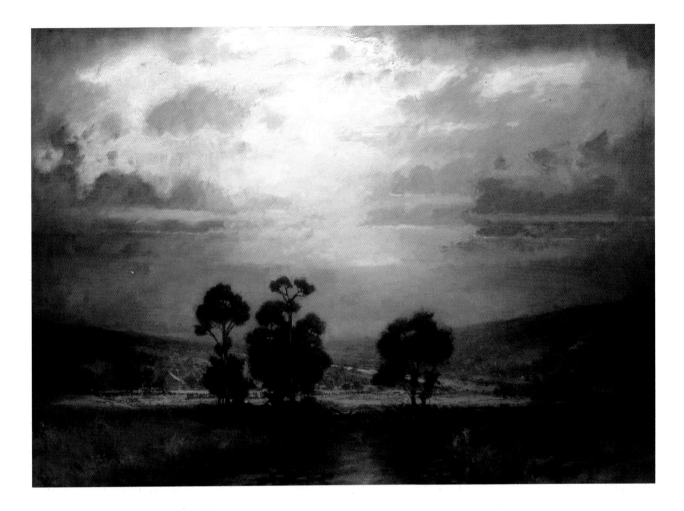

GREGG KREUTZ, *THREE TREES*, 2007, OIL ON CANVAS, 30 X 38 INCHES (76.2 X 96.5 CM).

I developed this painting from pencil sketches I did in upstate New York. It was painted entirely in the studio. For me, the fleeting light effect could be finessed in a controlled setting only.

STUDIO LANDSCAPES

I'm calling a landscape painted indoors a *studio landscape*. George Innes— in my view the greatest of all landscape painters—was an artist who exclusively painted studio landscapes. He did charcoal sketches outside, but his oil paintings were all created in his studio.

After all my heavy promotion of the importance of painting outdoors, I hope it doesn't sound too contradictory to say that beautiful paintings can also be painted exclusively inside the studio. My thinking is that while you lose a certain amount of freshness and spontaneity by painting indoors, what you gain is a visual exactness of time that's unattainable on site. *Exactness of time* here means that the painting can be about a very specific moment. It might be what's just seen as the sun tucks behind a tree, it might be what happens at dusk when the light's about to disappear, but it's a very precise, necessarily fleeting effect. And because this effect is transitory, painting outdoors doesn't offer you enough time to fine-tune it on your canvas. Paintings done outdoors tend to be about longer effects—afternoon sun on some distant hills or an overcast city street. But if you're trying to get the drama of dusk just as the sun is going down, being on the spot doesn't give you enough time to work all that out.

STUDIO LANDSCAPE CHALLENGES

One of the biggest challenges for the studio landscape artist is authenticity. You want to make sure that you're not painting a generic version of the outdoors. Achieving that is easier if you already have a deep familiarity with how light and shadow behave. Correctly rendering that interaction can give an authentic-looking resonance to the painting. And I believe the best way to learn the nuances of light and shadow is painting still lifes. Again, figuring out one genre can help you figure out another.

GREGG KREUTZ, *FRENCH FARM HOUSE*, 2010, OIL ON LINEN, 24 X 30 INCHES (60.9 X 76.2 CM).

This was painted in my studio from pencil sketches done in Burgundy.

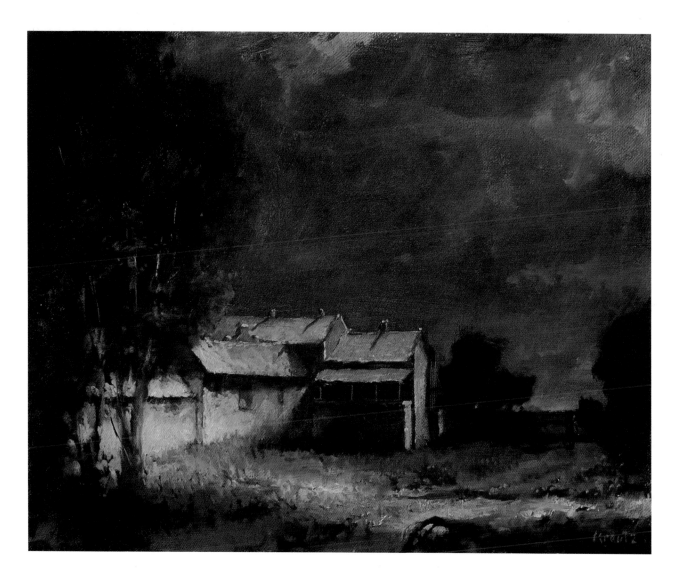

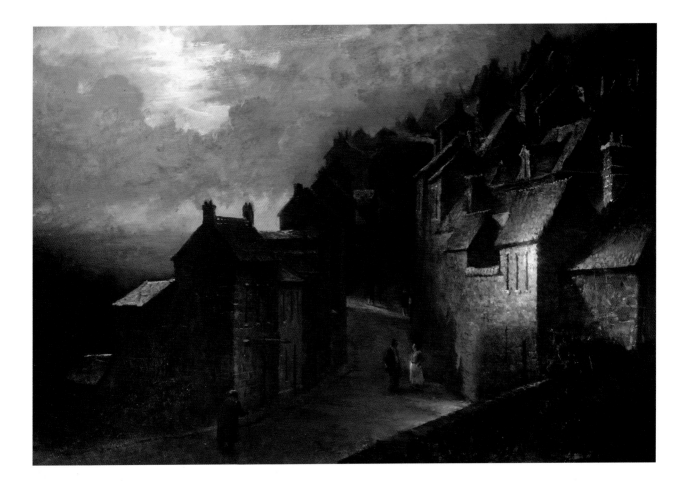

GREGG KREUTZ, *LAST LIGHT*, 2013, OIL ON CANVAS, 30 X 38 INCHES (76.2 X 96.5 CM).

This landscape was painted entirely from my imagination, and for a while, it seemed to have become my life's work. The sky was dark, then I lightened it, then I added smoke, then I took it out, then I put it back.

Selecting Source Material

Of course, one of the most challenging aspects of painting the studio landscape is finding source material. As I said earlier, as far as painting is concerned I'm antiphotograph, so in my work I rely on either landscapes I first painted on site, pencil sketches, or my imagination. Plein air paintings are my preferred source. With them, I can take off from whatever I did outside, build on it, and, by increasing the value contrast, heightening the color, and intensifying the light effect, push the drama further.

Doing a painting completely from the imagination allows for an expressiveness that might not otherwise occur. There's a catch, though. The further you get from direct observation of reality, the greater the danger that you will be unable to make meaningful choices. That is, if your painting is completely made up, it can be hard to decide whether to put the tree on this side or that side. With an imagined landscape, you might make the sky dark and feel that it looks good, but then, maybe in a different mood, you might decide the sky would look better lighter. To avoid this sort of flip-flopping, it's important to commit to a vision.

I've had imaginary landscapes on my easel for months that changed and evolved and morphed without ever reaching the finish line because I never had a clear vision of what exactly I wanted. Ultimately, committing to a vision is the only way out of such endless floundering.

PAINTING THE STUDIO LANDSCAPE

Painting the landscape in the studio allows the artist to finesse the painting, to go after quieter, subtler effects than what can be done outdoors. Inside, under a steady cool light, the artist can fine-tune delicate effects. And the studio-bound artist doesn't have to entirely depend on sketches or memories or imagination. I've done studio landscapes where I've lugged a tree branch or some rocks into the room that I could work from (like doing a still life) and thereby gave the painting an extra dose of reality.

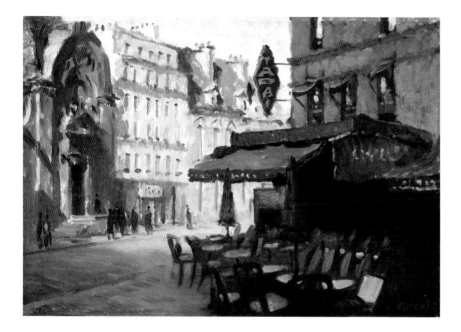

GREGG KREUTZ, *EMPTY CAFÉ*, 2001, OIL ON PANEL, 9 X 12 INCHES (22.8 X 30.4 CM).

This café scene was painted on site in Paris. I painted it quickly, trying to get the feeling of the place in addition to whatever specific information I could get onto the canvas.

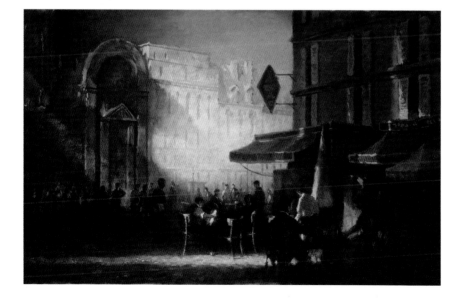

GREGG KREUTZ, *PARISIAN LIGHT*, 2002, OIL ON CANVAS, 24 X 34 INCHES (60.9 X 86.3 CM).

Back in the studio, I used the on-site painting as a kickoff to a stronger, more dramatic vision. By throwing shadows around, warming up the light, elongating the rectangle, and adding people, I pushed the sense of an immediate, if fleeting, light effect.

STUDIO LANDSCAPE STEP BY STEP

With studio landscapes, you can be very abstract when beginning your painting. Sometimes just a vague blur of texture and color is all that you need to get the picture going. Then after you've established the color world and the design arrangement, you can start to introduce more recognizable elements.

Step 1 (Placement): The abstract beginning of the picture is derived from a view I saw during a walk in the woods. Very broadly (with brush and paper towel), I wash in the design and color world using ultramarine blue, cadmium yellow, and transparent red oxide.

Step 2 (Background): Pushing the start a little further, I established the dark framing trees at the edges.

Steps 3 and 4 (Shadow and Light): Time to make the content more overt. I started giving the trees a little more specificity and built up the light drama in the center. For this effect, I painted shadow and light more or less simultaneously.

GREGG KREUTZ, *LIGHT IN THE WOODS*, 2010, OIL ON PANEL, 9 X 12 INCHES (22.8 X 30.4 CM).

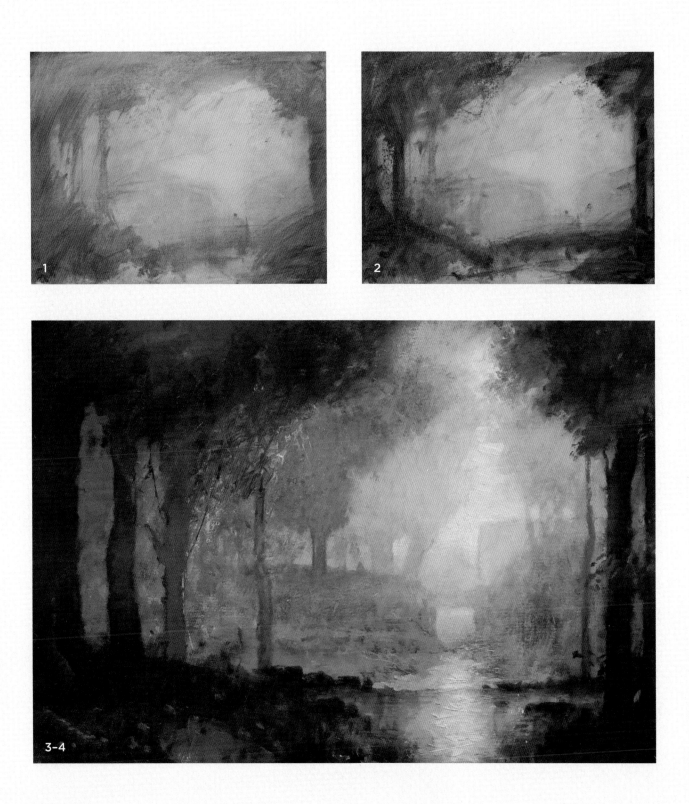

STUDIO LANDSCAPE REWARDS

The rewards of painting a studio landscape are significant. When you're painting a landscape indoors, you have more control over subtle time effects, and you also get an inherent emphasis on abstraction.

Working up new paintings from plein air landscapes is a good way to rethink and finesse issues that you didn't have time to nail on site. When you're back in the studio working on a new canvas, difficult rendering issues can be given more focused attention. Light effects, too, can be both intensified and made more subtle.

Looking at what you're depicting—trees, mountains, telephone poles— often makes you evaluate what's on the canvas solely in terms of how much it looks like those things. But ultimately, verisimilitude will only take your picture so far. Accuracy is important, but if the painting is to have real visual power, it needs to be about something more than accuracy. In effect, it needs to have an underlying abstract design that holds the picture together and leads the eye to the significant elements. A landscape started and finished in the studio allows you to emphasize abstraction from the get-go. In fact, the picture can start in complete abstraction with no evidence of the physical subject on the canvas. If you hang on to that abstraction all the way through, your painting will have a two-pronged dynamic. It will be both a truthful depiction of visual life and a beautiful abstract design arrangement. And it's that kind of double power—that two-for-one impact—that can lift the painting out of the literal and into the transcendent.

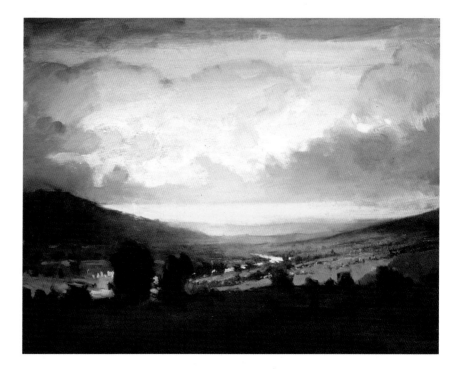

GREGG KREUTZ, *FRENCH HILLTOP*, 2003, OIL ON LINEN, 18 X 24 INCHES (45.7 X 60.9 CM).

Here's a studio landscape done from a sketch I did on site. A fleeting light effect was what I was after.

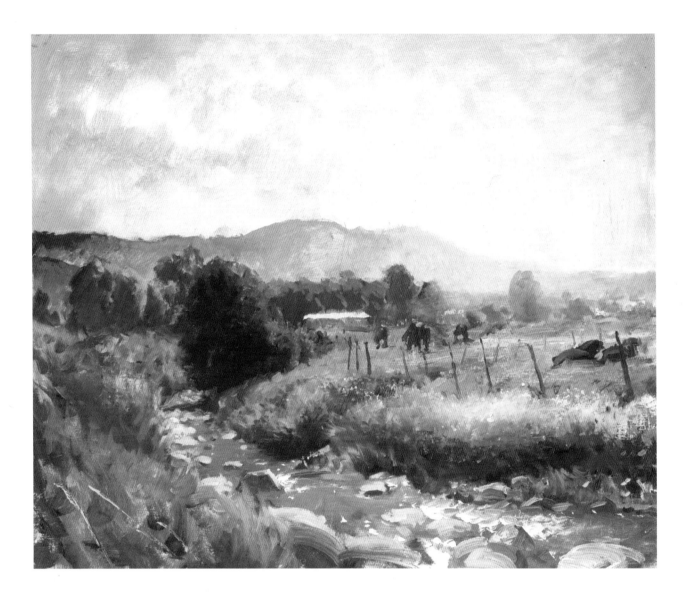

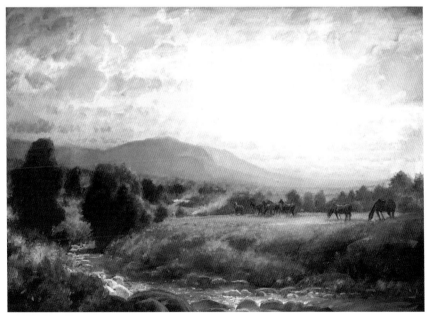

ABOVE: GREGG KREUTZ, *TAOS VIEW*, 1989, OIL ON PANEL, 20 X 24 INCHES (50.8 X 60.9 CM).

This was painted on the spot near Taos, New Mexico. I was working very quickly trying to capture the light effect and had no time for finesse—not even time to prevent those cows from looking like walruses.

LEFT: GREGG KREUTZ, *TAOS HORSES*, 1990, OIL ON CANVAS, 30 X 38 INCHES (76.2 X 96.5 CM).

In the studio version, I solved the cow problem by turning them into horses, then I quieted some of the brushwork in the sky (meaning I softened edges and smoothed transitions), and gradually pushed the picture toward a statelier, grander effect.

This first one was painted on the spot in the farmer's market right outside my studio on Union Square. I like the way the energy of the process shows up on the canvas.

PLEIN AIR VERSUS STUDIO: GAINS AND LOSSES IN LANDSCAPE OIL PAINTING APPROACHES

There are plusses and minuses in both types of landscape painting—outside you gain the energy of speed and economy, inside you gain the strength of greater resolution and subtler lighting effects. The two paintings on this page might help illustrate those gains and losses.

Finally, opposite are two paintings of the Seine, one painted on the spot, one painted in the studio. As you see, even though they describe the same scene, they express very different feelings. The first one might be seen as communicating an offhand, pedestrian, maybe even mundane feeling. The second is trying for a bigger effect: dramatic, majestic, and, hopefully, heroic.

LANDSCAPES: WRAP-UP

Landscapes are a big subject. Whether done in the studio or on site, they demand a clear vision and strong sense of depth. To be able to fully connect to this complicated subject, I recommend becoming familiar with both plein air and indoor landscape painting. That way you'll have a fuller understanding of how sky and land intersect, and a better feel for air and space.

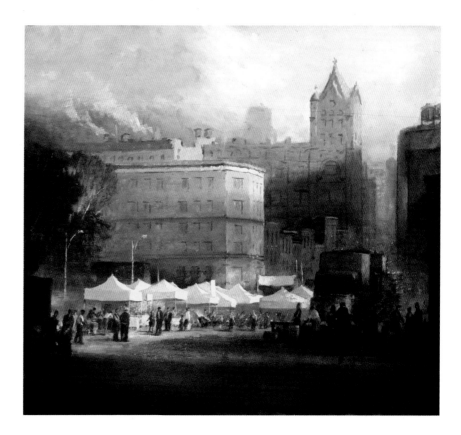

Because this one was painted in the studio, I had more time to fine-tune the light effects and orchestrate the color movement. In comparing the two of them now, it's possible that all that finessing cost me some visual excitement.

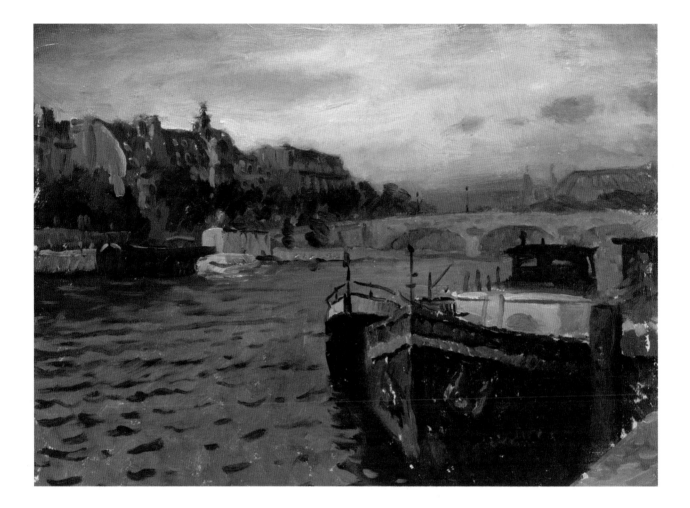

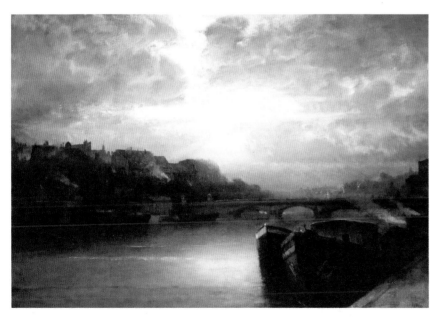

ABOVE: GREGG KREUTZ, *THE SEINE*, 2004, OIL ON LINEN, 9 X 12 INCHES (22.8 X 30.4 CM).

This painting was made at the water's edge under an overcast sky, and there wasn't much of a light effect to work with. When I got back to the studio, I started a new, bigger painting.

LEFT: GREGG KREUTZ, *LIGHT ON THE WATER*, 2005, OIL ON LINEN, 30 X 40 INCHES (76.2 X 101.6 CM).

On this one, I was able to fine-tune a dramatic light effect and thereby give the picture a more purposeful look.

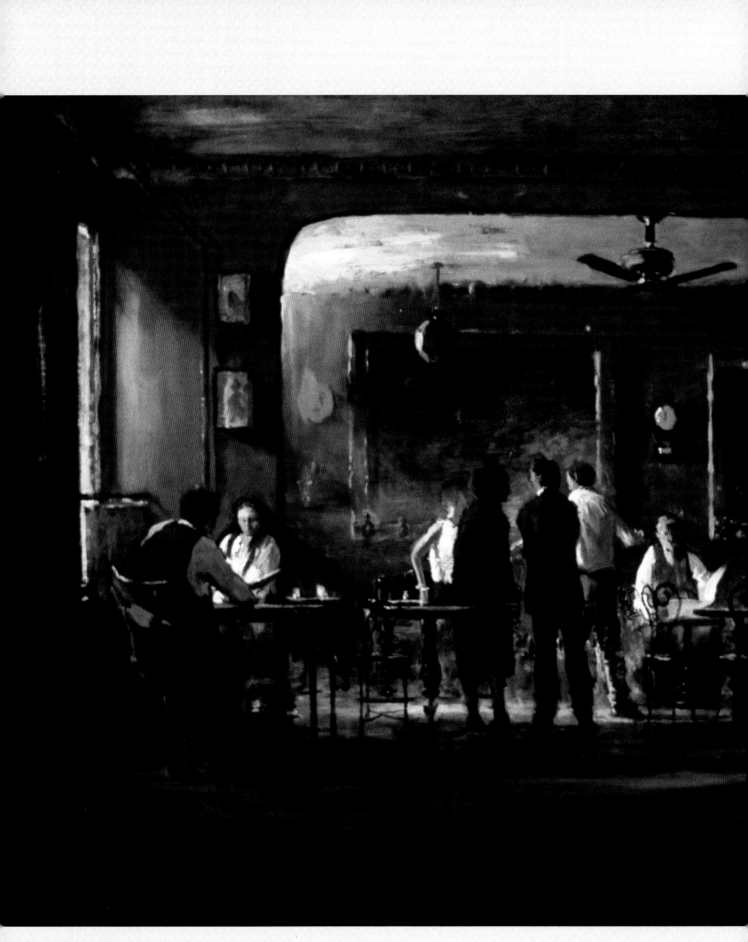

GREGG KREUTZ, *CAFÉ REGGIO*, 1998, OIL ON CANVAS, 20 X 26 INCHES (50.8 X 66 CM).

INTERIORS

To paint a successful interior requires the perseverance of a landscape painter, the sensitivity of a still life painter, and—if you decide to put people in your painting—the drawing skill of a figure painter. In other words, interiors are hard.

THE ESSENTIALS IN ACTION: INTERIOR OIL PAINTING

Oil painting essentials apply to all genres, but some are more relevant to certain subjects than others. Here are the essentials that are especially applicable to interiors.

CE SELECT FOR DEPTH

A high priority in interior oil painting, as in all representational painting, is depth—that is, making sure the interior you're depicting has a feeling of space. And once again, the solution is having the visual energy of the near meet or trump the visual energy of the far. This doesn't mean that the most excitement is, say, at the bottom of the canvas. If that were the case, the viewer wouldn't be pulled into the interior of the picture. But for depth to work effectively, there has to be something strong enough in the foreground to cue the eye that it is near, as in the painting below.

GREGG KREUTZ, *ART STUDENTS LEAGUE STUDIO*, 1997, OIL ON CANVAS, 22 X 26 INCHES (55.8 X 66 CM).

In this painting, I gave a lot of color and texture to the near palette so that it would come forward. While the painter in the middle distance is more brightly lit than the model in the far distance, he's not as vividly lit as the foreground material.

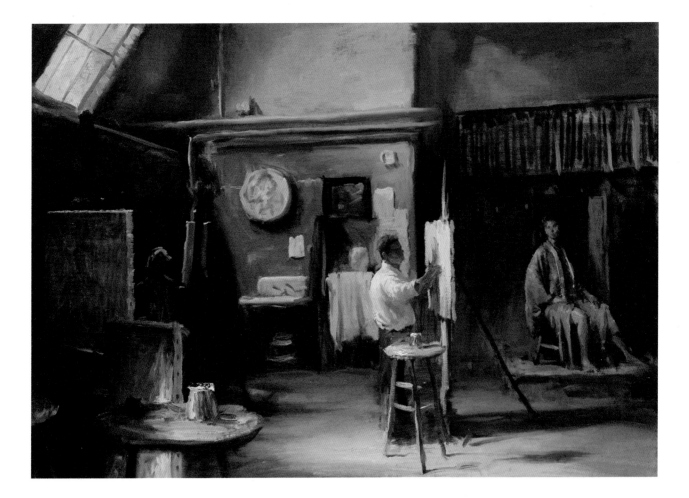

CE SELECT FOR HUMANITY

While you don't always have to place people in an interior, if you elect to put them in, it's usually a good idea to prioritize their position. This means you don't want humans to get lost in the shuffle. A painting where a couch, say, is more exciting than whoever is sitting on it, is something only an interior decorator could love.

CE MAKE THE VALUE MOVE FROM DARK TO LIGHT OR FROM LIGHT TO DARK

For drama to happen, you need a feeling of light moving across space. The whole room can't be lit with the same intensity. Sometimes the light is brightest near the light source; sometimes it slowly brightens as it moves across the room.

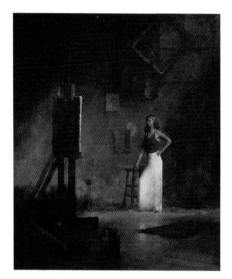

ABOVE: GREGG KREUTZ, *DARK STUDIO*, 2013, OIL ON CANVAS, 24 X 21 INCHES (60.9 X 53.3 CM).

This studio scene has a fair amount of studio content, but I subordinated most of that content by washing it down with a thin coat of raw umber. That way the viewer's eye goes directly to the woman looking at the canvas.

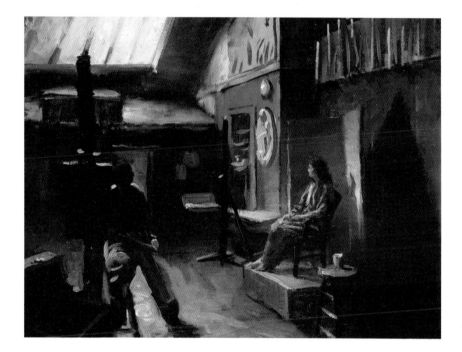

LEFT: GREGG KREUTZ, *ARTIST AND MODEL*, 2014, OIL ON CANVAS, 20 X 24 INCHES (50.8 X 60.9 CM).

I painted this in Studio Seven at the Art Students League. Because it was done on the spot and time was short, I went for a quick, energetic look.

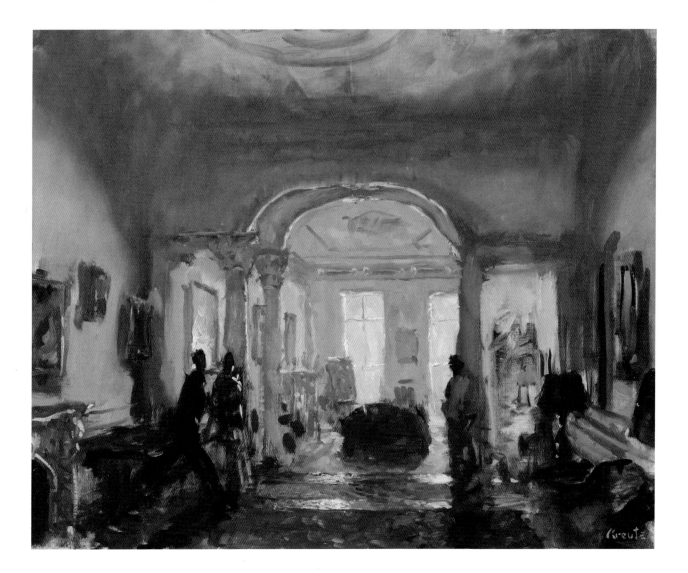

GREGG KREUTZ, *SALMAGUNDI CLUB*, 2013, OIL ON PANEL, 18 X 22 INCHES (45.7 X 55.8 CM).

Painted on the spot in the Salmagundi Club in New York, I had the problem of looking into the light source and turning my head back and forth. I was still so far away from the light source that to see exactly what was happening on the canvas, I had to occasionally flip on the overhead chandelier (it's a fancy club).

CE MAKE LIGHT THE MAIN EVENT

Lighting is one of the biggest challenges for interior painters. It's rare that the lighting in an interior space will be optimal. Lighting requirements for oil painters are (1) good light on the subject, (2) good light on the canvas, and (3) good light on the palette. With interiors, in my experience, it isn't often that you get all three. Interior painters typically have to settle for two and sometimes just one optimal requirement. Often, for example, the view selected means that the artist has to look directly into the light source. Doing so means facing a window and that, of course, poses the challenge of how to make the light in the window look bright without making it the star of the show. Typically, since aspects of the room you've selected are presumably more what you want to showcase, you have to figure out a way to give force to the light while at the same time making the subject look significant. And, as often as not, this problem has to be solved backward. That is, to get light on your canvas, you have to turn the easel so that it faces the light source and that means that while you're working on it, your back

faces what you're depicting. In such circumstances, there's inevitably a lot of back-and-forth head turning.

Other interiors, of course, are less about the space than the people in the space. For more on this and the use of "narrative" in painting, see "Interiors: Other Oil Painting Issues" on page 134.

CE MAKE THE SUBJECT MOVE

As I discussed in the portrait and figure chapters, people in paintings need to look animated—not intensely animated, but slightly-to-somewhat in motion. That feeling of movement in a settled space gives a dynamic to the scene.

In the studio interior below, I had been trying unsuccessfully to have the model look relaxed in the space. I wanted a certain casual, unstudied quality—a feeling of fleetingness—but the more I painted her, the more formal, and the more static, she seemed. It happened that on a break she took a moment to bend over and scratch her ankle and that gesture gave me just the amount of unstudied ease that I needed in the painting.

GREGG KREUTZ, *NICA*, 2013,
OIL ON CANVAS, 22 X 24 INCHES
(55.8 X 60.9 CM).

As so often happens when painting people, the unforced gesture communicates the most. That's why it's sometimes not a good idea to make the model stay too rigidly in the original pose.

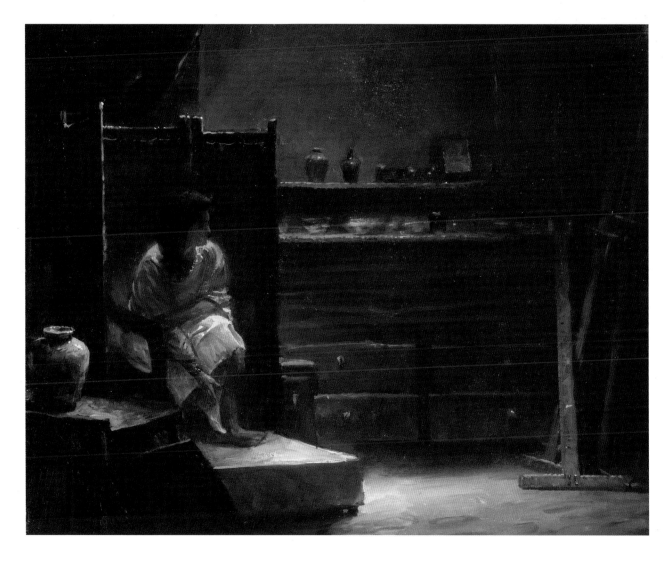

CHALLENGES

Because interiors are typically full of geometric shapes and lines (pictures on the walls, windows, and so on), perspective discrepancies stand out more flagrantly in this genre than in others. So if you want to paint interiors, there's not much choice but to hunker down and master perspective.

Mastering Perspective

Many people who've tried to master perspective and slogged through books and lectures that explained, say, how vanishing points work, have had the sinking feeling that the whole enterprise was beyond their powers.

It's no surprise that people feel this way. After all, it took humankind approximately fifty thousand years to master perspective. As brilliant as the Greeks and Romans were, for example, they couldn't nail it, and great pre-Renaissance painters like Giotto couldn't quite get a handle on it either. It wasn't till about 1480 that the laws of perspective were fully understood.

The first order of business in getting a handle on perspective is to find the *horizon line*, an imaginary horizontal line that's at your eye level. Finding this line is the artist's main initial task, and that task is best accomplished by looking straight out—not up, not down—and imagining a horizontal line moving from your eyes into space.

Once that's nailed, the next task is to figure out where along that horizon line the vanishing point occurs. Typically, that's done by finding a window edge, painting frame, or bureau top and following its angle down or up to

1: Notice how the horizon line here is at the artist's eye level.

2: In a straightforward, nonconvoluted space, the walls and furniture will align themselves with that vanishing point or with a second vanishing point also found on the horizon line.

the just-established horizon line. Where that diagonal meets the horizon is the *vanishing point*.

In figure 2 on the previous page, I've angled all the props above and below the horizon line so that they aim toward the vanishing point. Everything below the horizon line angles upward; everything above it angles downward.

Sometimes everything doesn't point to the same vanishing point. Sometimes a piece of furniture, say, might be angled in a different direction. When that happens, its angles should point toward a new vanishing point on the horizon.

Getting a handle on the information presented above will solve most of your interior, landscape, and still life perspective problems. But I should add that there is one other pesky perspective issue that frequently shows up in landscapes and interiors that needs to be understood. The issue occurs when what you're depicting isn't flat. If you're looking into a valley or down a staircase, or looking up at a hillside or a balcony, *one-point perspective* (where all vanishing points are on the horizon) won't do the job. With inclines, you have to move the vanishing points up or down, depending upon the terrain. Looking down, for example, means the vanishing point drops below the horizon line and the diagonals aim toward that new vanishing point location.

A lot of the perspective issues can be ballparked in. In "Painting the Interior" (page 140), I show perspective in action. As you will see in that example, there wasn't too much brain strain over perspective in the painting. I should mention, though, that sometimes it is helpful when you're painting an interior, still life, or landscape to get your hands on a T square and a level.

3: Observe how that box on the floor is aiming toward a new vanishing point on the horizon.

4: Look at how that dip in the road is communicated by lowering the vanishing point.

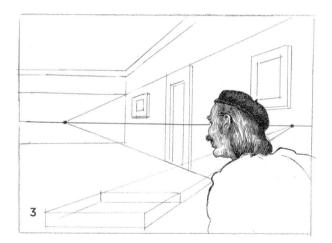

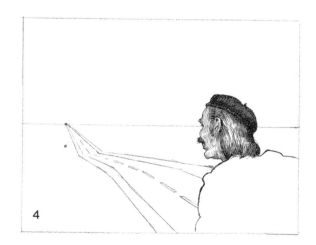

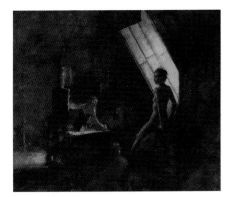

GREGG KREUTZ, *POSING*, 2014,
OIL ON CANVAS, 20 X 24 INCHES
(50.8 X 60.9 CM).

I was hoping to capture a quiet mood
here, trying to keep it all simple.

INTERIORS: OTHER OIL PAINTING ISSUES

Interiors allow the artist to explore a feeling of narrative. Not overt narrative—not a Norman Rockwell kind of story line (that's illustration)—but *implied narrative*, that is, an enclosed piece of story, a vignette.

A Rich Variety of Interior Subjects

Interiors are everywhere, so you have vast variety to choose from. Pool halls, for example, are exciting venues for exploitation. I like the way there's a drama already built into the situation—one player trying to beat the other player. And with pool, not only do you get some nice one-on-one conflict, but the conflict is always dramatically lit from above! A pool game, in other words, is a situation custom-made for artists.

The painting opposite, top is a picture of an interior, of course, but it wasn't painted on the spot. It was painted entirely in my studio, using just two models—moving them around to different positions, and improvising the lighting. I did some initial sketching in a nearby pool hall to get the details right, but because this was a big painting, I needed my own space to nail the effect I was after.

GREGG KREUTZ, *ROSE IN THE STUDIO*,
1999, OIL ON PANEL, 28 X 37 INCHES
(71.1 X 93.9 CM).

In this somewhat romanticized view
of my studio—things usually aren't
this elegant—I made sure Rose was
fully lit and placed in the right third
of the canvas. That way the eye can
travel left to right and come to a stop
on the most interesting (that is, most
human) part of the picture.

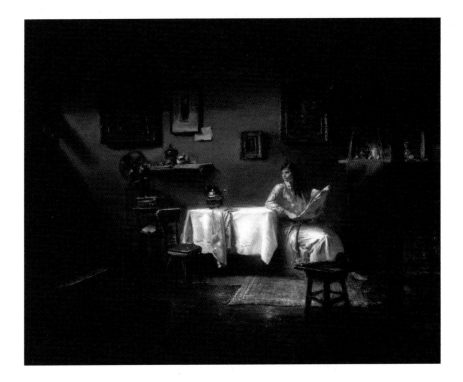

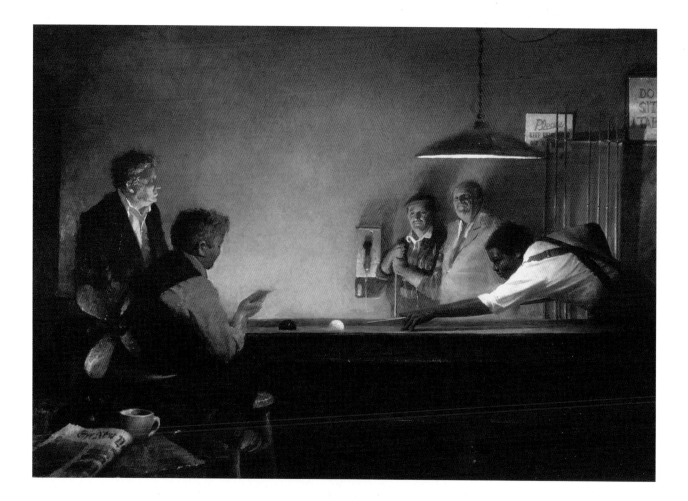

ABOVE: GREGG KREUTZ, *BANK SHOT*, 1985, OIL ON CANVAS, 30 X 40 INCHES (76.2 X 101.6 CM).

In this painting, I wanted the shooter to be center stage—totally focused on his shot—with the onlookers watching intently.

LEFT: GREGG KREUTZ, *ON THE GREEN*, 1987, OIL ON CANVAS, 16 X 20 INCHES (40.6 X 50.8 CM).

Here I wanted a quick incidental feeling of seeing the action through the barriers of the surrounding onlookers. The goal wasn't grandeur or formality or near/far movement, but a quick feeling of a moment captured.

An artist's studio also has potential as a subject. Here you can explore the *theme* of painting through the *subject* of painting. In other words, in a studio picture, the form—painting—is about the content—painting. A nice interweaving connection. (See the painting at left) for an example of this.) In addition, of course, you're working in a studio, ideally your studio. What could be more convenient?

The Palette and Chisel Club in Chicago (see painting below) has an impressive nineteenth-century hallway, but it was too small to accommodate me and my easel. I had to set up in the adjacent studio and, looking out the door, paint the scene from there. It's a good example of how, when painting interiors, you have to roll with the punches.

ABOVE: GREGG KREUTZ, *AT THE EASEL*, 2013, OIL ON CANVAS, 22 X 26 INCHES (55.8 X 66 CM).

This painting shows what I mean about form and content uniting. I liked the idea here of the model looking at what's been painted.

GREGG KREUTZ, *PALETTE AND CHISEL*, 1989, OIL ON CANVAS, 26 X 20 INCHES (66 X 50.8 CM).

While this painting doesn't specifically *depict* a studio, it was, in fact, painted in one.

Art classes are also are naturals for interiors. Here you get models, artists, dramatic lighting, and intensity, and if the classes are held in a slightly rundown space with paint-splattered surfaces (as is the case at the Art Students League), you get character. As in still lifes and portraits, character is primary.

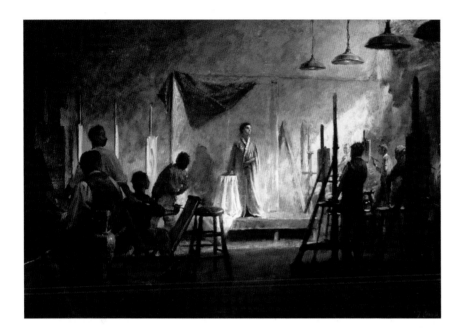

GREGG KREUTZ, *ART STUDENTS LEAGUE*, 1989, OIL ON CANVAS, 30 X 40 INCHES (76.2 X 101.6 CM).

In this interior, I kept the focus on the model by having a shaft of sunlight pull the eye over to where she's standing. Here, because the effect was fleeting (sunlight coming into the room), I did the bulk of the painting in my studio, using models and props where needed.

Backstage scenes are another rich venue for interior painting. There's something exciting about the offstage energy of people waiting and watching at the periphery of the main event.

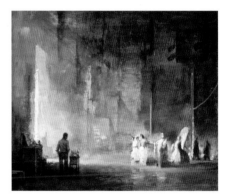

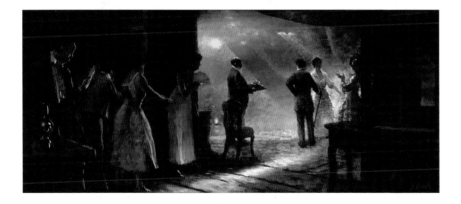

ABOVE: GREGG KREUTZ, *GETTING READY*, 1998, OIL ON CANVAS, 16 X 30 INCHES (40.6 X 76.2 CM).

Here's some backstage hustle and bustle with the main event off to the right. This is a left-to-right kind of composition; the idea is that the viewer is pulled into the space and led across the canvas.

LEFT: GREGG KREUTZ, *OFF STAGE*, 1989, OIL ON CANVAS, 26 X 35 INCHES (66 X 88.9 CM).

Here's a backstage scene with the figure on the left watching the action taking place on stage.

Restaurants and bars are also perfect locations for interior pictures. Not that you can very easily set up in such establishments and start painting, but sketches can definitely be done there. And from these sketches—along with some helpful models—you can get convincing effects. Here we have two passes at the same bar—the Old Town Bar on 18th Street and Broadway in New York City.

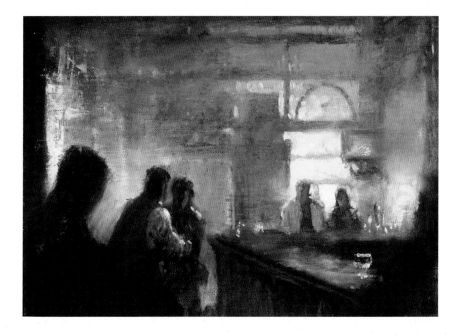

GREGG KREUTZ, *OLD TOWN BAR*, 1998, OIL ON CANVAS, 14 X 18 INCHES (35.5 X 45.7 CM).

With this one, I just wanted to get a feeling of quick energy as we look into the light of this venerable old establishment.

GREGG KREUTZ, *BACK AT THE OLD TOWN*, OIL ON CANVAS, 32 X 40 INCHES (81.2 X 101.6 CM).

This second depiction of the same bar pushes the detail and resolution much further so as to anchor the visual and make it more solid. In this near-to-far painting, I launched the event with the white tablecloth and, using people and props, guided the viewer across the space toward the window.

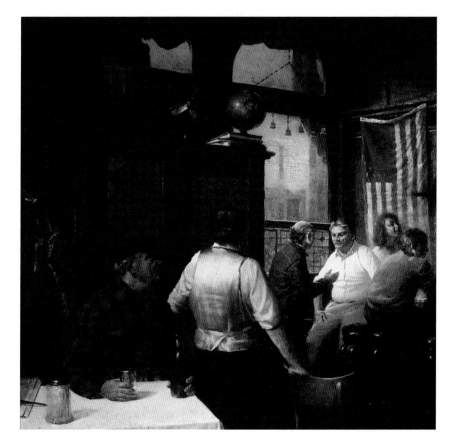

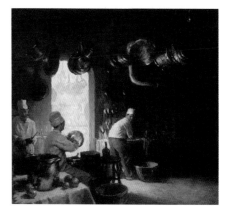

ABOVE: GREGG KREUTZ, *CHEFS*, 2009,
OIL ON CANVAS, 20 X 25 INCHES
(50.8 X 63.5 CM).

Here I shift location to a restaurant
kitchen. This is a near-to-far painting:
moving the eye from the lower left-
hand corner diagonally across the
canvas to the chef looking back at us
on the right. In this picture, I used a
single model for all the characters.

LEFT: GREGG KREUTZ, *TAKING
ORDERS*, 2008, OIL ON CANVAS,
18 X 14 INCHES (45.7 X 35.5 CM).

Here I kept the location information
down to a minimum and put much
more emphasis on what the people
are doing at the table. (Everyone in
this painting is played—incidentally—
by my daughter Phoebe.)

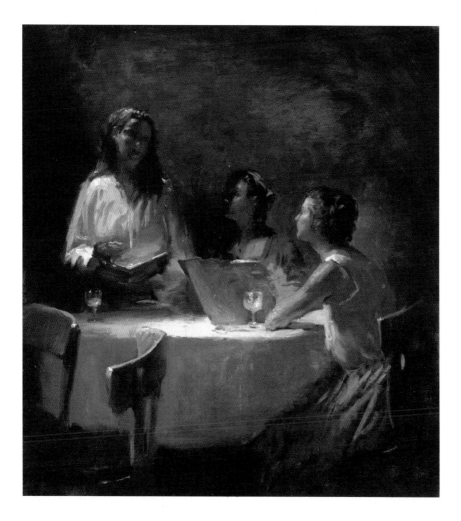

If the focus event is strong enough, you don't need a lot of architectural
background. When there's enough human content, the surroundings—walls,
doors, and so on—aren't really necessary. There are, after all, limits as to how
much information the eye can absorb, so it's a good idea to make the picture
a balance between the implicit and the explicit.

PAINTING THE INTERIOR

GREGG KREUTZ, *ITALIAN RESTAURANT*, 2007, OIL ON CANVAS, 25 X 33 INCHES (63.5 X 83.8 CM).

Here I emphasized the near/far space by brightening the near tables and muting information on the back wall. I also brightened the people and material near the window to communicate that that was where the light was coming from.

Light control is, I think, the biggest problem with painting interiors. There are often too many windows, or even if there's just one, it's frequently too bright. That's trouble because the eye goes to light, and the viewer's attention will be drawn to the lit windows instead of to whatever it is that you want to showcase. Solving that problem can be quite a challenge. But sometimes the solution—as you'll see in the step-by-step on page 142—is to go with it.

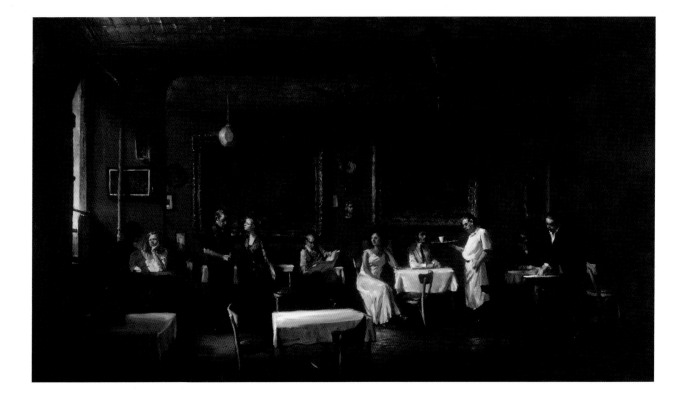

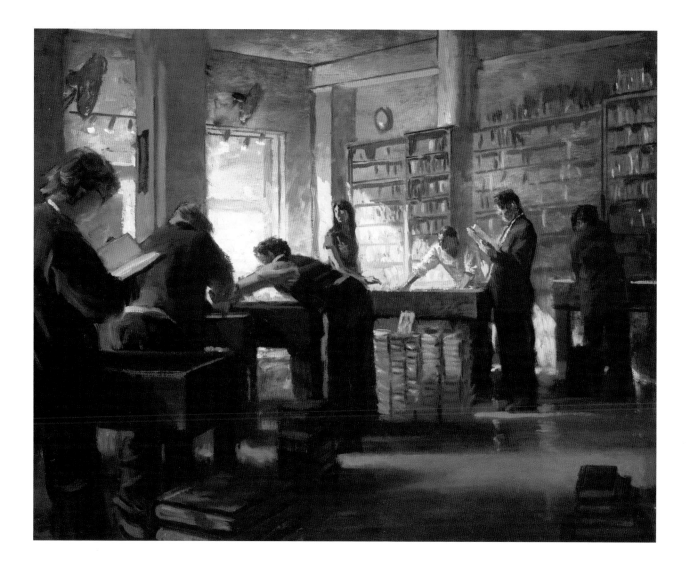

REWARDS

Interiors also provide opportunities to explore themes—aesthetic as well as social. Whether it's people gathering around a picture in a museum or an excited crowd at a prize fight, there's lots of potential for exploring human drama in this branch of painting. And, of course, not all drama has to be vivid drama. An interior could also depict quieter moments like someone looking out a window, or even someone sleeping on a bed. This probing of life's everyday concerns helps intensify the connection between art and life.

INTERIORS: WRAP-UP

Interiors are really a composite of all genres and, as such, are a productive genre to work in: lots of subject matter, lots of light energy, lots of human interest. To succeed, however, they require some (maybe more than some) knowledge of portraits, still lifes, figures, and landscapes. Once again, a familiarity with those other genres will help make interior painting easier.

GREGG KREUTZ, *BOOKSTORE*, 2007, OIL ON CANVAS, 29 X 22 INCHES (73.6 X 55.8 CM).

In this picture, I tried to evoke the concept of obsessive book lovers on the prowl.

INTERIOR STEP BY STEP

In this Caribbean studio scene, I used the placement step to establish the perspective and rough in my composition.

Step 1 (Placement): Here I used the perspective principles discussed in "Mastering Perspective" (pages 132–133). The heads of the two figures were lined up along the horizon line. Below that line—along the table edge in front of the near figure—all the horizontal lines were angled up. Above it, the horizontals angle down.

Steps 2 and 3 (Background and Shadow): I filled in the canvas, but tried to avoid outright drawing. Since I have already figured out the perspective issues, I could keep the brushwork broad and painterly. This was an unusual lighting situation, and I consequently fused together the background and shadow steps into this one step. I did that because I wanted to make sure the light from the window was the main event as it silhouetted the painter in the center. In this case, the brightness of the window provided a nice showcasing element for that figure.

Step 4 (Light): Because of needing to go fast, I tried to avoid too much detail. I traded in finesse for energy and light effect.

GREGG KREUTZ, *CARIBBEAN STUDIO*, 1998, OIL ON CANVAS, 16 X 18 INCHES (40.6 X 45.7 CM).

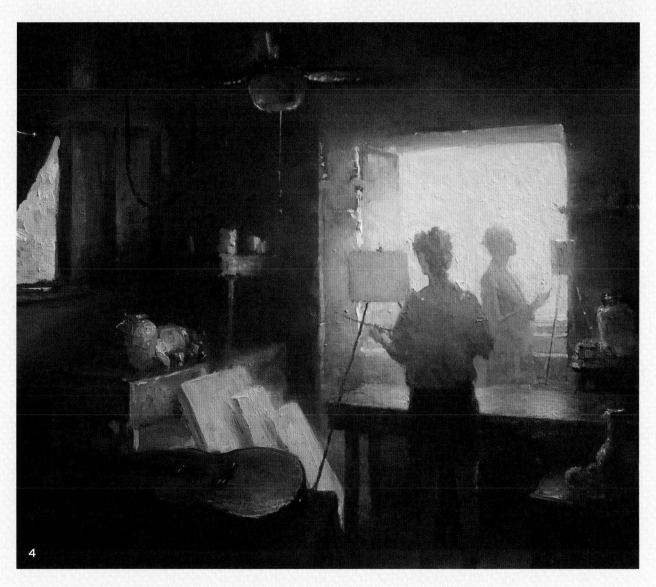

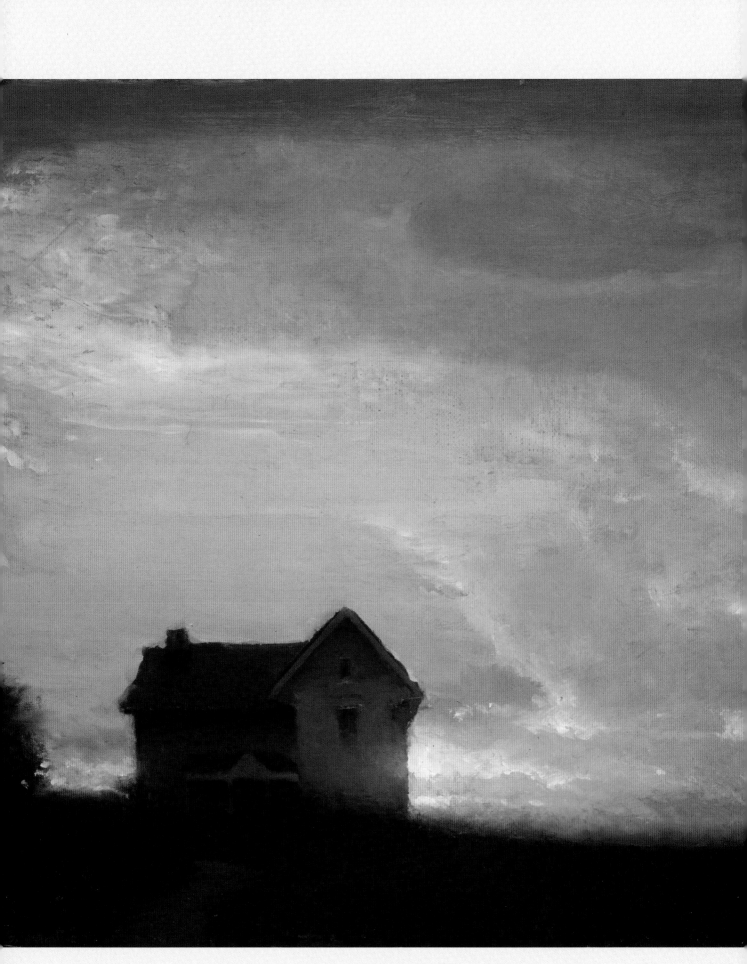

GREGG KREUTZ, *HOUSE ON THE RIDGE,* 1978, 14 X 18 INCHES (35.5 X 45.7 CM).

AFTERWORD: A FEW FINAL THOUGHTS . . .

I remember, early on in my career, having a breakthrough and thinking, *This is it! I've figured it out!*—only to discover in the middle of the next painting that this wasn't it, that there was, in fact, no "it."

While certain insights are invaluable for developing as a painter, every painting—at least every painting I've ever done—at some point becomes a battle zone. In my life, I've never painted along happily from glorious beginning to triumphant ending. There's always something. It might be a drawing problem, it might be a color issue, it might be not enough drama (it's almost never too much drama). But it's always something. And in a way, that's comforting to know. Thinking that the process of painting should run smoothly sets you up for disappointment. Accepting that trouble will eventually rear its head and snap at you makes for less trauma when it does.

To a nonpainter, the act of realistic oil painting might seem like just a pleasant diversion, a fairly harmless way to pass the time. To someone in the thick of getting a compelling image on the canvas, though, painting a picture can feel more like one of those juggling acts where candles, books, a bouquet of flowers, and a few chainsaws are flying through the air. For the painter to coordinate color coherence, meaningful brushwork, astute observation, design coherence, and drama calls upon a heroic amount of focus and concentration. And that concentration can sometimes have surprising results.

An example: I was in the process of painting a bouquet of flowers once, and I was working on a single flower in the middle of the bouquet. In this intense moment, all my energies were focused on trying to get the flower's color right, trying to get the edges right, trying to get the flower to relate to the flower next to it, trying to situate it on the canvas correctly in terms of near/far space, trying to make it fit into the design arrangement of the bouquet, trying to keep my brushwork expressive, and most important—sometimes hardest of all—trying to remember *which* flower I was painting!

In the middle of this frenzy of intense concentration, my mind suddenly quit. I simply couldn't sustain that intense focus any longer. All at once, my mind decided the whole thing was way too hard. After grinding away intensely for a few hours trying to keep track of everything, my mind announced, basically, *Enough! I'm outta here.*

The weird thing is, right after I had that feeling—immediately after I said to myself *Enough!*—my mind relaxed and painting suddenly got easier. Why? What's that about? I think it's that prior to my mind saying stop, I was working linearly, making lots of separate decisions and putting information together piece by piece. After I decided the whole thing was impossible, my mind relaxed. And by giving up, it stopped exerting effort. Then, all of a sudden, with no effort getting in the way, I was painting holistically.

I've often wished that I could go directly to that state—the holistic state where everything flows together—but as far as I can tell there's no easy access to that zone. You can't just will yourself there and you can't get there through effort because, after all, the nature of what you're trying to achieve is *effortlessness*.

In that sense, of course, painting is a perfect metaphor for life. As a wise painter once told me, everything that happens on the canvas has its life equivalent. Which is why realistic painting is important—it has essential questions to explore: *Why do things look the way they do? What is the underlying structure? What communicates—and what doesn't? What's harmonious? What's significant?* These questions—in a sense, these philosophical questions—have been grappled with by artists for centuries and show no sign of fully yielding their answers. Since life is fluid—open, ever-changing, mysterious—there can never be a solid formula to explain everything. The notion that the universe is reductive and that science has figured it all out disregards essential truths. Einstein said, "What can be measured isn't always important, and what's important can't always be measured."

Developing as an oil painter, then, requires perseverance, sensitivity, intelligence, compassion, flexibility, and the ability to see the whole instead of parts. It's a lifelong journey, and I don't believe a real artist ever "arrives." Since existence is ever-changing, artists—both you and I—need to evolve and change with it. Only within that shifting, moving flow of reality can oil painting essentials lead to truth.

GREGG KREUTZ, *CHESS*, 2011,
OIL ON CANVAS, 50 X 30 INCHES
(127 X 76.2 CM).

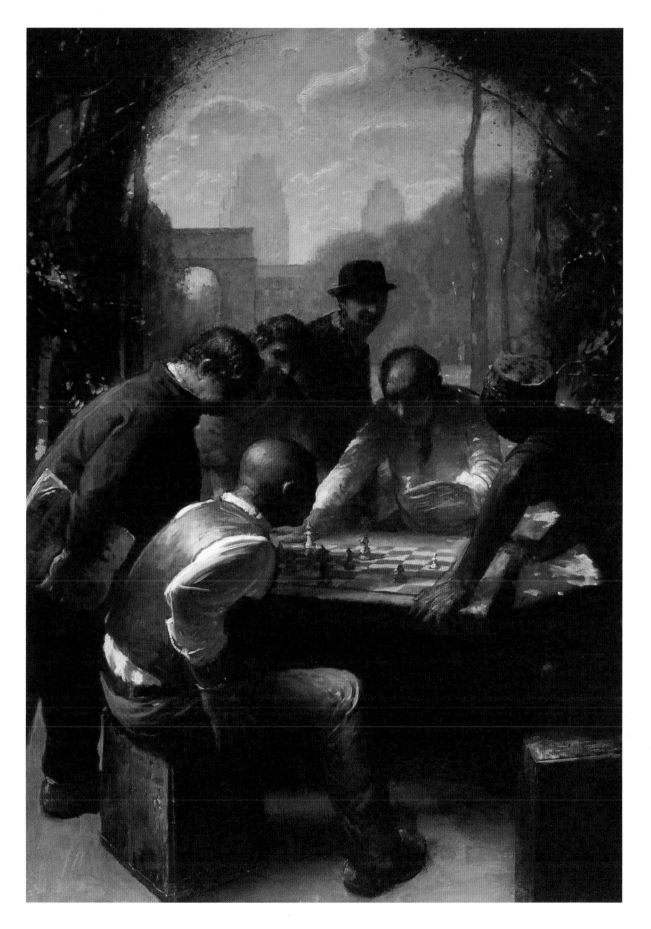

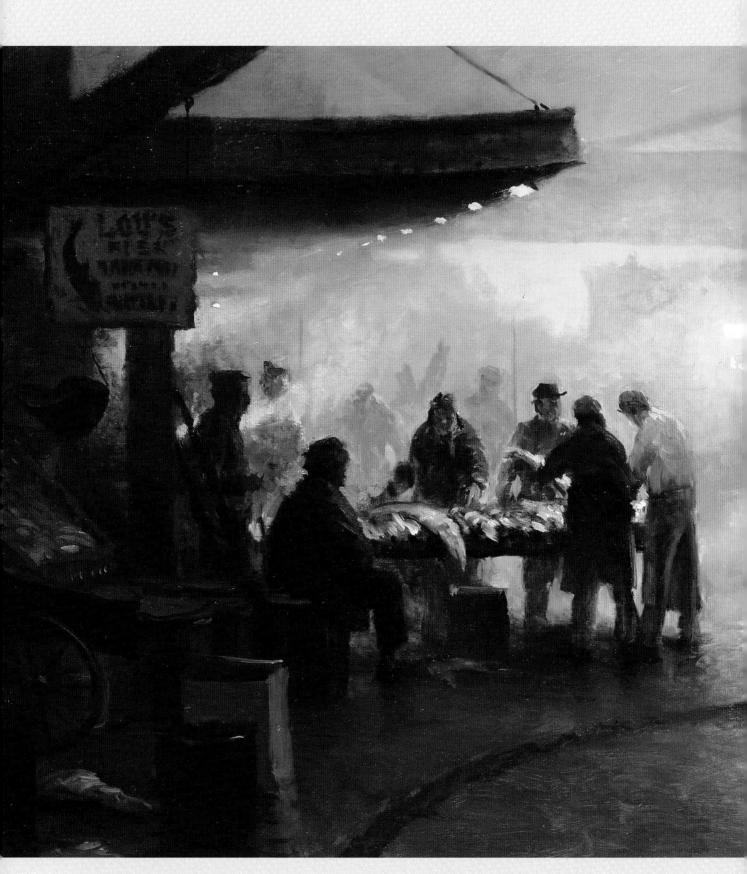

GREGG KREUTZ, *FISH MARKET DAWN*, 1989, OIL ON LINEN, 25 X 32 INCHES (63.5 X 81.2 CM).

ACKNOWLEDGMENTS

Help on this book came from many quarters.

Thanks to Michael Koch for working with me on the initial pitch; to Patrick Barb for going for it and guiding it along; special thanks to my copy editor Jean M. Blomquist, who slogged through all the crazy material and brilliantly pushed it into coherence; thanks to Chloe Rawlins for her beautiful design work; to Andrew French for tireless help with computer glitches; and to my daughters, Phoebe and Lucy, for being the kind of joyful geniuses who are always up for lending support. And speaking of helpful: thanks to their mother, Gina Kreutz, who—way back when—was willing to take on an artist as a spouse and thanks to Jessica Dalrymple for—later on—also giving it a shot. Thanks to my sisters, Nicky, Charlotte, and Libby, and my dear friends Sherrie McGraw and Nancy Cohen for being who they are. Oh, and a special thank you to Christine Su. And finally, thanks to David A. Leffel, a great friend and mentor who showed me the connection between real life and painting.

INDEX